The Secret World of Consumers, Connoisseurs,
Curators, Creators, Dealers, Bibliographers,
and Accumulators of "Erotica"

SEX COLLECTORS

Geoff Nicholson

Simon & Schuster

New York London Toronto Sydney

SIMON & SCHUSTER
Rockefeller Center
1230 Avenue of the Americas
New York, NY 10020

SIMON & SCHUSTER and colophon are registered trademarks
of Simon & Schuster, Inc.

Grateful acknowledgment is made to the following for permission to use
illustrative material: p. 220, Alfred Kinsey © Bettmann/Corbis;
p. 87, lotus shoes © Chris Hellier/Corbis; p. 105,
Cynthia Plaster Caster © Touhig Sion/Corbis Sygma.

For information about special discounts for bulk purchases,
please contact Simon & Schuster Special Sales:
1-800-456-6798 or business@simonandschuster.com.

Book design by Ellen R. Sasahara

Manufactured in the United States of America

1 3 5 7 9 10 8 6 4 2

Library of Congress Cataloging-in-Publication Data
Nicholson, Geoff.
Sex collectors : the secret world of consumers, connoisseurs, curators, dealers,
bibliographers, and accumulators of "erotica" / Geoff Nicholson.
p. cm.
Includes bibliographical references.
1. Erotic literature—Collectors and collecting. 2. Erotic films—Collectors
and collecting. 3. Erotic art—Collectors and collecting.
4. Sex—Literary collections. I. Title.
HQ462.N53 2006
306.77—dc22 2005057600

ISBN-13: 978-0-7432-6587-4
ISBN-10: 0-7432-6587-4

Contents

Contents

SEX COLLECTORS

1

AN INTRODUCTION

The usual throat clearing, my father's gnomic wisdom, anal retention, less than full disclosure, living with and without a sex collection.

I once had dinner in New York with Linda Lovelace. This is not a boast. It was some time ago, well before I'd thought of writing a book on sex and collecting, though I was certainly already interested in both subjects. The year was 2000 and Linda, who was then in her early fifties, was trying to make a modest comeback. My girlfriend, Dian, was the editor of a men's magazine called *Leg Show,* and Linda was in town to do a photo shoot for her. Linda wasn't prepared to take her clothes off for the shoot, or more precisely she wasn't prepared to take her clothes off for the sort of money *Leg Show* was willing to pay. Therefore Dian had arranged for her to be seen in a corset, high heels, shiny tights, and so on. This, I suppose, might have allowed Linda to square an appearance in a men's mag with her continuing professed antipornography stance, but my guess is she didn't need to square anything. She was a woman who could live with contradictions.

Linda Lovelace, real name Linda Boreman, was, as everyone of a certain generation will need no telling, the star of *Deep Throat,* a preposterously lame porn movie, made in 1972, about a woman whose

clitoris is located a long way down her throat and who can therefore get satisfaction only from "deep-throating" men. There have been crasser premises for movies but not many, not even in porn. Yet the moment found the movie. American society was ready and eager to embrace hard-core pornography, and *Deep Throat* struck lucky. It became a hit, a must-see, a couples movie, even a date movie.

I don't think you can pretend that Linda Lovelace was the only or even the main reason for the success of *Deep Throat,* but she did what was asked of her, and it's apparent that the camera liked her a lot back then. On-screen and in still photographs from that period, her face had a lopsided, quizzical, hippieish laxity about it that was very much of its time, but still remains appealing today. In the early days she had a shaggy, let-your-freak-flag-fly kind of perm, trading it in for a then-more-fashionable yet somehow more staid feather cut.

She always looked as if she was enjoying herself in front of the camera. She denied this fervently in person and in print. She said she was hating every minute of it, but was acting as if she was enjoying it because her manager and husband, Chuck Traynor, had threatened to kill her if she showed any reluctance. If this is true, then Linda Lovelace was an infinitely better actress than anyone I've ever seen in a porn film.

In England, where I lived at the time, we never saw *Deep Throat,* but we certainly knew about it and we knew who Linda Lovelace was. We'd read the articles, the interviews, seen the film stills, read or at least heard about the so-called autobiography *Inside Linda Lovelace,* which wasn't written by her but was prosecuted in England for obscenity. The prosecution failed, and after that England pretty well gave up fretting about the printed sexual word. Some of us thought that was a good thing.

The *Leg Show* photo shoot, indeed Linda's entire comeback, was being facilitated by a man called Eric Danville, a writer who had worked for *Penthouse, Forum,* and *Screw,* a man who would admit to having had previous obsessions for certain female stars including

Debbie Harry and Madonna. The name Joan Jett was—and I imagine still is—tattooed on his forearm. Joan had autographed his arm at a New York gig, and after some hesitation he'd had a tattooist ink in the signature before it faded. It looked as good as you'd imagine.

Eric is a very competent researcher, known for his determination to track down anything and everything on a subject. About six years earlier he'd decided to write about Linda Lovelace, and had managed to get her phone number and call her up. She'd refused to speak to him, had indeed pretended to be her own secretary. This only spurred him on to become a serious Linda Lovelace expert and collector.

There is apparently quite a lot of stuff out there, although the primary materials, as it were, are limited. Linda Lovelace only worked in hard-core pornography for a very short time, literally a few weeks. A lot of the movies that purport to have her as their star are shameless rip-offs and repackagings of the porn loops she made before *Deep Throat*. These include a couple of her having surprisingly enthusiastic sex with a dog, which I had in fact seen, but before we had dinner that time I was sternly informed by Eric and Dian that "nobody mentions the dog."

After *Deep Throat* she rose without trace, to become a celebrity, to make "straight" films like *Linda Lovelace for President*—a satire of sex and politics that's probably even more disappointing to those interested in politics than to those interested in sex. She even appeared on the New York stage in a play called *Pajama Tops*.

Eric Danville, of course, had videotapes of all her movie work, he even had two versions of the sound track of *Deep Throat* that had been released on vinyl. He had masses of magazines in which her photographs appeared. He had bootleg live recordings of a Led Zeppelin concert where Linda had been the emcee. He had every pop or rock song that contained the name Linda Lovelace—most famously Elton John's "Wrap Her Up."

Of course he had all the books attributed to her, all of them ghosted, all more or less autobiographical, charting a course from fake

sexual liberation, via victimhood, toward a misanthropic feminism. *Ordeal,* a midperiod work, and in some way the most compelling in the oeuvre, tells horrific tales of rape and sexual violence, yet still remains part of that long, long line of popular confessional literature in which the sins have to be recalled in prurient detail before they can be forgiven.

While amassing his collection, Eric made further attempts at contacting Linda and assuring her of his good intentions. After her experiences with Chuck Traynor she was naturally suspicious of men who wanted to "help" her, but she and Eric became friends, and she gave him some snapshots for his collection, nice enough, perfectly innocent pictures taken on holiday in England in the 1970s, one of which showed her posing with Stonehenge as a backdrop. In return for this, Eric was helping her make some money by organizing the sale of authenticated Linda Lovelace items on eBay.

Linda needed all the money she could get. A liver transplant had left her in need of some very expensive drugs, and she'd fallen on hard times when Eric caught up with her. She'd worked briefly as an office cleaner in Colorado but lost the job because company policy insisted that employees had to give details of every name they'd ever worked under. For entirely obvious reasons she hadn't told them that she used to be Linda Lovelace, but they found out anyway and were then able to fire her because she'd "lied" to get the job.

So she was glad of the attention, glad to be invited to New York to do a photo shoot, glad to be taken out to dinner. It wasn't just me and her, of course. Eric was there, too, and so was Dian, and I seem to remember Eric's wife, Abby, being there briefly, too. Linda looked not bad that night. The skin on her face was a little florid and pockmarked, but she was lean and tanned and she certainly looked alert and alive, and if she seemed a little damaged at the edges, she certainly didn't look destroyed. She still had the feather cut. She was polite and a little nervous and seemed to be consciously on her best behavior, but then so was I.

In some ways she was quite the innocent. She hadn't heard of reflexology, for instance, and when the drinks menu came she didn't know what "ale" was. She talked a lot about her children and her grandchild, but she was also happy to talk about her past. She'd met her fair share of the rich and famous, she said, but they'd seldom been the way she wanted them to be. Clint Eastwood was a terrible disappointment because when he sat next to her at the Playboy Mansion he'd been wearing jeans and sneakers. Elvis had been a sad, drugged-up fat man who erupted from time to time in a flurry of karate moves. The only one she'd really been impressed by was Tony Curtis because, she said, he seemed like the same guy offscreen as he was on.

There had been some talk that after dinner we might go back to Eric's apartment. It would be a rare occasion when a collector, the subject of his collection, and the collection itself would all be in the same room at the same time. And so it came to pass. As I've said, I had no idea at the time that I would ever write a book about sex collectors, but even so I could see this was going to be a special moment.

Eric's apartment, where he lived with Abby, was a monument to their shared and separate enthusiasms. She was editor of a magazine called *Extreme Fetish,* and a professional giver of parties, usually with some fetish theme. Around the apartment were some of her clothes that bordered on fancy dress, books, fetish magazines, videotapes, records, vibrators, and it was all highly organized. Along one wall of the living room were two museum-style floor-to-ceiling vitrines that had been sawed into sections before they could be got up the stairs and into the apartment. There were also a couple of "cabinets of curiosities" mounted on the walls.

The Linda Lovelace collection was in a glass-fronted bookcase in the bedroom at the foot of the four-poster bed. It would have been easy for Eric to sit up in bed and gaze with pride at his collection; in fact it would have been pretty impossible for him not to. Eric was keen to show it off, and Dian and I were an enthusiastic audience, but the presence of Linda was clearly giving Eric some anxiety.

To an extent Linda reacted the way anyone might while rummaging through an old box of photographs or family keepsakes. Some of the things in Eric's collection she remembered well, others she'd never seen before, didn't know where they could have come from. There were photographs that she didn't remember being taken, of her standing next to someone she didn't recognize. But occasionally she'd look at herself in a photograph and say something like "Oh, I still have that dress," and Eric would say, "Well, if you want to sell it we can put it on eBay." The fact that there was a picture of Linda wearing it improved the provenance and supposedly increased the value.

I think both Linda and Eric were a little embarrassed by the occasion, as who wouldn't be? Occasionally she'd laugh nervously and say something like "This guy knows more about my life than I do." Whether or not this was literally true I'm not sure, but I suppose all serious collectors know things in a systematic, codified way that the subject of the collection never will.

But one thing Linda certainly did know was her own signature, and when Eric showed her a signed film still, she was immediately able to tell him it was a fake. It wasn't her signature. Someone had forged her autograph to increase the value of the still. Eric was crestfallen and horrified. He'd bought the still from a dealer he regularly did business with, and he swore he'd get his money back, though he didn't sound very confident. But there was obviously something else at stake here. A true, knowledgeable Linda Lovelace collector, a connoisseur of the type Eric wanted to be and thought he was, should surely have spotted a fake a mile off. Eric hadn't. He'd failed to live up to his own standards. Eric smiled nervously and then his face settled into a study of mortified disappointment. It pretty much soured the evening.

I don't want to say that witnessing this event was some great road-to-Damascus moment of literary inspiration. I had already written about obsession, sex, and the relationships between people and

things, though it had mostly been in fictional form. And I suppose, like any professional writer, I was always on the lookout for some new way of writing about old subjects. Nevertheless that night with Linda and Eric and the forged signature was one of those intense, moving, all-too-rare occasions when a writer says to himself, "You know, I think there's a book in this."

Incidentally, on page 55 of *Ordeal* Linda says that Chuck Traynor gave her two pieces of advice: "I should never let anyone take my picture, and I should never sign my name to anything. He said those were two things that would always come back and haunt you later on."

I remember very clearly the first piece of sexual material I ever, so to speak, collected. It was a copy of *Carnival,* what we would probably today refer to as a pinup magazine. It contained jokes, cartoons, a bit of hairy-chested fiction, and on most pages were my reasons for buying it: pictures of partly undressed women. Many were in bikinis, or if naked, they were posed in a way that preserved most of their modesty, but a few were less modest and showed bare breasts, nipples, and the occasional bottom. Pudenda and pubic hair were entirely unseen, their display as unthinkable to the publisher (City Magazines Ltd, 167-170 Fleet Street, London EC4) as they were to me.

I was thirteen years old, the year was 1966, and given that I managed to buy the magazine quite openly, if nervously and furtively, at a newsstand in the center of Sheffield, I don't suppose I, or the person selling it to me, was involved in anything very transgressive. Nevertheless, as I thumbed through the magazine that night in bed (yes, under the covers; yes, using a flashlight), it seemed to me I'd gained access to a world of infinite female mystery. In fact I probably believed that the magazine was the means of solving that mystery. Here were women showing their naked bodies, exposing themselves, flaunting themselves. It seemed a bizarre, an indecent, and a wonderful thing

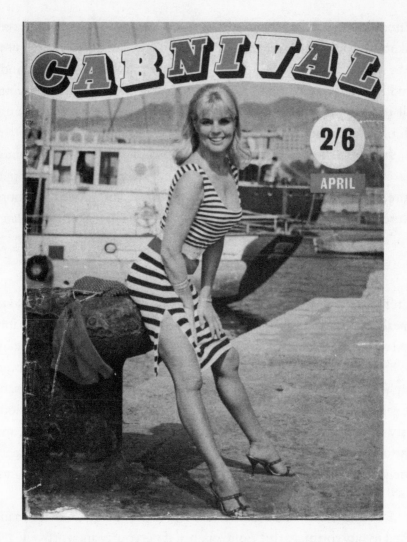

The cover of a copy of Carnival from 1966, the first piece
of erotica I ever "collected."

for them to be doing. I looked, I saw, I seemed to understand. And I
remember thinking to myself these images were so intense and so
revealing that they were the only ones I'd ever need to look at or own.
That delusion lasted a surprisingly long time; say a month.

One of the reasons I remember that copy of *Carnival* so well is that

I still have it. It's here now. The cover, printed in intense, slightly blotchy color, shows a blonde wearing a striped dress that manages to expose both cleavage and thigh. She's at a dockside, half sitting on a metal capstan, and the mountains in the background suggest she's somewhere in the Mediterranean. Her face shows a healthy, enthusiastic, uncomplicated sexuality. There's nothing corrupt or decadent about her—she's a cover girl—although some of the models inside the magazine look far more knowing and overtly sexual.

Actually, the models are of two sorts; first there are young actresses, some of whom you may even have heard of: Edina Ronay, Martine Beswick, Jackie Collins (yes, *Jackie,* not Joan), and they're more or less decently dressed. Then there are the glamour models proper, some of them identified as French, Italian, or American, thereby representing the wildest shores of sexual exoticism that could be imagined in England in the midsixties, and these girls were prepared to show rather more. So here they are, as naked as the magazine allows, wearing see-through baby-doll nighties and high-heeled mules and wisps of leopard skin, pretending to play the guitar or lolling provocatively on patchwork leather poufs. It's tame stuff, of course it is. I suspect that almost any thirteen-year-old boy of today would find it quaintly innocent, and I'm certainly not trying to make any claims for it as a classic or significant or seriously collectible bit of erotica.

Now, the mere fact that I still have that copy of *Carnival* might suggest to you that I am, and have long been, a sex collector, but when I first started writing this book I certainly didn't think so. Back then I'd have said I kept that first magazine simply because it was the first. It was a souvenir I'd held on to because of what it represented, because of the effect it had once had on me. It certainly didn't mark the beginning of my career as sex collector, I'd have said, since I didn't think I'd had any such career.

I meant it sincerely. I wouldn't have been trying to deceive you or myself. I would have said I was fascinated by the subject of collecting,

and that I could see the attractions of creating and owning a collection, but that I didn't have any urge to do it myself. And I would probably have admitted that I shared some of the same acquisitive "genes" as collectors, but I'd also have said that there was some important gene missing, something that held me back, that prevented me from becoming a "true" collector, whatever that was, and that I was happy to be held back.

And yet, and yet . . .

That copy of *Carnival* wasn't exactly the only piece of "erotica," or pornography, or whatever we decide to call it, in my possession. Over the years I'd been a regular if infrequent buyer, and although a few things had got lost or misplaced over the years, I was definitely a keeper rather than a thrower away.

It's worth noting that for substantial parts of my adult life anything resembling hard-core pornography was illegal in England, where I then lived, and therefore extremely difficult to get hold of. To have amassed a collection would have involved a lot of expensive trouble, at best involving dealings with unreliable mail-order dealers, at worst involving transactions with both unsavory criminals and police.

Hard-core pornography was therefore rare and enticing, and consequently when I went abroad, to Amsterdam or Paris, or even to the United States or Australia, I tended to take a look in the local sex shops to see what we were missing in England. And I sometimes brought a magazine, two at most, back with me as a souvenir. Fear of being searched and shamed by customs men was certainly a factor, but one or two was all I wanted.

Equally it's worth noting that there have been even more substantial periods of my adult life when admitting to any familiarity with or interest in pornography, or even "erotica," would have condemned a man as a scum-sucking, probably self-loathing, and certainly woman-hating pervert and inadequate. We're talking about the kind of women I used to meet back then. I didn't want to cause offense and be hated by them. Some of my best friends were feminists.

We know there are some necks of the wood where this attitude persists. In less densely foliated areas, the ones I inevitably inhabit, to be interested in pornography is currently considered to be okay, to be a sign that you're *un homme moyen sensuel*—it's what guys are like— but some of us won't be entirely surprised if and when the backlash comes.

So, in the interests of fullish disclosure let me briefly describe my holdings as they stood before I began to write this book. In addition to that copy of *Carnival,* at the very mildest end of things were a number of *Readers' Wives*–type magazines, with amateur content supplied by men who like to see their wives and girlfriends naked and in print. I love this stuff and always have. I think it's because it allows you to see naked "ordinary" women, the kind you don't normally find posing in magazines. More than that, you see them in their natural environments, in their own bedrooms or living rooms and kitchens, places you're never going to be invited in reality, and definitely not for sex. It creates an intimacy that more professional, "industrial," pornography never achieves.

But, of course, I owned a bit of the industrial product, too, the brightly lit, full-color, overpolished, overglossy mainstream stuff: issues of *Private, Busen Leben,* and *Eroticat*—the latter impenetrably subtitled "High Class Pornography from Scandinavian Picture." This stuff seemed very hot and desirable when I first acquired it, but I must say it's looked less and less interesting as the years have gone by.

More enduring are the few genuinely exotic or eccentric items, the odd water sports, piercing, or foot-fetish magazine, and, for example, a French publication called *Transsexual Climax (auteur, éditeur,* Manuel Lizay), a thing so thoroughly bizarre and downright odd that I never dared show it to anyone for fear of what they might think about me. I also owned a few videotapes, again both generic and curious, Sarah Louise Young on the one hand, and a fat, tattooed, pierced orgiast called Rona of Ipswich on the other.

I bought this stuff for all the usual reasons: as an aid to masturba-

tion, to share with a female sexual partner (always a risky thing to do), and also to satisfy my curiosity about the varieties of what people do and how they look while they're doing it; and that last thing is a function of pornography that isn't to be underestimated. But in all cases we're talking small numbers. Put all my acquisitions together, and did they constitute a sex collection? I wouldn't have said so. I'd have said it was just a bunch of smut that I happened to have accumulated over the years.

Another issue might be that at this point in cultural history, anyone with an interest in art, literature, or the movies is de facto a sex collector. Your bookshelves are likely to contain novels by Joyce, Bataille, Burroughs, de Sade, Henry Miller, Bret Easton Ellis, et al. You're likely to own books or magazines containing images by Bellmer, George Grosz, Man Ray, Mapplethorpe, Helmut Newton, Araki, Warhol, Nan Goldin, and many of these images will be highly sexual, and some of them consciously, deliberately pornographic. Likewise you might own DVD copies of movies by David Lynch, Peter Greenaway, Kenneth Anger, Richard Kern, and there'll be some very explicit stuff in there, too.

I pick these names not quite at random. I choose them because, even before I started this book, I owned work by all these people, but did my ownership of these texts and images make me a sex collector? No, no, I'd have said again, it just makes me a man of my time. Hundreds of thousands of people owned much the same material as I did. We weren't all sex collectors, surely.

In any event, I was much less of a collector than my girlfriend Dian, the one who organized the photo shoot for Linda Lovelace. When I first met her she called herself a "career pornographer," which is a good line, and almost true. She'd worked for men's magazines of var-

ious sorts for a good long time, though when I met her she was involved with the decidedly soft-core end of things. As well as *Leg Show,* she edited the magazines *Tight* and *Juggs;* well, somebody had to. I wouldn't say that pornography brought us together, but clearly I was fascinated by the notion of a female pornographer, as are many others.

I also knew that she was something of a collector of erotic materials, which she kept in her house in upstate New York, a two-hour drive from Manhattan. I made the journey there at the beginning of our relationship, with some trepidation, intrigued and not knowing at all what to expect. The house was ordinary enough on the outside, small, rustic, painted pale blue, but the interior was extraordinary, its decor based on old-curiosity-shop chic, with elements of a certain kind of saloon: heavy oak furniture, stained glass, motion lamps, a neon beer sign, multiple pieces of taxidermy, a live snake in an aquarium. I'd been there for a while before I even began to notice all the erotic items. There were original artworks and photographs on the walls, by the likes of Eric Stanton, Russ Meyer, Elmer Batters, Bobby Beausoleil (yes really, Mansonite Bobby—a kitsch little painting showing two "mythological" figures kissing). Then there were Barbie dolls and their sexualized imitators, some fetish masks, whips, and one of those Balinese male figures that are really drums, with a detachable penis that you can use as a drumstick. Here and there were a variety of sex toys, vibrators, and electric stimulators that had generally been sent to the magazines for "testing," some of which looked (and were) extremely dangerous.

The bookcases were packed with sex books and magazines: a catholic selection, from Krafft-Ebing's *Psychopathia Sexualis* to Hirschfeld's *The Sexual History of the World War,* from *Puritan* to *Amputee Times,* from medical textbooks to underground comics, along with all manner of erotic novels, sex guides, and manuals. One particularly cherished item was *The Illustrated Presidential Report of the Commission on Obscenity and Pornography,* published as a Greenleaf

Classic. Dian had bought it on the day she turned eighteen, the very first moment it was legal for her to buy pornography. There was also an attic full of many hundreds of videotapes: from *Orifice Party* to *Black Bun Busters,* from Chuck Berry's water-sports tape to Linda Lovelace's dog movie.

In other places around the house there was a large and spectacular array of outfits that had been used by nude models. Dian had always had a hands-on approach to photo shoots. She wasn't a photographer, and never actually pressed the shutter release, but she'd done pretty much everything else: chosen the models, dressed the sets, directed the shoots, bought or borrowed outfits for the girls, and then costumed them. Consequently the house contained countless stockings, corsets (one purporting to have belonged to Maureen O'Hara), gloves, hats, feather boas, a nurse's uniform, and of course there were scores of pairs of shoes and boots, in all sizes and in many styles, though chiefly of the high-heeled fuck-me variety. There was, I admit, a certain thrill in knowing that these clothes had been worn by bona fide sluts who'd torn them off during the making of pornography. She also had filing cabinets full of slides, glossy nude photographs, business documents, souvenirs from the "sex industry."

Dian was evidently attached to all this stuff, in that she'd not thrown it away, but again, the extent to which it constituted a collection was debatable. Very little of it had been acquired in any systematic way. Very little of it had been sought out or bought. It had come her way in the course of her career. Can you be a passive collector? Yes, I'm sure. And in any case a selection process had definitely taken place. She'd kept only a fraction of the masses of material that had passed through her hands, and in part she'd kept things she liked, that she found sexy or funny or interesting. But there was also an anthropological dimension to it.

It may surprise you, it certainly did me, that some readers of men's magazines (a tiny minority to be sure, but the numbers add up) like

to correspond with the editor, especially if the editor is a woman. They like to discuss the merits of the models in the magazine. They like to send in photographs of themselves, with or without their partners, with or without clothes, with or without erections. They like to send in autobiographical writings, confessions, manifestos, politico-sexual tracts, and artwork. Some of it frankly gave me the creeps, but to Dian it was well worth preserving. I mean, if a man sent *you* some photographs of himself in full drag, saying that his greatest turn-on in life was to wear high heels and pump the gas pedal of his station wagon, you (and indeed I) might think, "Oh boy, this guy should get over himself," and then you'd throw away the photographic evidence that he'd provided. But Dian would keep it. It was interesting, she said. It was, that Kinseyan word, *data*.

Did I find all this stuff easy to live with? Yes and no. Much of it was fine, of course. Much of it was fun and interesting and sexy and arousing. But some of it wasn't. Perhaps it's absurd to complain about pornography being offensive, that's surely one of its attractions and defining factors, but offended I sometimes was. There were things in Dian's filing cabinets that I saw once and never wanted to look at again, that I wished I'd never looked at in the first place, that I wasn't even all that keen to be under the same roof as. Some of the magazines in the collection seemed both misogynistic and racist, often at the same time; I'm thinking particularly of a dubious tabloid called *Interracial News*. Nor did I share Dian's taste for "primitive" reader art, especially when it featured scenes of sexual torture, as so much of it did. If I'd encountered these things in somebody else's collection or someone else's house or in a sex museum, they might have been bizarrely fascinating, and would have been fine, but having them at home, as it were, was a different matter.

But perhaps the problem was a more general one. Perhaps everyone finds it hard to live with someone else's collection. Whether it's overtly sexual or not, a collection is always intensely personal. It has meanings and intimacies that another person can never share. It

excludes others. No doubt Peggy Guggenheim's husbands found it difficult to live with her world-class art collection.

When Dian and I eventually bought a house together we agreed that we didn't want to feel like we were living in some quirky private sex museum. We agreed that our shared living space should be as uncluttered as possible, and we've more or less stuck to that, while our offices, hers far more than mine, have become warrens of accumulation and obsession. Out of sight is not entirely out of mind, but at least it means that when a plumber comes to the house he doesn't look around him and think we're a couple of weirdos; or if he does, the judgment isn't based on seeing piles of nude photographs and dirty magazines. Dian always says I worry too much about that sort of thing, and I'm not saying she's wrong.

My father, who wasn't much given to gnomic utterance, and was no sort of collector, did drop one bit of wisdom that I'll always remember: "When you've got furniture," he said, "furniture's got you." Substitute a collection for furniture and you see why this has been on my mind lately. It occurs to me that one of the main reasons I never became much of a collector was that until recently I always lived in very small flats or houses, and regularly moved around. Moving is quite difficult enough without having to transport precious collections as well.

My father worked for the council in Sheffield. He started out as a carpenter and joiner, building council housing after the war, and he rose through the ranks, ending up in a job that seemed mostly to involve listening to the complaints council tenants had about their accommodation, then sending a man to fix it.

One day an old couple told him their toilet was stopped up. My father said he'd send a plumber. How long had it been blocked? About two years, they said. For about two years they hadn't been able to use their toilet. They'd managed to use the sink for liquid waste,

but solids were trickier, so they'd been putting those in black garbage bags. They still had them. They were stacked up in the spare bedroom, did he want to see them? He didn't, and he had a lot of trouble finding a plumber prepared to set foot inside the house, which frankly surprised me: I thought council plumbers were made of sterner stuff.

You'll find plenty of psychologists, not least Freud (of whom more later), who'll tell you that collecting is an anal compulsion. He says that orderliness, obstinacy, and parsimony are the three traits that go along with anal eroticism. The need to keep and the refusal to give is what adults do as a substitute for the childhood habit of retaining feces. We gather objects, or indeed money, because we can't bear to part with our dung. The old couple in Sheffield had demonstrated the point more literally than anyone, certainly than any Sheffield council plumber, would ever want.

It so happened that I, too, worked for the Sheffield council one summer. They employed me as a garbage man. I carried away domestic waste from the poorer parts of the city. Men who work with garbage every day are no less curious about its contents than the rest of the population, and they don't feel any inhibition about satisfying their curiosity. We always dug through the bins to see if anything of interest was being thrown away, and we always, *always,* found pornography, lots of it, girlie magazines, dirty books, some of it quite odd and explicit, although never anything truly hard-core, that was obviously too valuable to be disposed of by this method.

Throwing away pornography is not quite the opposite of collecting it. In both cases it has to have been sought out and obtained. But owning and keeping it has uncomfortable implications for some people. They may like pornography, they may like to use it, but having used it they don't want it in their home. This of course says a great deal about their feelings toward sex, arousal, and home.

There are historical precedents. We know that Samuel Pepys owned and enjoyed a copy of *L'escholle des filles* (it consists of a dialogue

between two young women, one innocent, one sexually experienced), but after reading it he burned it so "that it might not be among my books to my shame." The fact that I'm telling you this now suggests that the burning wasn't quite enough to rid him of his shame entirely. But he evidently knew all along that his pornography wasn't for keeping. The book came in several bindings, and he chose a cheap one.

None of the garbage men I worked with ever claimed to "care" about pornography, much less admitted to collecting it. Nevertheless they always showed off the magazines they found on their rounds, brandished them like trophies, and they always took them away with them. Maybe they kept them at home and treasured them. Maybe they used them once and threw them away. It was never discussed. Since I was at the bottom of the pecking order, none of this loot ever came my way.

There was an incinerator at the council depot and every once in a while a police van would arrive with sacks of confiscated hard-core pornography that had to be burned. Naturally we all asked if we could have a look in the sacks and I think we were surprised when the police said no. We hadn't imagined they took themselves so seriously or that they really believed pornography was such a terrible thing. But apparently they did. Or at least they cared about being seen to do their job properly. They even had to throw the sacks into the flames themselves, and wouldn't trust us garbage men to do it.

No doubt they were right to be suspicious. We council employees spent a lot of time thinking up madly ingenious ways of foiling this incineration. It usually involved trapdoors, asbestos, flameproof chambers. But we were only playing. We were just saying the things guys say.

My father took early retirement from his council job and was almost immediately diagnosed with terminal cancer. His deterioration was

shockingly swift. In no time at all he was transformed from a work-ingman to a bedridden invalid. I don't know that he ever accepted the fact of his own death. He certainly never discussed it with my mother or me. But he did discuss the tools of his trade. All his woodwork tools were kept in the garage. They'd never be any use to my mother, and they'd never be any use to me, he said. I had long been cast as the bookish incompetent who couldn't knock a nail in straight. However, my father had a good friend called Graham who was another carpen-ter. He was the one who should have the tools, my father said.

Now, it so happened that I wasn't quite as cack-handed as my father wanted to suppose. I did small jobs around my flat—I had to, I couldn't afford to call in a professional just to put up a few book-shelves—and I'd have found some of his tools useful. But far more than that, I wanted them as a way of remembering my father: he cer-tainly didn't own anything valuable or collectible.

I went into the garage to investigate. The tools were kept in a black wooden tool chest that my father had made as part of his apprentice-ship. I opened it up and found a serviceable but really unexceptional set of well-worn, much-used tools. And I also found something else: a yellow folder containing letters, greetings cards, and photographs.

Perhaps there are people who would have known immediately what this was, or at least they'd have realized after a second or two and immediately destroyed it. I move slower than that. I had to examine everything in the folder before I knew what I was looking at.

They were love tokens, of course. They came from a woman unknown to me and they'd been sent to my father at his work address. They formed a collection undoubtedly, and they were sexual to the extent that the writer frequently said what a good time she'd had in bed with my father, though they weren't, by anybody's stan-dards, explicitly pornographic. The writing was clumsy, girlish, gush-ing, full of all the clichés of undying love and one day being together forever. The short notes were written on greeting cards with pictures of hearts or teddy bears or Snoopy. If my father had been the man I

thought he was he'd have found this stuff unbearably cloying and embarrassing, but, of course, I was realizing that he wasn't precisely that man.

There were photographs, too. My father's mistress—if that's the word—was a plain, taut, rather hard-faced woman (at least when photographed), younger than my mother but not a lot. A part of me perhaps wanted this folder to contain the full horror of sexy, dirty, naked pictures, but thank God there weren't any. Mostly they showed the woman alone, sitting or standing in a modest, comfortable living room. There were, however, a few pictures of her and my father together, perfectly decent, fully clothed, but posed with their arms around each other, and they looked (I realize this is unprovable) like a couple who either just had or were just about to have sex. My father looked happier than I'd seen him in years. There are times when I think I'd *never* seen him that happy.

There was nothing to be done, or at least nothing I could do. I couldn't confront my father: he was on his deathbed by then and barely coherent. I couldn't discuss it with my mother. On balance I suspected that she knew about the affair but I was far from sure, and in any case we weren't the kind of family who discussed things like that. I only feel free to write about it now, years after my mother's death.

I kept that collection of letters and photographs for well over a decade, stored away with various files and papers that I didn't need to consult very often. I seldom thought about it at all, and when I occasionally came across it while looking for something else, it seemed an embarrassment, a silly and painful thing to be holding on to. I certainly had no intention of ever rereading any of the letters, or poring over the photographs.

I finally threw everything away at about the time I started to write this book. That timing seems far more significant to me now than it did then. I'm slightly ashamed to say I didn't even really think about it at the time. I was moving again, selling my flat, moving in with

Dian. I had far too much stuff, and I was throwing away lots of things, and a collection of love letters sent to my father didn't seem like something a reasonable person should hold on to any longer. It went into the trash along with back issues of *Guitar Player* magazine and a faltering old vacuum cleaner. I can't say that its destruction was in any way liberating, but I did feel quite good afterward, and it did make me realize that destroying a sex collection might be just as satisfying as creating one.

What exactly do I mean by the term *sex collector*? Well, I take a pretty broad definition. First, I mean someone who collects any type of object or artifact that is primarily sexual. We may be talking about collectors of books, magazines, art, films, photographs, shoes, sex toys, and so on. These artifacts generally tend to be preexisting but in some cases they may have been created or commissioned by the collector, and in any case these categories are not mutually exclusive.

I also recognize another kind of sexual collecting, which again is not necessarily separate from other kinds, and that is the collecting of sexual experience itself. I'm talking about people who are sexual adventurers, experimenters, obsessives. In general we know about these people only if their activities are recorded in some way, via a journal or diary or photographic record, so again I suppose we're talking about artifacts. But a woman who's collected several hundred videotapes of herself having sex is doing something rather different from the man who's gone out and bought those same tapes for his own collection. The woman I'm thinking of is the porn star Vanessa del Rio. Her working years were chaotic and she didn't hang on to much, then about a decade ago she started assiduously acquiring all the videos she appeared in as well as all the photos, film stills, and magazines. It's quite a collection.

In writing this book I was interested in sex collecting in all its many manifestations. I wanted to write about collections large and

small, high and low. I didn't simply want to write about the world's greatest erotic art collections, for instance. The collector with a small stash of highly treasured nudie playing cards was as interesting to me as the collector with a country house full of museum-quality erotic etchings.

Incidentally, I'm not sure who's the premier collector of nudie playing cards—very possibly Mark Rotenberg, who's published a book on the subject—but surely one of the most unlikely has to be Brian Eno, formerly of Roxy Music and a leading popularizer of ambient music. In an interview with *New Musical Express* he said, "It's a burning shame that most people want to keep pornography under cover when it's such a highly developed art form—which is one of the reasons that I started collecting pornographic playing cards. I've got about 50 packs which feature on all my record covers for the astute observer . . . I have such beautiful pornography—I'll show you my collection sometime." The interview was done in 1974 and the interviewer was Chrissie Hynde, in her rock-journalist days. I don't know if he ever followed up on his offer.

It's interesting there that Eno uses the word *pornography* so freely and so definitively. For my own part, as we've seen already, I've been extremely reluctant to define *pornography, art, erotica, smut,* or any of the other words we might use to describe sexual materials. It seems a futile task. I suppose there are some people who think that any depiction whatsoever of sex is offensive and unacceptable, but for the rest of us, in the end it's a question of degree, and of personal taste. Of course I know that art is different from pornography, so do you, so does everybody. Of course I can see that Picasso's *Vollard Suite* is art, and that a copy of *Weekend Sex* from the 1970s is pornography, and that the former is in every conceivable sense of the word "better" than the latter. That much is easy. But the gray areas are so gray and so broad and unstable that trying to make any hard-and-fast definitions seems just pointless. That way madness lies.

In any case, increasingly we see it's not a matter of either/or.

Sometimes art wants to be pornographic, or at least to interrogate the discourse of pornography, and to use that as an element in a work of art: I'm thinking of Jeff Koons in his Cicciolina period, or Andres Serrano in his *History of Sexuality*. They're not making pornography, they're making art; but their art contains elements that are, by any reckoning, pornographic.

Some people used to say that art was good because it was celebratory and porn was bad because it was masturbatory, but now we all say, what's so wrong with masturbation? Camille Paglia says, "What people call pornography is simply the moment when the physicality of the act becomes obtrusive to them." I say the difference between art and pornography is this: you can masturbate to art if you want, but you don't *have* to. It still has an appeal and a function even if it doesn't get you aroused. Whereas if a piece of pornography doesn't get you aroused, then it's a complete failure, and few things are worse than failed pornography. But for our purposes, whether it's art or pornography, or any of the things in between, doesn't really matter so long as somebody's collecting it.

In the course of writing this book I've seen a lot of collections, and I've seen a great many things that were sexy and fun and beautiful and fascinating, and I wouldn't have missed them for the world. But I wouldn't want you to think I'm unshockable. I've seen quite a few things that I've found shocking, and ugly and offensive, too. I haven't enjoyed seeing those things, but I'm a tough guy, somehow I've managed to cope. In the end, being a grown up, you have to demand the right to be offended.

Finally, I suppose the question inevitably arises, why would a professed noncollector such as myself want to write a book about collectors and collecting? The simple answer is I don't really know. In my experience writers very seldom know why they write anything. But to the extent that any piece of writing involves thinking about a subject

and clarifying your own attitudes, I certainly welcomed the chance to do that. And I was very interested to meet collectors and find out what I had in common with them and what I didn't, though I certainly wanted it to be a book about them, not about me.

Then I thought of another possible motive. Perhaps the real reason I wanted to meet collectors and view their collections was simply that it would allow me to have all the thrills of seeing and admiring, of connoisseurship (real or imagined), of being in the presence of curiosities and rarities, of wild sexual materials, but without any of the angst of having to acquire or own them. I liked this explanation. I liked this explanation a lot. And it seemed to be further evidence that I wasn't a collector.

And then I started writing. I did research, I started accumulating information, stories, news clippings, phone numbers, catalogs, downloads from the Web. I went to libraries. I started talking to people. Sometimes if I wanted to ingratiate myself with a dealer I'd buy something from him to show willing. I started meeting collectors, and sometimes one of them would give me something, since not all collectors are Freudianly parsimonious by any means. And sometimes, when I visited, say, a sex museum, I'd buy a souvenir from the gift shop, or I'd be in an antique store and buy some little erotic knickknack. Sometimes this could be construed as research material but just as often I bought things simply because I liked them, because I wanted them. I was aware that this was a little bit odd, and not precisely the way a strict noncollector would behave. The truth is, there's no denying it, in the course of writing this book there were times when I really did start to think that perhaps I was a sex collector after all.

2

WOMEN AND MUSEUMS

Wilzig, Kubrick, Evans, Homer.

Both words hum. Both suggest radiance,
antiquity, mystery and duty.

—John Updike

I t's four-thirty in the morning
and I'm staying in the spare bed-
room of a condo in a gated community in a place called Lutz, in
Florida, just north of Tampa, and I'm trying very hard to get some
sleep. Unfortunately I flew in from England only the day before, so
I'm racked with the usual shapeless anxiety and emotional lability that
goes with jet lag, and sleep is completely out of the question. I get up
from the bed and decide to make an inventory of the room's contents.
This is a little less bizarre than it might sound. The room contains
part of a sex collection, rather a small part of the whole in fact, though
the uninitiated might well think there's more than enough here to
form a substantial collection all by itself.

I begin by looking at what's on the walls. I count just over seventy
pieces of framed, mounted artwork. It's all "erotic art," of course.
There are a couple of what look like genuine drawings by Tomi

Ungerer and some rather good French engravings from a series called *L'Aventure charmante,* but the majority would probably be more at home in the Kinsey Institute than in any regular art museum, and a certain number look like thrift-shop paintings, which I suppose is to say they're probably best considered as examples of erotic folk art, which is fine by me.

The subject matter of the art is sexually diverse. The majority are essentially heterosexual, but it's not a big majority. There are one or two quasi-Pre-Raphaelite nudes in sylvan settings, and in a more modern style there's a painting of a pair of naked women scrambling down a steep rocky slope. More modern still, and way more garish, is a painting of Bettie Page done in electric primary colors. There are a couple of reclining nudes, here's a cancan dancer, and here's a print of a piece of Frank Frazetta–style sword and sorcery illustration, though I can't see a signature.

So far so (comparatively) restrained and tasteful. But there's plenty in the room that's far more explicit and raunchy, and occasionally ridiculous. Here's a Minotaur with a monstrous, mythical erection; here's a merman, ditto; and here's a print that looks like it's a landscape of green hills, but the hills turn out to be piles of writhing, orgiastic bodies.

There's plenty of overtly gay male stuff: a few blow jobs (one of them a piece of stained glass), twosomes, threesomes, an all-male orgy with the six participants all ejaculating simultaneously in a moment of superhuman synchronization. There are lesbian scenes, too, naturally, including one involving an enema. There are fetish and bondage scenes, three females riding gigantic zoomorphic cocks with legs, and while we have the zoo in mind, here's a woman having wild and anatomically improbable intercourse with a small horse, and then there's my favorite in many ways: a black giantess who's breast-feeding two full-size elephants—I mean, I assume she's a giantess, I suppose it's possible they could be two miniaturized elephants, but that'd be just plain weird.

That by no means describes all the work on the walls, but my concentration was failing, and in any case the two-dimensional art wasn't even the half of it. All around the room were shelves and cabinets containing three-dimensional objects: plaques, plates, figurines, coasters, replica Greek vases. There was a freestanding Japanese screen, an Asian female puppet that had strings attached to the breasts. There was African tribal art, including fetish and circumcision masks. There was a plastic head of Pinocchio with a penis for a nose, two carved wooden pigs having sex in the missionary position, multiple miniatures of that statue of Hercules and Diomedes by Vincenzo dei Rossi, you know the one—where they're wrestling and one of them's being held upside down and he's grabbed his opponent's penis: that one. There were also a few dildos and I didn't investigate them all, but the one I happened to pick up was battered, made of metal, and weighed a ton.

In fact I soon abandoned my attempt at inventory, partly because of the jet lag, and largely because it seemed so futile. Outside the bedroom door, all over the rest of the condo, there was more of the same, much more, perhaps twenty times as much, a houseful; perhaps, given how cramped and crammed the place was, multiple houses full. You could barely move through any of the rooms, including the bathrooms and the kitchen, or along the hallways, or up or down the stairs, and you certainly didn't dare step backward for fear of treading on something and destroying it or causing a domino effect of erotic destruction.

The collection ran to some four thousand pieces, I was told, not every one of which was in the house when I was there—some were in storage, some were out being framed or photographed—but there was more than enough to be going on with. The collection was insured for $5 million. I didn't think I'd ever been in a house containing $5 million worth of anything, least of all sexual collectibles. I recommend it.

The condo and the collectibles belonged to Naomi Wilzig, a sixty-

nine-year-old Jewish widow. This was her own personal, private collection and she'd just decided to go public with it. She was in the process of opening a museum to show it off, and I had hurried along to see it while it was still in her own home.

It was none of my business, and certainly nobody was asking my opinion on the subject, but if they had, I'd have said that a person should think very carefully indeed before opening a sex museum. In general I really like both sex and museums, and in fact I think there's something inherently sexual about many museums. It's something to do with confinement, intimacy, a sense of being let into secrets. To be sure, it's not the *Playboy* idea of sexy, but places like the Pitt Rivers Museum of ethnography and anthropology in Oxford, with its intriguingly sinister charms and amulets and hair samples, or the Mütter Museum in Philadelphia, with its anatomical and pathological specimens and models, suggest worlds of private, fetishistic obsession that seem to me intensely sexual, if obliquely so.

However, my experience is that when a museum is overtly about sex, there's often something unsatisfactory and disappointing, and sometimes downright depressing, about it. This was a subject about which I'd developed a certain amount of reluctant expertise.

Only a fool, or someone who was writing a book about sex collecting, would devote very much energy to visiting sex museums. I am, or was, that someone. In the course of my research I've been to sex museums in Berlin, Hamburg, Paris, New York, and Los Angeles, plus various other minor, only quasi-sexual establishments such as the Frederick's of Hollywood Lingerie Museum. And I know this is only scratching the surface. These days there are sex museums all over the place: one in Barcelona, one in Copenhagen, two in Amsterdam, any number in Japan, at least one in Australia, one in Seoul, and there definitely used to be one in Shanghai, but its curator, Liu Dalin, had to go on the lam when the Chinese authorities closed him down.

If you had world enough and time, I suppose you might think

about visiting all these museums, comparing and contrasting, and perhaps compiling a consumer's guide. As sexual obsessions go it would be a pretty harmless one, you'd see some of the world, and no doubt you'd get to look at some very cool artifacts. But as I say, I think it would be foolish, and in the end I'm not at all sure how much real sexual enjoyment, education, or enlightenment you'd actually derive.

I'm using the term *sex museum* here in a loose, catchall way. The owners and curators of the various museums around the world would probably think I was being pretty sloppy in my usage. The museum in Los Angeles, for instance, calls itself the Hollywood Erotic Museum. Likewise in Berlin it's the Beate Uhse Erotic Museum, while in Hamburg it's the Museum of Erotic Art. Incidentally, the one in Shanghai called itself the Museum of Ancient Chinese Sex Culture, and in Japan they have names like the Strange Goods Pavilion and the Toba SF Future Pavilion, though it's probably safe to say these names gain some inscrutability in translation.

One place that does insist it's a sex museum is MoSex (as in Museum of Sex) in Manhattan. Its mission statement is to "preserve and present the history, evolution and cultural significance of human sexuality," which should be inclusive enough for anybody. Its inaugural exhibition at least tried to narrow things down to a geographical focus: NYC Sex: How New York City Transformed Sex in America. And of course the curators reckoned that New York transformed sex out of all recognition.

From that first exhibition I remember a sort of art installation about the murder of a prostitute, and there was a surprising account, with voice-over, about a raid on a very modern-sounding gay bathhouse that had actually taken place in the earliest years of the twentieth century. I also remember displays on Linda Lovelace and Vanessa del Rio, some condom tins, a skull deformed by syphilis, and some burlesque stage outfits. The rest has slipped away.

But I do recall that throughout my visit I found myself observing a studious, respectful silence, and there's an argument that the

museum's chilly white spaces were the ideal environment for high-minded speculation about sexuality and culture, but I don't think that's the whole story. I think the curators of the museum were running scared. They wanted to make it absolutely clear that this wasn't the Museum of Sex *Fun,* and that I wasn't there to enjoy myself. They'd had trouble enough from the Catholic League, among others, who apparently thought the place was a stain on the otherwise spotless reputation of New York City.

But sexuality is a peculiar and subversive thing. There was one moment in MoSex when I found myself incredibly, if briefly, aroused. It was while I was looking at the Vanessa del Rio display, supposedly contemplating the sexual mores of the 1970s and 1980s, and ruminating about the spread and development of modern pornography. However, there was a video being shown, featuring Vanessa's face surrounded by multiple erect penises, which she was doing her very best to service, singly and in pairs, manually and orally. It might have been a hot scene in any circumstances, but in the museum context it seemed infinitely indecent, and to be aroused by it while in this temple of high-minded research and speculation felt just plain wrong. Of course, I knew this was an absurd feeling. If you can't experience arousal in a sex museum, where the hell can you experience it? Nevertheless I moved on swiftly to some less stimulating exhibit. There was another moment in the basement of the Hamburg Erotic Art Museum: more of that later. But at least I sensed that the people in Hamburg would have been rather more understanding than the ones in New York. For one thing, they were concerned with art, and we're accustomed to being moved, provoked, and stimulated by art.

However, that term *erotic art* seems to me an immensely slippery and problematic one. What price erotic art in Paris, for instance, when you can go to the Rodin or Picasso Museums? When you can go to the Musée d'Orsay and see Courbet's *The Origin of the World*? Or even in Hamburg itself, the Hamburger Kunsthalle displays works by

Warhol, Nan Goldin, and Jeff Koons. By what limiting and reductive definition does art become "erotic art"? Beats me.

From time to time I've imagined a small, perfect sex collection, consisting of just a few exquisite specimens: half a dozen Aubrey Beardsley originals, or five signed Helmut Newton prints, or seven de Sade first editions, or ten crystal dildos. But these would have to be private collections. When it comes to the public sex museum, more is very definitely more. You want lots of things and lots of variety. You want to be able to make your own way among the penis sheaths and the scroll paintings and the chastity belts. You want to make your own discoveries and have your own experience.

The Hollywood Erotic Museum, for instance, disappoints because it's so thinly stocked: a couple of Picassos, a Tom of Finland corner, some photographs by Dave Naz, artwork by Julian Murphy. The work itself is great, but there's just not enough of it. However, there is, or at least used to be, a rather impressive glass case in the middle of the main floor in which there were two naked, life-size, state-of-the-art sex dolls, one male, one female. Actually the female was more than naked, since half her flesh was peeled away to reveal the armatures and mechanisms inside.

A female friend of mine was peering closely at the male doll, wondering whether it was intended for straight female or gay male consumption, so she knelt down and peered at its anal regions to see how anatomically correct it was. Very, was the answer. Her curiosity was satisfied, but a young Hispanic man, seeing what she'd been looking at, denounced her loudly and publicly as a sick, twisted woman for being interested in men's anuses. I suggested this might be his way of flirting, but she didn't think so.

From the point of view of sheer quantity, the Beate Uhse Erotic Museum is hard to beat. It's located unpromisingly above a sex shop close to Zoo Station in the center of Berlin, and it looks as though it's going to be a tacky tourist attraction. In fact it turns out to be a vast

accumulation of the most amazing stuff, five thousand top-quality items displayed over three floors across sixteen thousand square feet: everything from four-foot-tall Balinese phalli all the way through to a Marilyn Monroe mannequin standing over a metal grate from which blasts of air regularly gusted.

Beate Uhse was both a woman and a trade name. She was the head of a vastly successful German chain of sex shops, and the museum is partly a celebration of her life, with a corner devoted just to her. Here are photographs of Beate and her family; here she is waterskiing and riding her bike and in her boat, and here she is sunbathing nude, and here she is in her long leather flier's coat from the days in World War II when she was a Luftwaffe pilot, though it must be said she flew transport missions rather than bombing raids.

After the war she was grounded, and her first venture into the sex industry involved printing pamphlets on contraception for German housewives, specifically about the Knaus-Ogino rhythm method. From there it was onward and upward. When she died in 2001, aged eighty-one, her company had two hundred sex shops in nine countries, a huge Web business, a telephone-sex network, and a TV channel. Somewhere along the line she also accumulated enough high-end erotic paraphernalia to fill a very substantial museum, which was probably my favorite of the ones I visited.

Here, too, there was plenty of art, not just erotic art: Grosz, Bellmer, von Bayros, Rojan, Dalí, and Mario Tauzin (artists I've come to think of as the erotic usual suspects), as well as some terrific anonymous pinup art and a convincing reproduction of *The Origin of the World*. From nineteenth-century China there were brothel tokens and a porcelain peanut about four inches long with a naked couple inside. There were Japanese geisha balls from the same period, rather smaller than their modern equivalent, and a tortoiseshell dildo, intended to be strapped to the ankle. There was a large glass sculpture, formerly owned by Alberto Moravia, and made by a craftsman rejoicing in the name of Renato Analue. The sculpture consisted of a

female figure astride a giant phallus that had two equine legs at its base. Between the legs, and in scale with them, was another phallus, and there was a tail, also phallus shaped. You don't see that sort of thing every day.

However, my favorite, freakiest part of the museum was probably the cabinet of curious aphrodisiacs: all manner of animal parts cut up and treated in order to improve somebody or other's sexual potency. There were jars of scorpions, geckos, and snakes' penises. I suppose I'd never given much thought to snakes' penises. It turns out they're long and thin and snakelike, and here they were preserved, or I suppose pickled, in schnapps. The resulting liquor was then to be drunk and the penises thrown away. You don't see that every day either, if you're lucky.

So yes indeed, there's some fun to be had in a sex museum, but I think the very form contains an inherent, and pretty obvious, contradiction. An art museum contains art. An automobile museum contains automobiles. A lingerie museum contains lingerie. But a sex museum never really contains sex. It contains representations, accessories, traces, but never the thing itself.

And I think there's also a problem with making sex a self-contained category of experience, similar to the problem that arises when you separate erotic art from just plain art. A sex museum demands that sex be detached from all the other aspects of life, given boundaries, annexed. And yes, all museums do this to some extent, but when it comes to sex, this process involves a sort of death. Quite simply, things die when they're put in museums. If they're dead to begin with, like postage stamps or Greek pottery or Roman coins, well, that's not such a big deal, but sex is a living thing and personally I'd prefer it to stay that way.

It might be foolish to talk about these things in terms of Lacanian theory, but an essay by a Lacanian theorist called Eugenio Donato expresses these doubts and dissatisfactions pretty well, and dresses them up in some very serious terminology. The essay is called "The

Museum's Furnace: Notes Toward a Contextual Reading of *Bouvard and Pecuchet*." He writes:

> The set of objects the Museum displays is sustained only by the fiction that they somehow constitute a coherent representational universe. The fiction is that a repeated metonymic displacement of fragments for totality, object to label, series of objects to series of labels, can still produce a representation which is somehow adequate to a nonlinguistic universe. Such a fiction is the result of an uncritical belief in the notion that ordering and classifying, that is to say, the spatial juxtaposition of fragments, can produce a representational understanding of the world. Should the fiction disappear, there is nothing left of the *Museum* but "bric-a-brac," a heap of meaningless and valueless fragments which are incapable of substituting themselves either metonymically for the original objects or metaphorically for their representations.

I had no idea whether Naomi Wilzig's personal sex collection, once it was made public in Miami, would become a fictitious metonymic displacement of fragments for totality, but I rather feared it might, which is to say I suspected it might die when it got to the museum, and that was why I hurried to Lutz in the middle of hurricane season to see the collection while it was still alive and kicking and in her own home. And that was why I had found myself that morning in the spare bedroom of Naomi's condo, jet-lagged, sleepless, trying hopelessly to make my inventory, and feeling overwhelmed by the sheer number of items in the collection.

I had arrived some eighteen hours earlier and most of that time had been spent looking at and talking with Naomi about her collection, its length, its breadth, its origins, its future. She had greeted me at the door to her condo. She was an alert, feisty, no-nonsense, dark-

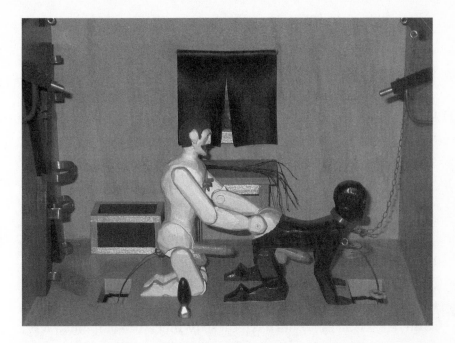

An automaton, part of the Naomi Wilzig collection;
note the security cameras.

haired, olive-skinned woman, not fancy, not glamorous, but very alive, and with an intensity that meant you tended to take her seriously and at her own estimation.

Her condo was a house, or in fact two houses knocked together by a previous owner, creating thirty-five hundred square feet of living space. One of the houses, as it were, had no ceiling between the upper and lower levels, creating a huge, high-ceilinged room overlooked by a sort of minstrel's gallery. There was certainly a sense of being in a hidden place, a treasure-house, a cavern. The blinds and curtains were drawn tight against the Florida sun; the doors were kept firmly shut, partly to keep in the air-conditioning, but also because Naomi feared being attacked by the colony of bees that was nesting nearby.

Within that domestic space every wall, every surface, large expanses of the floor, and every piece of furniture including the chairs

and sofas, as well as all the endless display cabinets and shelf units, were decked to more than capacity with things erotic: art, sculpture, figurines, knickknacks, novelties, souvenirs—the works.

There was so much stuff, so much clutter, and it was so varied, so densely packed, that at first it was almost impossible to take any of it in. I just had an impression of surfeit, of quantity, of delirious excess. In due course Naomi gave me the long and detailed tour, but at first it was easiest to talk about her museum plans.

I suppose there's no getting around the fact that there's something a little extraordinary about a sixty-nine-year-old woman going public with her sex collection. A lot of her publicity had been along these lines. A headline in a local newspaper called *The National Examiner,* March 7, 2000, had screamed "GRANNY Proves You're Never Too Old for PORNO!" But even without her collection Naomi didn't seem like anyone's idea of a typical sixty-nine-year-old, much less a granny. She seemed a very tough cookie. She was friendly enough, but not exactly easygoing. She was welcoming, and had invited me to stay in her house before she'd even met me, but very clearly she wasn't a soft touch. For instance, while I listened, she was giving a very hard time on the phone to various people involved with the museum.

Plans were reasonably well advanced. Premises had been found and leased—a former recording studio—and Naomi was having the kind of difficulties you'd expect. Work was behind schedule. She was having trouble with her architect, her designer was "crappin' around," as she put it, over the kind of display cabinets and wall colors the museum should have, and she was having special trouble with the landlord. In the mishmash of wiring left behind by the recording-studio people, nobody knew which circuits powered the air-conditioning, and since nobody wants to do any construction work in Florida in a building without air-conditioning, progress had ground to a halt. The architect reckoned the landlord had some duty to sort things out. The landlord reckoned that anyone who called

himself an architect ought to be able to sort out a bit of wiring by himself. There was also some debate about the rent. The building supposedly came rent-free for the first few months, and Naomi had assumed that meant no service charges either. The landlord assumed otherwise. It all sounded like exactly the kind of stuff you wouldn't want to have to deal with, certainly not if you were a sixty-nine-year-old with no background in business or construction, when all you wanted to do was show off your sex collection.

In fact Naomi had previously had offers from existing museums. Recently the one in Hollywood had offered to display her collection but, as Naomi put it, they were a dollar short and a day late. By then she'd already made her own plans. Earlier still she'd gone some way down the road with the people behind the Paris museum before negotiations had broken down. A particularly bitter sticking point had been who got profits from the gift shop.

Naomi lived in some, probably well-justified, fear of being ripped off, not just by landlords, architects, and designers, but by everyone— photographers, publishers, sellers on eBay, and no doubt by people like me who wanted to interview her and use her for their own ends. She had a terrible story about a man she'd met on a buying trip to Europe. She was part of an organized bus tour, and he was the bus driver. She tipped him well. She liked him. He seemed like a good guy. He offered to ship to America the six boxes of erotic antiques she'd acquired on her travels. After a long wait and much bad blood, after he'd failed to provide proof of posting, only two boxes had ever arrived, far more than a day late, and contents-wise far more than a dollar short.

Naomi's problem here is that everyone thinks she's rich as all get-out, and they're probably right. Her late husband was Siggi Wilzig, a man who had one of those improbable, epic lives that encompass the most extreme experiences of twentieth-century existence. He was a prisoner in Auschwitz, where both his father and mother were killed, the latter in front of his eyes. But he was a survivor and in 1947 he

went to America, where, starting at the bottom, with no education or training, he achieved staggering business success and eventually owned his own bank, the Trust Company of New Jersey.

The Wilzigs had two sons and a daughter, and the bank became the family business. I don't know exactly how much money Siggi Wilzig had or what he did with it or how much of it went Naomi's way, but I gather that the family owned 30 percent of the bank's stock, and when the bank was sold to North Fork Bancorporation Inc. in 2003, less than a year after Siggi's death, the company was valued at $726 million. If Naomi got anything like her fair share, you feel she shouldn't have to worry unduly about the odd service charge or untrustworthy bus driver, which is not to say that she shouldn't care about being ripped off.

It will hardly come as a surprise that living with a multimillionaire death-camp survivor is no picnic. Naomi and Siggi seem to have had a less-than-joyous relationship, and although they remained married, they lived increasingly separate lives, and Siggi certainly had no time for, or interest in, Naomi's erotic collecting. Perhaps that was the very thing that spurred her on: the desire to assert her independence, and possibly just to annoy him. He evidently thought it was unseemly for a bank president and his wife to be associated with erotica, and Naomi seems to have accepted that. Prior to his death, as the collection gained some notoriety, the name Wilzig wasn't mentioned. It was attributed to "Miss Naomi," and it was under that name that she published two books showing off her collection, *Forbidden Art* and *Visions of Erotica*. She had a predictably unhappy time with the publisher and she was self-publishing three further volumes to be sold in her museum.

Siggi Wilzig's death brought some big changes to the family. Not only was Naomi able to go public and give full vent to her collecting, but one of the sons, Ivan, in his midforties, was able to develop his alter ego as a cape-wearing techno-pop artist going by the names of Sir Ivan and Peaceman. To be fair, he'd started this career while his

father was still alive, and Siggi had vaguely approved of it once there'd
been some commercial success. Sir Ivan recorded techno versions of
Lennon's "Imagine" and Scott Mackenzie's "San Francisco," which
were sufficiently on the money to make it onto the Billboard chart.

Actually Ivan has quite a lot to answer for in this story. If it hadn't
been for him, his mother would probably never have started collect-
ing erotica at all. Before he was Sir Ivan and Peaceman he was a
swinging playboy banker and he thought that having some erotic art
in his bachelor pad would go down well with the ladies. Knowing that
his mother spent a lot of time antiquing, he asked her to acquire some
erotic art for him. She bought him an oil painting, which he rejected
on the grounds that it wasn't hot enough. Naomi kept it herself and
it became the first piece in her collection. It was there in the house
when I visited, on the wall above the sofa, a big painting of a nude
female figure emerging from a gigantic white flower, all a bit spiritual
and uplifting, with a background of heavenly clouds. You can see why
Ivan mightn't have wanted it in his home.

But Ivan clearly had a sense of humor about these things. Naomi
recounted the occasion when he came into her home, looked at the
mass of erotic bric-a-brac, and said, "I can't believe I'm going to
inherit all this someday." On another occasion he said, "I can't believe
I'm going to be *responsible* for all this someday."

Having bought that first erotic painting, Naomi decided to buy
herself a few more female nudes. Then she bought a male nude to
keep them company. Then she bought paintings of men and women
together, then some sculpture, and then . . . well, by then she had
become a collector, and it seems that she wanted everything.

As my time in Naomi's house wore on, I was gradually able to see,
focus on, and pay attention to more and more of the collection,
although I don't for a moment believe that I did more than get a dis-
tant overview. There were multiple paintings of Adam and Eve, Lady
Godiva, Leda and the Swan; Naomi had plans for a "Leda Lounge" in
her museum. There was an oil painting of a woman copulating with

a skeleton (that old classic). There was a wonderfully kitsch piece of saloon art, original in a couple of senses, signed by someone called Caddo, of a reclining nude that had a motorized winking eye and a stomach that pulsed in and out as though breathing.

There was one print by Hans Bellmer that Naomi believed was an original, though she didn't seem to have absolute confidence in its provenance, and in any case she wasn't going to be able to display it in her museum since it had a whiff of pedophilia about it. There was a signed painting by Olivia and a signed photograph by Justice Howard. Not that Naomi seemed to care very much whether the art was original or not. Mapplethorpe was represented by a poster and Marcel Duchamp by a framed book cover. She had a catalog from one of John Lennon's exhibitions of erotic drawings and she was thinking about slicing it up and framing the individual pages.

In fact it had crossed my mind to wonder why Naomi hadn't gone for broke and bought some really big-name art, real art. It seemed she could have afforded it. Why not a few major works by Grosz, Picasso, et al.? Again, she explained, it was fear of being ripped off that deterred her. She didn't have the knowledge to tell a real Picasso from a fake, didn't know what the going rate was, and she certainly didn't trust dealers and galleries to sell her the genuine article at a fair price. Anything that could be called "erotic" carried enough of a premium as it was; to start buying major works by modern artists would have pitched her straight into the hands of gougers and shysters. She could do without that, thanks very much.

And this was something that characterized her collection, she said, the fact that it was made up of the kinds of things that anyone might acquire by putting in the work and doing the rounds of antique stores and fairs. A lot of the pieces might have been unique, but individually they were never that expensive. And she was keen to say that she'd created the collection piece by piece. With a few exceptions she'd never bought job lots, had certainly never acquired other people's whole collections. A group of paintings by an outsider artist called

John Schreiner was one of the rare exceptions. They were an intriguing bunch, all gaudy metallic colors, women in ultratight clothing, like superheroines, often with hooks for hands, having their genitals licked by strange lizardlike monsters. Naomi had seen one painting that was part of a lot at auction, but in order to get it she'd had to buy the whole set. They sat rather well on the minstrel's gallery.

Some of the pictures in the house, of course, were better than others, but in the world of the sex museum, it seems to me, it's the objects that really draw the attention, and Naomi had collected these with a thrilling lack of discrimination.

In the main living room a giant erotic totem pole competed for attention with a carousel horse imbued with a giant wooden penis, which in turn competed with a metal sculpture of a schoolboy displaying a penis far greater than life-size. In the room's many glass cases were, for example, martini glasses with nude figures for stems, a pottery toast rack with a row of women's legs lined up to hold the slices of bread, a piggy bank shaped like a sperm, a phallic-shaped glass decanter. There were tiles, stamps, cuff links, wine labels, vases, and cigarette cases, all decorated with erotic images, and there were corkscrews, pipes, chess sets, and teapots that had taken on erotic shapes, usually of nude figures or penises. There were automata, of a couple in bed, of a threesome on a pool table, of two men in a dungeon having some heavy S&M sex.

There were things that defied easy classification. There was something that looked like a wine bottle but was made of metal, and it opened up to reveal a nude woman inside; and there was something similar that involved opening a figure of a mouse. There was a long wooden thing that had probably started life as a tree branch and had been carved with a snake at one end, a fish in the middle, and a penis at the other end. There was a golf club with a penis head. There was what looked to be a life mask of some chubby-faced man, cast while he was sucking a cock. There were some picture disks of Madonna, featuring nude images from her book *Sex*.

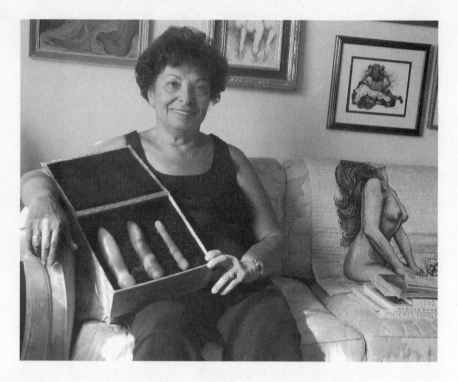

Naomi Wilzig in her condo in Lutz, Florida,
with a collection of jade dildos, probably unused.

Naturally there were lots of dildos, some made of fine art glass, some porcelain, some metal, and some made of jade, Chinese I think, that came in padded presentation boxes. The provenance was again unclear, and Naomi suggested someone might like to do DNA tests to see if they'd ever been used.

And of course there were lots and lots of figurines, all the naked women and men, couples and groups, replicas of relics from Pompeii, folk carvings some of which claimed to be by Sultan Rogers and some of which didn't, rows of miniature wooden devils, action figures of S&M and bondage characters, a naked woman and her tattooist, another woman riding an airplane with a penis-shaped nose cone. There was a porcelain model of two men standing beside a woman in bed, with the words "After you my dear Alphonso" painted

on the base. There was, bizarrely, a little yellow model of a naked Homer Simpson. It looked like an ordinary Simpsons toy, but I don't suppose it was official merchandise since he was naked and showing his very little yellow penis.

Some of this stuff certainly looked like cheap junk, but there were other things that looked very fine and expensive indeed. There was a vase by the French Art Nouveau sculptor Emmanuel Villanis, for instance, that you just knew had to be very valuable indeed, assuming it was genuine, and for which Naomi had paid a bundle even if it wasn't. There was a chair and footstool that Naomi had had specially made, a replica of Catherine the Great's chair, known only from some blurry photographs, she said, though in fact there's another replica in the Beate Uhse Erotic Museum in Berlin. A local craftsman had done his best to interpret the photographs and added his own touches here and there. A face and phallus on the top of the chair were true to the original, but the mouth on the footstool that lined up with the vagina on the front of the chair's seat was entirely the furniture maker's own invention; and you could be sure this kind of invention didn't come cheap.

But there was one thing that dominated the living room, the house, and my whole experience of the visit. It was another phallus, though not by any stretch of the imagination a dildo. It was bigger than that, about three feet in length, a bit stubby, emerging from a somewhat egg-shaped, somewhat testicular, bloblike base. It was white, made of plastic or fiberglass, and it was of precisely the sort that Malcolm McDowell's character Alex uses as a deadly weapon in Kubrick's *A Clockwork Orange*.

In the movie, if you remember, the victim and indeed the owner of the phallus is a character who's identified in the titles as "Catlady." When Alex breaks into her health farm, he begins messing about with the phallus and she screams, "Leave that alone, don't touch it. It's a very important work of art." Naomi would have agreed about its importance but she did let me touch it.

This was one of those occasions when provenance really did matter. Naomi had had dealings with someone who ran a *Clockwork Orange* fan site who had initially reckoned hers must be a fake, or at least a knockoff. It was thought there were only six of these things in existence. Naomi's was the unknown seventh. Only after much debate, after Naomi had given him precise details of her specimen's size, construction, and so on, had he finally conceded that it must be genuine. He then admitted that he was filled with envy.

It certainly looked genuine to me. It had a patina to it, a certain roughness, a certain amount of wear. There was some crazing of the surface and there was a panel in the base that had been cut rather crudely. A fake would have been neater, more perfect, I thought. And the reason for the panel in the base was so that weights could be inserted to create a rocking mechanism. If you pushed the tip of the penis the whole thing lurched back and forth in an irregular and threatening, yet also vaguely comic way. Naomi and I pushed it together. It was the highlight of my trip.

On the other hand, the presence of this mechanism made me wonder whether this phallus had really been used in the movie. It was very heavy. By the time McDowell had raised it to head height a few times, done a few takes, he'd have been exhausted. But then, of course, the very existence of the crudely cut panel in the base meant that the weights could be taken out. The rocking motion wasn't required for that scene in the movie, so during the shooting he'd have been brandishing it in a lightweight form. I convinced myself that this was proof of the piece's utter authenticity.

It was the one object that I'd have wanted to take away from Naomi's house with me, not because it was in any ordinary sense erotic, but because it had history, cultural resonance, an albeit vague connection with Anthony Burgess—a literary hero of mine—and because it had, may Walter Benjamin strike me dead, an *aura* about it.

I made no further attempts at an inventory; even Naomi hadn't done that, though it was obviously something that needed to be done

before the museum opened. She'd been told it could be done quite easily with a computer program that created bar codes, but she obviously wasn't convinced. Given that I've met people for whom making a catalog was at least half the point of owning a collection, it was quite refreshing to find that Naomi wasn't like that.

For that matter she seemed surprisingly uninterested in the stories behind the objects. I'd ask where a thing came from and she might reply "Africa," an answer that left more unsaid than said. Or I'd ask about a certain intriguing piece, imagining there must be a good story behind it, and she'd say, "It's just an erotic object." Again this had its attractions. It meant that she was enamored of the object itself, not of its history or its relation to other objects.

So Naomi wasn't exactly scholarly, but you couldn't have all that stuff around you without picking up some knowledge. She asked me if I knew how to tell the difference between Japanese and Chinese erotic art. I admitted that I didn't, but I wondered if it had something to do with the feet. No, she said, it had to do with the size of the male genitals. In Chinese art they were life-size. In Japanese art they were monstrous. I thought this was well worth knowing.

Naomi told me she was an occasional guest lecturer at the nearby community college, though her lectures formed part of the human sexuality course in the psychology department. She'd rather have been in the art department. Her teaching included a tour of the house, which not surprisingly the students loved, and her only problem was getting them to go home when she'd had enough. She also gave tours to her friends and neighbors, and to their friends and neighbors. People were constantly bringing over new people to see Naomi's amazing collection. And if you were looking for a reason as to why Naomi formed her collection, this would surely do nicely. It made her special, unusual, a little bit notorious, and it guaranteed that she got attention.

There were two last things that Naomi wanted to tell me. First, that she hadn't done half the sexual things depicted in her collection.

I suppose I'd never thought she had, but this bit of information did beg the question of which half she *had* done. I was certainly aware that she'd got a good-looking boyfriend, called J.C., a man twenty or so years younger than her who worked as a private detective and who, I was told with less than absolute jocularity, would come and hunt me down if I said anything bad about Naomi. I believe I've entirely kept my part of the bargain.

The other thing she told me was to make sure that I filled up my rental car with gas before I took it back to the airport. The prices those rental companies charged for gas were daylight robbery.

I've been reluctant to make too much of Naomi's age. There's an absurd notion about, as Alan Bennett put it, that once people get to a certain age we're supposed to be amazed if they can so much as eat a boiled egg. On the other hand, one of the few advantages of being sixty-nine years old must surely be that you can do whatever the hell you want and not worry what other people think about it.

Another reason I'm not as staggered as I might be by Naomi's allegedly great age is that she isn't the oldest female sex collector I've met. That honor goes to Dixie Evans, who runs the Exotic World Museum of Burlesque, better known locally as "the stripper museum." She admitted to being a year older than Naomi.

To get to Dixie Evans's museum you drive about a hundred and twenty miles out of L.A., up a couple of freeways, then onto the remains of Route 66, into the desert, to a place called Helendale. It feels authentically like the middle of nowhere, but it's not quite the bleak, isolated desert you might imagine. In Helendale there's some new suburban sprawl and on the outskirts there's still a certain amount of agriculture. Exotic World itself is housed in a former goat farm.

There's no missing it. The entrance is a wrought-iron arch decked out with stars and glitter, and there's a plaster lion with a mailbox on

his head. You maneuver along the driveway toward a huddle of buildings and trailers, and at first it isn't absolutely clear if they're inhabited. But the presence of a couple of cars, not least a Cadillac limo, and a sign that tells you to sound your horn three times to draw attention if you want to be admitted let you know you're welcome.

There I was greeted by Dixie Evans, the curator, the spirit of the place, a seventy-year-old lady whom one hesitates to describe as a former stripper, since there's plenty of evidence from photographs around the museum that she'll still very willingly take her clothes off if circumstances seem favorable. There's evidence, too, that she has a penchant for low-cut satin evening gowns, but on the day I went she was wearing a thick wool sweater.

She walked with a stick and she said she'd just had an eye operation, but she looked entirely bright-eyed to me. She had a sweet, strangely babyish face, and she looked a good deal prettier in the flesh than in the many photographs I saw of her that day. She still conducted personal tours of the museum. It gave her the evidently much-cherished opportunity to show off, to perform, to do her Marilyn Monroe impersonation. Naomi would have understood.

Dixie Evans was once known as the Marilyn Monroe of Burlesque and there were certain pictures in which she did look quite convincingly like Marilyn, others in which she simply didn't. Dixie will tell you that when Marilyn died, a part of her died, too, though not such a large part as in Marilyn's case, obviously. If Marilyn Monroe had survived she'd have been precisely Dixie's age. Whether she'd have aged the same way, or indeed held up as well, is anybody's guess, but those of us who've often wondered what Marilyn might have become had she lived have every reason to be comforted by the enduring looks and vitality of Dixie Evans.

Dixie was the figurehead and officially the president of Exotic World, but in a way the collection wasn't really hers. It was originally the creation of another stripper called Jennie Lee, who seems to have been the nurturer, the earth mother, for other strippers. In 1955 when

Jennie was in her late twenties she set up "the League of Exotic Dancers" in Los Angeles, a form of trade union, fighting for better conditions and pay. She also organized bowling and softball teams. And all the time she was collecting stripper memorabilia, her own and other people's.

Jennie was married to Charlie Arroyo, known as the Singing Cowboy, though I have to admit that my research hasn't revealed where, when, or what he sung. Jennie and her husband owned a bar in San Pedro called Sassy Lassie's, and also a club called the Blue Viking. Jennie Lee used her collection as decoration for the bar. Members of the League of Exotic Dancers sometimes worked there and they often left her their own collections for safekeeping.

As well as the bar and the club, Jennie and Charlie owned forty acres out by Helendale, bought in the early sixties as an investment, and perhaps as somewhere to retire to. Or maybe Jennie had the idea of setting up a museum all along, but she hadn't managed to do it by the time of her death in 1990. If anyone understands the mechanism by which Dixie Evans inherited the museum, they're keeping very quiet about it, but she's certainly made it her own.

The museum is a gem: homely, personal, idiosyncratic, a bit grubby and frayed at the edges. Everywhere you look exhibits arrange themselves into still lives of high heels, bras, and pasties, all the elements looking like they've been thoroughly worn in the course of long working lives. There was also a surprising number of trophies displayed all over the place. Who knew that strippers won, competed for, or even cared about trophies?

The were special areas, shrines, devoted to individual performers: a Jayne Mansfield section with a pink heart-shaped couch, an area for Sally Rand showing the ivory-handled fans she used in her dances, another for Blaze Starr, another for Sherry Champagne that included her ashes.

One of the best things about the museum was that although a lot of the exhibits were in cases and behind glass, quite a few of them

weren't, so I'm now able to say that I'm a man who's touched a feather boa worn by Tempest Storm, a man who's stroked Gypsy Rose Lee's shoes, which were sturdy and dusty, though scarcely worn.

On every wall there were eight-by-ten framed glossies of strippers. Every wall was a wall of fame. Who knew there were so many? Some were famous on pretty much any scale: Marilyn (of course), Josephine Baker, Bettie Page. Some were famous only among fans of striptease and burlesque: Lili St. Cyr, Evelyn West, Virginia Ding Dong Bell, Linda Doll, Gina BonBon. Some seemed simply anonymous. They ranged from the stunning to the plain and lumpen. The photographic styles ranged from the transcendentally glamorous to the ham-fistedly amateur.

And was this really a sex museum? Well, sort of. Many of the women in the pictures were definitely sexy. Obviously it was a very public form of sexuality, concerned with display and performance. Perhaps some of these women did the same act in private for their men as they did onstage, but these presentations didn't seem to have much to do with what went on in the bedroom and the bed. They were about what went on in public. And perhaps that was one way to avoid the contradiction at the heart of the sex museum. Burlesque isn't about real sex, about actually doing it. Burlesque is about posed sex, danced sex, staged sex. And so since the museum was less about sex than about the presentation of sex, it worked pretty well.

But frankly the exhibits took a backseat to Dixie Evans, to her own performance and personality. She was extrovert, a little gauche, very likable. Without her, or with somebody else in charge, the whole experience of the museum would have been completely different, and I imagine less enticing.

In the souvenir shop there were photographs for sale of the youthful Dixie, in some of which she was performing a skit based on the Marilyn Monroe movie *The Prince and the Showgirl,* with a wooden dummy standing in for Laurence Olivier. There was also an opportunity to take home an image of the current seventy-year-old Dixie,

depicted topless on a souvenir mug. Who could resist buying one of those for his personal sex collection?

And I also took Dixie's photograph. She professed some reluctance at being photographed, but as I got my camera ready, she leaned against the doorway to the museum and posed in a way that was so practiced it had become entirely natural.

She told me that the trailers out in back of the museum were every bit as packed with exhibits as the museum itself. As far as that went, Tempest Storm was living in one of the trailers, a prime living exhibit, though she was away when I visited. I made some enthusiast noises along the lines of "Gosh I'd really like to see the insides of those trailers," but Dixie wasn't falling for that.

Was there, is there, something sad about a seventy-year-old stripper holed up in a museum in the middle of the California desert with her memories and a staggering collection of burlesque memorabilia? Will there be something sad about Naomi's museum in Miami? Maybe. But it didn't seem that way to me, mostly because it quite evidently didn't seem that way to Dixie Evans or Naomi Wilzig. If there was something melancholy about these two women, it was rather that they were such game and spirited old parties, and yet it was obvious that they couldn't have so very many years left. What would happen to their collections then?

The quotation at the head of this chapter comes from John Updike's short story "Museums and Women." The story's central character is a boy who makes his first museum visits accompanied by his mother, and finds himself particularly attracted to some small bronze statuettes "of nudes or groups of nudes" whose "excuses for nudity varied," he tells us, some being American Indian, some mythical Greek. The boy is fascinated and he doesn't quite know why, but their nakedness and sexuality is certainly part of the attraction. He sees the figurines as inhabiting a separate world inside the glass dis-

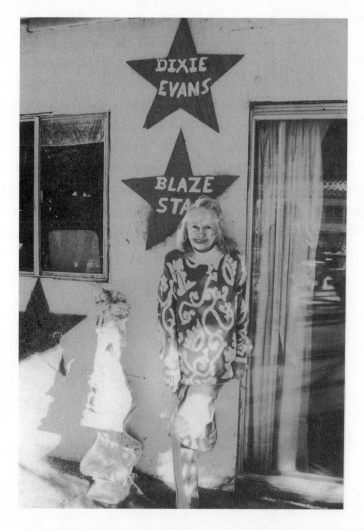

Dixie Evans, ready to perform, standing outside
Exotic World, Helendale, California.

play cabinets and he imagines that he might live in that world. Seeing
her son's fascination, and neither quite understanding nor approving,
though keen to snap her son out of it, his mother says to him of the
statuettes, "Billy, they seem like such unhappy little people."

It's easy enough to see how you might become a victim of your
own collection. You put your specimens in order, you put them

securely in a display case, and you're the one who's imprisoned. When you've got a collection, a collection's got you. To be trapped by a collection might certainly make you unhappy. I found it impossible to think of Naomi Wilzig or Dixie Evans as unhappy people, and if their collections represented a kind of captivity, it was a desired and benign one. But I did keep thinking of the little naked yellow Homer Simpson in the glass case in Naomi's living room. He certainly seemed unhappy, and (I know this sounds silly) he also looked very lonely and vulnerable in his bright yellow nakedness. It would be an exaggeration to say that I pined for his liberation, but I really did wish that somebody would cover him up.

N.B. The world of the sex museum moves more rapidly than that of book publishing. Since I wrote this chapter, Naomi Wilzig's World Erotic Art Museum has opened in Miami to enthusiastic reviews. However, Dixie Evans's Exotic World has been forced to close down for safety reasons, and to seek new premises.

SOME HISTORY, SOME THEORY

*Hair, horn, holy foreskins; Benjamin,
Freud, Marx, Aljasmets. Aljasmets?*

"This is Mr. Atwater," said Susan. "He's going to
show me the indecent exhibits in his collection."

Faintly stirred, the tall woman said: "Do you
collect then?"

Atwater said, "I guard some of the national
collection."

—Anthony Powell, *Afternoon Men*

I f you were looking for someone
to exemplify the difficulties of
researching the history of sex collecting, you could do worse than
choose King George IV of England. According to some authorities,
he was a hair fetishist who collected a lock of hair from each of his
many mistresses. After his death in 1830, his brother is said to have
gone through his effects and discovered seven thousand envelopes,
each containing a sample of hair.

Further research suggests that at least one sample got away. A Scottish club of political and sexual freethinkers called the Beggar's Benison, founded in the early seventeenth century, created over time its own collection of sexual memorabilia, including erotic medals, a pewter plate for measuring penis length, phallus-shaped wineglasses complete with testicles, and a snuffbox presented to them by George IV. By some accounts this box contained the pubic hair of one of the king's mistresses. Another story, which I take to be a variant of the above, and historically just a little more probable, concerns the Wig Club of Edinburgh and has them owning a wig made from the pubic hair of several of Charles II's mistresses.

In any case, the club's collection seems to have been well traveled. According to Burgo Partridge in *A History of Orgies,* it was once part of the Kavanagh Collection, and at the time he was writing, in 1960, it was owned by a Mrs. Canch Kavanagh. It was eventually presented to St. Andrew's University by a local solicitor, where it remained in a locked cupboard until the 1990s when David Stephenson, a history professor at the university, literally and metaphorically unlocked the cupboard and wrote a book called *The Beggar's Benison: Sex Clubs and Their Rituals in Enlightenment Scotland*. It's a cracking read. However, the question of whether George IV was really a hair fetishist, and whether he really collected seven thousand locks of hair, and whether any of them found their way into a snuffbox in Scotland, remains unresolved.

This is how it is with the history of sex collecting. Information is thin on the ground, patchy, piecemeal, sometimes no doubt apocryphal, sometimes appearing to be not much more than a type of urban myth—all of which I suppose is only to be expected from anything to do with sex.

You could find another clustering of dubious data around Adolf Hitler. Some say he was a fan of pornography, and that his stash included nude photographs he took of Eva Braun. Some of these photographs are extant, but they're a long way from being porno-

graphic, and in any case, taking nude photographs of your girlfriend hardly proves that you're a porn aficionado.

Personally I find it hard to think of Hitler as a sex collector. Frederick Oeschner, who wrote a book called *This Is the Enemy,* spent some time documenting Hitler's library. He described one book on the Spanish theater as containing pornographic drawings and photographs, but he reported there was no pornography "as such" among Hitler's books. Of course it's possible that even Hitler felt the need to hide his pornography, and of course you can't help wondering what the heck was going on in the Spanish theater in those days that a book about it should contain pornographic images. But if you really want to make the case for Hitler as a porn fan, even more so as a sex collector, you'd probably have to explain away his book burnings and public denunciations of pornography and degenerate art as so much overcompensation, and that seems unnecessarily ingenious.

We know that the German book burnings of May 1933 included the destruction of the collection at Magnus Hirschfeld's Institut für Sexualwissenschaft (Institute of Sexual Science) in Berlin. According to Mel Gordon in *Voluptuous Panic,* the collection there contained "thousands of erotic artifacts and pictorial materials, categorized according to Hirschfeld's unique sexual taxonomy," including twelve hundred fantasy drawings by convicted Lustmord prisoners, masturbation machines, and mechanical sex aids—a public favorite, says Gordon—and eight thousand selected photographs and items "from the collections of Berlin hand and foot fetishists." I don't know how this subcollection divided up between hands and feet, but in my experience it seems that foot and shoe lovers are ten a penny; hand and glove enthusiasts are much rarer.

However, one intriguing example can be found in Krafft-Ebing's *Psychopathia Sexualis* (first published in Germany in 1886), which is in itself a collection of sexual case histories. Case 122 concerns Mr. Z, an American, thirty-three years of age, a manufacturer. Krafft-Ebing tells us, "Z became a collector of ladies' kid gloves. He would hide

away hundreds of pairs in various places. These he would count and gloat over in his spare time, 'as a miser would over his gold,' place them over his genitals, bury his face in a pile of them, put one on his hand and then masturbate. This gave him more intense pleasure than coitus." Hitler, I trust, would have been appalled.

Occasionally while scrabbling around for information, I've come across a source that promised a great deal. Gershon Legman's *The Horn Book,* for instance, contains the chapter "Great Collectors of Erotica." This sounded like exactly what I was looking for. Gershon Legman (1917–99), real name George, is one of those characters who pop up in many a discussion about the history of erotica and sexual research. He was a collector, folklorist, bibliographer, and essayist who worked for Kinsey for a while, before falling out with and denouncing him.

Legman tells us in *The Horn Book* that collectors of erotica are either the "inexperienced young" in search of information and education, or the "old and impotent . . . searching in books or pictures for the reviving of their drooping sexuality." "Few collectors exist between these limits," he says, and he reckons the young are in the majority. This seems so transparently untrue and such a downright weird thing to say that you have to wonder what his agenda is. When he starts talking about "these children, with their hopeless pornographic pamphlets, grotesquely illustrated as often as not with smeary photographs of old time pimps and whores in pointy shoes and torn stockings," his scholarly credibility seems to be sprinting rapidly toward the exit.

But Legman's essay does provide some valuable chapter and verse, and indeed some names: Adriaan Beverland (c.1650–c.1716: sources differ wildly), a Dutch scholar and blasphemer who proudly displayed his collection of obscene engravings and captioned them with quotations from classical authors; Richard Heber (1733–1833), per-

haps the ultimate bibliomaniac, whose book collection filled eight houses and included a fair bit of erotica, not least a rare copy of Rochester's *Sodom;* Henry Spencer Ashbee, Frederick Hankey, Richard Monckton Milnes, Sir Richard Burton—a coterie of scholarly, English, Victorian flagellation enthusiasts, of whom more later; and of course Kinsey himself. I'd actually heard of these people.

Legman also names a lot of Frenchmen I'd never heard of at all, though I accept I probably should have: Bernard de La Monnoye (1641–1728), for instance, who according to Legman was "the real progenitor of erotica-collecting in the West," and he cites the Duc de La Vallière as the prime erotica collector of the eighteenth century. La Vallière's library of seventy-six thousand volumes was apparently "strong in the erotic poetry, the unexpurgated facetiae, and the new genre of the erotic novel, which had sprung up in the seventeenth century."

As names go, Legman's seemed perfectly good ones, but I wasn't sure they were all sex collectors as I understood the term. Other disappointments came thick and fast. I found an old prospectus for a forthcoming issue of *Eros*—the 1960s large-format hardback "magazine" edited by Ralph Ginzburg—promising an article called "The Private Parts of the Public Library," an exposé of collections of erotic literature in American public institutions. Since *Eros* ran only to four issues the article would be easy to find—if it were there, but I've looked and it's not.

Frequently I found myself relying on scraps and oblique clues from decidedly secondary material. For instance Andrew Summers's book *Honeytrap,* about the Profumo affair, tells us that as the scandal broke in England in the early sixties, the London police began to raid the homes of individuals they considered sexually dubious. One of them was David Mountbatten, the third Marquess of Milford Haven, a great fan of pornography who, according to Summers, owned one of the world's largest collections, one that had been handed down to him, having been in the family for generations. As the police ran wild,

he decided he'd better get rid of it. Some went to the University of Texas, and some to the Private Case of the British Museum.

The catalog entry at what is now the British Library attributes the collection to David Mountbatten's father and reads "MOUNTBAT-TEN, George, 2nd Marquess of Milford Haven [1892-1938]. Scope: Prospectuses and catalogues of erotic and obscene books, pictures and instruments, dating from 1889 to 1929. 81 parts. Collected by George Mountbatten. Location: Cup.364.g.48."

Having surmounted various obstacles put in my path by the British Library, and proved that I wasn't just some sensation-seeking onanist, I was allowed to see this collection, and it was a disappointment. I was presented with something that looked like a big photo album, complete with tissue interleaves and a label on the front that said "Whenever this book has been issued to a reader, it is to be checked by the Superintendent of the North Library immediately after it is returned." These words seemed to have been written a long time ago and some of the checking looked to have been a bit slack over the years. A number of its eighty-one "parts" had gone missing.

The ones that remained were items of printed erotic ephemera, some of them a lot of fun, such as a business card from a Mr. Arthur of 6, rue Lécluse, Paris, offering his services to those who want to see "the inner life of the Gay City," or a beautifully illustrated leaflet advertising tickler condoms with names like *le porc-épic* and *l'inusable*.

The majority of items, however, were catalogs and prospectuses selling erotic books, and in some cases photographs. The books on offer had titles like *Mysteries of Conjugal Love Revealed; Raped on the Railway; Genital Laws: Their Observation and Violation;* and *And Only a Boy,* described as "A summer amour. Everywhere and nowhere, but to be found in all Booksellers' Back-Shops, in this Joyous Year of 1892," and there were ads for "Mr. Charles Carrington's Choice Publications"—buy a copy of *Curious By-Paths of History* and get a copy of *Flagellation in France* free. This was fine as far as it went, but I'd been expecting more.

Anthony Summers also refers to a character called Beecher Moore, a friend of Stephen Ward and another pornography fan and collector, and also a committed orgiast. He was raided by the police, who warned him that given what went on in his home, his wife could be prosecuted for running a call-girl racket. Why his wife rather than him I don't know. Rattled, Moore surrendered his collection to the British Museum, which, in some embarrassment, duly passed much of it on to the Kinsey Institute.

After a long, serendipitous process I finally spotted something in the catalog of the Kinsey called the "B.E.M. Erotica Manuscript Collection," which, it says, is composed of "more than 1100 original, unpublished manuscripts of erotica (36 linear ft.) . . . The manuscripts were written primarily by anonymous military personnel in the 1940's and consist of sexual fantasies and stories, many of which feature bondage and domination or mild sado-masochistic themes." This had to be part of the collection Beecher Moore had so urgently got rid off.

Eventually, in the library of the Kinsey Institute, I was allowed to peruse a sample of this material, only a couple of boxes of it, but from what I saw, the catalog description wasn't strictly accurate. They weren't by any means all manuscripts. Some were, all blotchy typewriting and stuck-in illustrations that had been cut out of magazines, and some of them were bound in wallpaper, but others were definitely published, semiprofessionally it appeared, and probably clandestinely in minute editions, but they definitely weren't manuscripts.

There was "the beige/blue series," "the thread bound series," "the beige humiliation series" and they had titles like *Curiosities of Feminine Lust, Sure Cure* by Anita Koestler, *Journey of Lust—a Sex-Sadism Story, With Buttocks Bared, The Footman and the Lady* by Harmon Jenkinsop, *Animal Lovers* by Erlon Mareston. The only one I can really claim to have read much of was called *The Interrupted Honeymoon*. The interruption, as I recall, is caused by desperadoes who come to the honeymoon cottage where bride and groom are staying, hold them hostage,

and rape them both repeatedly until the happy couple develop a taste for it. Then I seem to think some girls from the local village get involved in the action, too, but I could be misremembering that part.

There are times when I worry about collectors, like Moore, who commission items for their collections, because in some respects it seems to me that collecting and commissioning are opposites. Collecting is a type of hunting and gathering, involving the seeking out and acquiring of what's already there. The process of commissioning causes things to exist that weren't there before. It seems too easy a way of adding to your collection, though I'm sure the relationship between the collector/patron and the artist is often not easy at all. You might also think that work done to order mightn't be the artist's very best. In any case, such reservations obviously don't mean much to the great many collectors who throughout history have commissioned artists, whether it's the Empress Josephine commissioning Canova to make sculptures for her collection at the Château de Malmaison, or the Baron de Saint-Julien commissioning *The Swing* from Fragonard as the illustration of an elaborate private sexual fantasy, or in the twentieth century Roy Melisander Johnson of Oklahoma, of whom more later.

A special place in this commissioning hall of fame has to be reserved for Khalil-Bey, the nineteenth-century Turkish diplomat and rake, and one of the greatest collectors of erotic art of his time. His biography, by Michele Haddad, is called *Un Homme, une collection*. The works he commissioned included *The Turkish Bath* by Ingres and, most famously of all, Courbet's *The Origin of the World,* that still-shocking, faceless, though far from characterless female nude body shot.

When Peter Webb wrote his book *The Erotic Arts,* in 1975, he said the whereabouts of this painting was unknown, and had a story about it being stolen by Nazis, restolen by the Russians, and ending up in

the hands of a private collector in Hungary. This collector would appear to have been the Baron Francis Hatvany of Budapest, but he owned the painting as early as 1910. By the time Webb was writing, it seems that it was in the private collection of Sylvia Bataille, the former Mrs. Georges Bataille, who went on to marry Jacques Lacan. I'm not sure that two husbands can really count as a collection, but she surely bagged a couple of prime specimens there.

In recent years there's been a lot of academic work done on the history of collecting. Universities run courses and conferences which discuss collecting in terms of cultural practice, markets, and the establishment of value, often with reference to the emergence and status of museums.

At the same time there are any number of more or less serious histories of sexuality, the erotic arts, erotic literature, and so on. You'd think it might be possible to merge these two fields of interest, the history of collecting and the history of sex and its manifestations, and come up with a combined history of sex collecting. If only.

Histories of art refer to the earliest erotic cave paintings as being about thirty-seven thousand years old, and generally of a symbolic type: three diagrammatic "vulvas" painted on a cave wall in Angles-sur-l'Anglin are fairly typical. But it's hard to see how erotic cave paintings can really constitute a collection. Who was the collector? In what sense did he or she "collect" these paintings? What were the criteria by which they did or didn't belong in the collection?

More recently, from around 23,000 B.C., we have the *Venus of Willendorf*, now more often called the *Woman of Willendorf*, since its status as a goddess is questioned. This is a female figurine, made of limestone, about three and a half inches long, discovered in 1908 in Austria, and now on display in a natural history museum in Vienna. The woman in question is fat, and she has no face, instead having a spiral of what looks like braided hair wrapped evenly around her entire

head. Certainly it looks like something precious, something atavistic, something that somebody would have treasured and looked after, otherwise it would have been unlikely to survive. It certainly appears to be an object that had something to do with sex, but you'd guess it was an item concerned with fertility rites rather than a decorative object to be put on display, so again it's not easy to see in what sense it was part of a collection. Objects can all too easily change their status from sacred object to sexual knickknack.

The problem is neatly demonstrated by the "Secret Museum" of Naples, which is also the title of an important book by Walter Kendrick about the origins of "pornography." When the ruins of Pompeii were excavated most actively, from the mid-eighteenth century onward, the newly found artifacts suggested that the Pompeiians had lived surrounded by the most extravagant obscenity. There were lascivious frescoes and murals on the walls of their houses, lewd statuary and carvings of erect phalli on every street corner; domestic vases and lamps were decorated with graphic scenes of copulation. This was a shock and a puzzle to the scholars of the day.

Another age and culture might simply have destroyed these archaeological finds in disgust. On this occasion, however disagreeable they appeared, they were seen to be worth preserving, but they still couldn't be displayed in a public museum. Instead they were hidden away and went into a locked room in the Museo Borbonico in Naples, the so-called Secret Museum. In reality, it was largely an open secret, much referred to and much visited. Access was restricted, but it could generally be arranged by giving the caretaker a bribe. If you think this sounds like hypocrisy and a misguided paternalistic desire to "protect" some ill-defined class of innocents, you're almost certainly right.

What became a sex collection in Naples had been no collection at all as far as the Pompeiians were concerned, any more than a contemporary department store is a museum of the present. These objects, though they must certainly have been considered sexual by the Pom-

peiians, were presumably not considered obscene, since even those who tolerate and enjoy a little obscenity still don't hang it from their street corners. So it wasn't a question of taste but of function. The founders of the Secret Museum didn't see how such sexually charged objects could function, or even exist, except as objects in a locked room.

Whether the Pompeii collection has finally lost its magic is debatable. In the late 1990s the Italians finally abandoned all pretense at secrecy, and the collection of what they insist on calling "erotic art," a term that seems entirely to miss the point, finally went on display in the National Museum of Archaeology in Naples, joining the growing throng of sex museums around the world.

If the Pompeiians won't quite do as sex collectors, you can still find a pretty good example of the breed in ancient Rome, in the person of Tiberius (42 B.C. to A.D. 37). Chapter 44 of Suetonius recounts Tiberius receiving an inheritance and having to choose between ten thousand gold pieces or a painting of Atalanta and Meleager, by the artist Parrhasius. Atalanta and Meleager are best known in Greek mythology for hunting the monstrous Calydonian Boar together—she wounds it, he kills it, then he goes on to kill two centaurs who try to rape Atalanta—but in the Parrhasius picture she was just giving him a blow job. There are no surviving works by Parrhasius but written accounts say he was famous for painting "obscene subjects" in his spare time. However, he lived around 400 B.C., so Tiberius would have been contemplating a valuable antique, which he duly went for and, Suetonius tells us, kept in his bedroom.

Pliny the Elder also tells us that Tiberius developed a passion for a statue that had been erected by Marcus Agrippa in front of the baths in Rome. The statue was of Apoxyomenos using a "bath scraper" on his own naked body. Tiberius removed the statue, and again installed it in his bedroom. This sounds like serious collecting mania to me,

and obviously not the only mania with which Tiberius was afflicted. However, after a public outcry he did reluctantly return the statue, which can currently be found in the Vatican.

Ah dear, the Vatican—an insoluble problem for those who are trying to research sex collecting. A long-held and enduring belief has it that there's a terrible secret stash of pornography somewhere in the Vatican, possibly in the Vatican Library, though some rumors place it elsewhere. On the other hand, those of a skeptical nature will tell you this is simply an antipapist fantasy.

The problem is finding a disinterested authority. Anyone with a strong opinion inevitably has an ax to grind. Father Leonard Boyle, keeper of manuscripts and chief librarian at the Vatican until 1998, and a good egg by all accounts, denied it in a sane, good-humored way, but then he would, wouldn't he? By contrast the Web site of the Legion of Decency (the name's a registered trademark) not only insists that the collection exists, it even provides shelf numbers: F2–F-1T, rows 89 to 704,969. They also say that those with a reader's card—senior clergy only—can call the library on the Vatican in-house telephone system and have items delivered by one of thirteen young nuns in less than ten minutes. At this point in history it's hard to believe that any library can find and deliver anything to anyone in less than ten minutes, while the notion that nuns do the delivering just sounds like feverish fantasy. But I have no proof that this isn't true. And no proof that it is.

One assumes the rumors, if they are rumors, have a great deal to do with the Vatican's own Index librorum prohibitorum, the notorious list of books denied to good Catholics, a list that was established in the early seventeenth century, and grew and mutated until 1948, when common sense prevailed and it was finally abandoned. The suspicion that any banned book must be worth reading is a reasonable one, and it's true enough here, and it seems equally reasonable to assume that the Vatican would have copies of these banned books or else how would they know they were worth banning? But the list is

made up of authors such as Voltaire, Balzac, Isaac Newton, Luther, Galileo, Descartes, Rousseau, Jeremy Bentham—all subversive writers in their way, but none of them exactly a smut merchant.

Interestingly, however, on that list you'll find a work by Pietro Aretino, called *Le carte parlanti*. And I think Aretino, too, played a part in establishing the association between dirty books and the Vatican. Aretino is one of those characters celebrated by historians of eroticism who don't make much of an impression on the world at large. He was responsible for one of the first, earthiest, most collected, and most republished pieces of smut, the *Sonetti lussuriosi,* sometimes known as *I modi,* or just as *Aretino's Postures.* The work, dating from 1524 or so, consists of sixteen sonnets by Aretino, along with engravings by Giulio Romano showing people having sex in various positions.

In fact the illustrations came first. Romano painted them on the walls of the Vatican. God knows why he did that. Possibly, it's thought, it was revenge on Pope Clement VII, who was slow in paying him for previous work, but if so, it must have been an extremely time-consuming and self-defeating form of revenge. Another theory is that he'd actually been commissioned to paint these erotic scenes, much as Raphael, his mentor, had painted some earlier ones, but given the Vatican's reaction, this seems unlikely.

The pope was furious when he saw the murals. He was even more furious when they were turned into engravings and an edition with Aretino's specially composed sonnets was run off by a printer called Marcantonio Raimondi. He ordered all copies to be destroyed, and decreed that reprinting was punishable by death. But of course a reprint duly appeared, and editions have been appearing ever since.

If the Vatican's collection of pornography contains anything, it surely ought to contain a version of this work, but if it does the Vatican is keeping quiet about it.

The fact is, if you're looking for smut, you'll be much better served by the British Museum than by the Vatican, largely because of

the legendary Private Case, now part of the British Library, which found premises separate from the BM in the 1990s.

For a long time the Private Case was another kind of secret museum, a collection of books owned by the British Museum, but unacknowledged and uncataloged. Alfred Rose made the first list of titles in the early 1930s, Gershon Legman claims to have made the second, and Patrick J. Kearney published *The Private Case: An Annotated Bibliography* in 1981.

The need for secrecy was at least partly caused by the status of the British Museum. How could a public and publicly funded institution offer access to materials that most of the public would have been appalled by? This argument is slightly complicated and perhaps invalidated by the fact that for a long part of its history the British Museum library welcomed only a very small proportion of the public indeed.

In "The Private Case: A History," Paul James Cross says the Private Case was originally just a cupboard in the office of the Keeper of Printed Books, and that it was a collection of obscene materials in general rather than specifically of erotica. He cites the works of William S. Burroughs, de Sade, and *The German Prisoner* by James Hanley as books that are the former but not the latter, although given the diverse nature of human sexual response, I think he might be being a bit dogmatic here.

The first book he can find allotted to the Private Case is *Paradise Lost, or the Great Dragon Cast Out* by Lucian Redivivus, published in 1838, with the accession date of March 31, 1841, which is not an erotic book. Nevertheless, the three large individually donated collections that make up the nucleus of the Private Case are erotic indeed: those of Henry Spencer Ashbee, Beecher Moore, and Charles Reginald Dawes, a man lucky enough to have owned two first editions of *My Secret Life,* though one of them was confiscated by customs.

A special mention is also needed for Dr. Eric Dingwall, a collector, and an anthropologist with an interest in psychic research. He did

unpaid work at the library and used his own money to build up the British Museum's holdings of erotica, a service for which they eventually made him an honorary assistant keeper. One of his donations, according to Cross, consisted of "three pederastic works . . . from the infamous Reverend Alfred Reginald Thorold Winckley," a contribution that I haven't been able to track down in the British Library catalog.

Cross says, writing in 1991, that only 2,143 works remain in the Private Case (Kearney had counted 1,939) and he reckons that compares rather well with "L'Enfer" at the Bibliothèque Nationale in Paris, which contains only 1,500, though quantity obviously isn't everything. Since the 1970s rather more material has gone out of the Private Case than has gone in. Previously restricted volumes have been moved into the general stock and very few new works have been added. However, again according to Cross, when eighteen volumes of D. W. Boydell's "extremely unusual zoophilia/bestiality collection" were donated in 1989, they went straight to the Private Case, and again I've been unable to find any trace of them in the catalogs.

The current problem for institutional collections isn't what to keep, since it appears that everything is worth keeping—the day of the unconsidered trifle is long past—but of knowing how to organize and make sense of what they've got. For example, the Institute of Advanced Study for Human Sexuality in San Francisco claims to have an archive of three million items, including 400,000 films, stored in twenty-two warehouses, unclassified and uncataloged and as far as I can tell largely inaccessible. In Berlin, at the Robert Koch Institute, there's a new archive that shares its name with Hirschfeld's Institut für Sexualwissenschaft. In part they're trying to duplicate the collection that was there in Berlin in 1933 at the time of its destruction, though presumably it will be impossible to re-create the hand- and foot-fetish materials

The fact is, collections inevitably come together and fall apart, even without any help from the Nazis. Quite a lot of what we know about people's ownership of sexual material comes from other people's attempts to prevent their owning it, whether it's Savonarola's "Bonfire of the Vanities" in Florence at the end of the fifteenth century, incinerating copies of the *Decameron* and the works of Ovid, as well as some original Botticellis, or whether it's British Customs suppressing the Grove Press editions of the works of de Sade, as late as the 1980s. I happened to be working in a bookshop in the Charing Cross Road in London at the time. Customs men raided the shop and made us take the books off the shelves, but they said they wouldn't prosecute so long as we stopped selling them. In consequence I, and most of the others who worked in the shop, went home that night with a substantial collection of the works of de Sade.

One of the most startling stories of collection and dispersal also comes from London, but a good century earlier, from 1874, when police raided two houses belonging to Henry Hayler, a photographer. They seized over 130,000 photographs and 5,000 slides, and found correspondence from satisfied customers all over Europe and America. According to press reports, Hayler, his wife, and two sons were recognizable in "the more offensive pictures," a fact that doesn't seem much less shocking today than it must have done then. It's hard to imagine what punishment the courts of Victorian England would have thought suitable, but Hayler was never caught. He'd been tipped off about the raid and had fled, to Berlin according to some sources, to New York according to others.

He'd have hardly found New York any more congenial than London at that time. It was then the home of Anthony Comstock, founder, secretary, and special agent of the New York Society for the Suppression of Vice. In the year that Hayler fled, Comstock reported that he'd seized and destroyed 134,000 pounds of books and 194,000 pictures and photographs, as well as 5,500 indecent playing cards. As with Hayler's clientele, not every buyer and consumer could be con-

sidered a collector, but these figures suggest a huge international market for pornography, albeit a risky and clandestine one, and wherever there's that amount of material, you can be sure someone is creating a collection.

At various times in history it's been possible to collect real live people as sexual curiosities. Exoticism and otherness, often racial, are inevitably part of the package. It might be a harem, say that belonging to Firuz Shah, of the Tughluq Sultanate, in the late fourteenth century, consisting of three thousand women, and a collection that was constantly revivified by emissaries who traveled the world purchasing women of all nations. Or it might be the court of Peter the Great, which contained "sexual anomalies" such as a hermaphrodite and a dwarf. There were dwarfs at the Medici court, too, the dwarf being a Renaissance symbol of not quite human lasciviousness. In eighteenth-century England, a young Indian girl sent there by the Hudson Bay Company proved a very popular curiosity, and a little later, Omai, a young Tahitian man, was presented to George III's court and was a big hit, especially with the women.

Some of this "collecting" of living human specimens seems at least partially forgivable. Curiosity about other people's bodies and sexuality doesn't seem like the very worst part of human nature. However, the most unforgivable case is that of Saartjie (or Sara) Baartman, known as the "Hottentot Venus," a Khosina woman brought to England from South Africa in 1810 by Alexander William Dunlop, a ship's surgeon. She was publicly exhibited in London and Paris, where her greatly enlarged buttocks and prominent, elongated genitals made her an object of genuine, if ignoble, sexual fascination.

The story goes that when abolitionists tried to prevent her being displayed, she declared, in court, that she was happy with the arrangement, and that she received a share of the profits. The case was dismissed and Sara continued her career, but only briefly. It's thought

she became a prostitute in Paris, suggesting that certain members of the public were keen to satisfy their curiosity by more than just looking. She lived only a few years more, but even after her death she remained a spectacle.

Her body was dissected and investigated by scientists, including Baron Cuvier, one of Napoléon Bonaparte's surgeons, and these investigations led, predictably enough, to the conclusion that the black races were inferior. The large genitals seem to have been regarded as compelling evidence of this. Sara Baartman's body was duly cast in wax, and her genitalia and brain were pickled and displayed at the Musée de l'Homme in Paris until the early 1970s, when postcolonial sensibilities prevailed. Her remains were finally returned to South Africa in 2002 for burial.

As visitors to that later Sara Baartman display might have noted, the part will sometimes stand in for the whole. Ever since the death of Napoléon, collectors have claimed to own his penis. It was shown in New York in the 1920s, "looking like a maltreated strip of buckskin shoelace or shrivelled eel," according to a contemporary account. It's currently owned by John K. Lattimer, a urologist at the Columbia University College of Physicians. Rasputin's penis was regarded as similarly collectible, and went into an auction at Christie's in 1995. It was withdrawn, however, when investigations revealed it to be a sea cucumber.

As for the holy foreskin: don't even think about it. It's so much the ultimate collector's item that at one time there were a dozen or so of them in circulation. Even more than with most antiques, provenance proved to be a big issue here. The Abbey of Charroux owned one example, which was taken to Rome so that Pope Innocent III could determine its authenticity. Wisely, he said that such a decision was beyond even his powers. But Pope Clement VII, Aretino's nemesis, subsequently looked at it and declared it to be authentic. Twerp.

———

Certain written works are in themselves sex collections. *The Golden Ass,* the *Decameron,* the *Arabian Nights,* perhaps *The Canterbury Tales,* are groupings of texts that share an erotic, or at least amatory, subject. They may or may not have a single author, but either way the creative act is one of curatorship as much as of imagination. The *Kamasutra* or *The Perfumed Garden* are nonfiction equivalents of the same phenomenon.

And perhaps the sexual confession or memoir is always a kind of collection, too. A written confession, it seems to me, is a form of catalog. Before you can be forgiven for your sins, you have to get them in order, describe them, be sure you haven't left any out.

There are those, above all Michel Foucault, who consider confession deeply problematic. Foucault sees it as a form of abasement, an act of submission, an abandonment of power. You tell all to someone more powerful than you—the priest, the psychiatrist, the chat-show host—and you're supposedly set free. In fact, in Foucault's view, you are further enslaved.

The problem with a great many sexual confessions, such as those of Casanova or Frank Harris or even Catherine Millet, is that confession very easily becomes a sort of boasting. There's often no concern with forgiveness or absolution because the writer considers there's nothing to forgive. The writer is saying, "Look at me, see how much sexual experience I collected, look how much I have to confess." And I'm not sure who the power figure is in these cases. Is it simply the reader, who confers status on the confession and its author simply by the act of reading it? Or is it a more complicated hypothetical relationship with posterity? The writer's sex life must be meaningful because here it is in book form, in a text that will exist long after he or she is dead. There is also, inevitably, a commercial aspect to most of these texts: telling equals selling.

I suppose the Internet sex blog is the most modern form of con-

fession. Whenever I read any of them I always find myself wondering about the blogger's motives. The least interesting of them are just gateways to porn sites, and the second least interesting are more or less feeble attempts at "literature." To the extent that I find myself thinking most bloggers need a good editor and/or a good talking-to, I know I'm not the target audience, but I admit I've wasted more than enough time skipping through blogs, be they the Washingtonienne or Librarygirl, Captain Cum or the Unablogger. Curiously enough, some blogs are now indeed being edited, collected together, and published in book form, which seems a surprisingly Luddite development.

I've also wasted time, and some of it could just about be construed as research, among the Yahoo! adult groups. A great many of these aren't much more than collections of images, some of which have simply been picked up from the Web and recirculated. This doesn't seem to be collecting in any very interesting sense, but if you want to find concentrations of hundreds of pictures of, say, bare feet or pierced nipples or staggeringly large breasts, then these groups certainly have their attractions.

Some of the groups are a little more creative. I found one belonging to a man who ran a private glory hole in his own home. Men would come anonymously to his apartment, stick their penis through a hole, and he would service them. What made the site obsessively fascinating was that he photographed every penis that came though the hole, scores of them, and the results were all there in the photo section of the group's Web site. I made the briefest e-mail contact with him to see if he had any thoughts about what he was doing and why, and whether he considered himself a collector. We didn't get very far. His most nuanced reply was, "I guess I'm just a redneck faggot."

Still, there's no denying that the Web is a sexual wonderland for a certain sort of collector, and perhaps a new collecting frontier. You'll find people who'll tell you that the Internet has completely changed the relationship between people and objects. There's a notion that as

we spend more time in cyberspace, which I guess is synonymous with sitting in front of a computer, we'll inevitably become less attached to things, to physical entities. We'll be satisfied with the virtual and the digital, with things and experiences that exist only as bits of transferable information.

To some extent this is no doubt true. With a few keyboard clicks and mouse movements the moderately experienced surfer can have access to a quantity of erotic words and images that would have been impossible, indeed unthinkable, not so many years ago. Very little of this material is high quality, in any sense, but it's there, and a lot of it's free, and for many consumers it's all they need. They're not going to go out and buy the modern equivalents of *Carnival* or *Grecian Guild Pictorial* or an Olympia Press edition of *The Story of O,* then hide them away and preserve them, because they don't need to.

Perhaps some young people growing up today will cherish the first smutty jpegs they ever saw, and hang on to them in some form, and no doubt every time any hormonal youth downloads a few more erotic images, he's creating a collection of a sort. These collections may well tell us a lot about their creators, about their tastes and obsessions, and no doubt also about the state of sexuality in the early twenty-first century. This data can certainly be construed as valuable, but it's hard to see how the value could ever be monetary. As far as we can tell, things that have only a digital existence are never going to become precious, because they're infinitely reproducible and therefore never going to be scarce.

However, if the Internet is really going to destroy our relationship with objects, and make us stop valuing them completely, it has a very long way to go, not least because it's such a terrific aid to acquisition. It enables us to buy things, to locate objects that were previously unobtainable, which in many cases we simply didn't know existed. Collectors enjoy that. And if we want to acquire things discreetly without having to go to some out-of-the-way place and confront some dubious and forbidding dealer, then the Internet is our greatest

pal. There are a few exceptions, but the majority of collectors I've talked to have all used Internet sources, primarily eBay, as a means of adding to their collections. Buying things online may destroy some of the thrill of the hunt—but it certainly doesn't make collectors any less competitive. The bidding frenzy that sometimes goes on in the last few minutes of an online auction is as passionate and naked as any transaction we're likely to find in the real world.

None of this, of course, addresses the question of why people make collections in the first place, and for some people, collecting needs no explaining at all, neither psychologically nor culturally, nor any other way. To the collector it seems a perfectly natural pursuit. If you accept that certain things in the world are inherently attractive and desirable, and if you have the means to acquire them, then why wouldn't you do so? If you *don't* accept that, of course, then collecting is likely to be a mysterious activity. Fortunately a number of authorities have taken it upon themselves to solve the mystery.

In Walter Benjamin's "Unpacking My Library," his short, much-quoted 1931 essay subtitled "A Talk about Book Collecting," he writes, "All passions border on the chaotic, but the collector's passion borders on the chaos of memory." I've spent a lot of time trying to work out what he meant by that, and I'm still not sure that I know. What seems certain is that he thinks of his books as memory triggers, Proustian if you like. As he unpacks his library, he recalls where, when, and how he acquired each of his books, the foreign city where he found an unexpected treasure, the bidding war he won at an auction, and so on. If this process is chaotic it doesn't appear so in his writing, but in any case this remembering seems, for him, to be the "real" reason for collecting, and this troubles me.

Most collectors do have a considerable interest in provenance and anecdote. The story of how they obtained an object is sometimes far more interesting than the object itself. But Benjamin seems to sug-

gest that the items in a collection are little more than souvenirs of their own acquisition. If this were so it wouldn't really matter what he was collecting. Seashells or beer cans, or for that matter nudist magazines, could stimulate his memory in much the same way. The actual subject and content of the collection would seem to be irrelevant, which would mean that all collecting was, so to speak, "equal."

Some authorities would say this is precisely the case. More than that, some would also say that all collecting is inherently sexual, however neutral the ostensible subject of a collection may appear. The collector sublimates his sexual desire into a desire to possess objects. The desire is what matters, not the objects, and therefore all collections are sex collections. We're talking Sigmund Freud, right?

In fact he didn't write so very much about collecting. Most of what he had to say can be found in "Character and Anal Eroticism," where he links collecting with miserliness and the childish pleasures of fecal withholding. What he said elsewhere was sparse, but it was highly quotable. In the *Minutes of the Vienna Psychoanalytic Society*, Otto Rank records him as saying, "The core of paranoia is the detachment of the libido from objects. A reverse course is taken by the collector who directs his surplus libido onto an inanimate object: a love of things."

We now know that Freud himself was a collector. By his own account, as a student he got into trouble with his father for running up a large debt with a bookseller. Buying books was his main hobby, and he pleaded that he might have had far less innocent extravagances, which seems reasonable to me, but it didn't cut much ice with Freud père. Incidentally, it was only after his father's death in 1896 that Freud's collecting began in earnest. This seems, in every way, so "Freudian" that I shan't labor the point.

While Freud was in Vienna he amassed an impressive collection of archaeological specimens from ancient Egypt, Greece, Rome, and China, about two thousand artifacts in all, accumulated over approximately a forty-year period: that's fifty a year, or one a week, which

depending on your point of view is either comparatively serious or comparatively modest collecting.

We know that he arranged the collection in his office so that it looked like a private museum, and he kept a small crowd of statuettes on his desk. We hear that he fondled some of them while working, and that each morning as he entered the room he greeted a statue of a Chinese scholar.

We also know that in the period immediately preceding his enforced departure from Vienna, in May 1938, he was deeply, perhaps unnaturally, concerned that he might have to leave his collection behind. In fact he didn't have to. A friendly appraiser deliberately undervalued it, and having paid a small fee to ease the way, Freud and his collection made it safely to England. The majority of it is still in the Freud Museum in London, and can be visited: the private museum has become public. There's a sampling of artifacts in the Freud Museum in Vienna, too.

Here's Freud again, writing in a 1924 letter to Wilhelm Fleiss: "When an old maid keeps a dog or an old bachelor collects snuffboxes, the former is finding a substitute for the need for a companion in marriage and the latter for his need for—a multitude of conquests. Every collector is a substitute for a Don Juan Tenorio, and so too is the mountaineer, the sportsman, and such people. These are erotic equivalents." This worries me, too.

And here is Werner Muensterberger, author of *Collecting: An Unruly Passion* (unruly but apparently not chaotic), a book that looms large in all the bibliographies about collecting:

> While one would ordinarily not think of the infamous nobleman Don Juan Tenorio as a collector, did he not in fact *collect* the chaste young maidens he seduced one after another? . . . Much that can be said about the Don Juan also applies to many devoted and passionate collectors. The intricacies of the find; its discovery or attainment; the sometimes clever ploys utilized

to effect an acquisition; the fortuitous circumstances of the lucky strike; the energy expended in obtaining the object, and occasionally the waste of time . . . The true significance lies in the, as it were, momentary undoing of frustrating neediness but is felt as an experience of omnipotence. Like hunger, which must be sated, the obtainment of one more object does not bring an end to the longing.

Muensterberger is a serious scholar, a retired associate professor of psychiatry with the State University of New York, and a psychoanalyst, but I'd find this opinion a bit more impressive if he didn't serve it up as though he was delivering some previously unthought-of revelation, if he'd acknowledged that Freud had used the same analogy some seventy years earlier. Nevertheless, between them, Freud and Muensterberger make the case that there's something primarily sexual about collecting, but Muensterberger goes even further.

I don't think I'm oversimplifying or misrepresenting him if I say he believes that all collectors are psychologically damaged. He writes, "I was surprised to learn from the many collectors I had an opportunity to interview that beneath their longing for possessions there was often a memory of early traumata or disillusionment, which then shifted the need for people to a narcissistic need for substitution functioning as their equivalent—in other words, a self-indulgence with objects. More specifically, this usually took the form of a chronic longing for objects rather than people." One obvious cavil here is that Muensterberger was a psychoanalyst and psychiatrist, and so was perhaps more likely to meet unhealthy collectors than healthy ones.

His explanation of collecting—one that would have been broadly assented to by Freud, and by D. W. Winnicott, and even Jacques Lacan—begins with a theory of child development in which the infant can't tell where his or her body ends and the world of external objects begins. When the child becomes aware that this separation exists, a profound anxiety ensues, and to assuage it an attachment to a

transitional object develops—a doll, a teddy bear, a blanket, and so on, things that are part of the world yet which belong distinctly to the child. This attachment also alleviates the trauma of separation from the mother. In both cases, the object makes the child feel less alone. The healthy child, who's developing normally, sooner or later gets over such an attachment. The unhealthy one gets stuck in this immature developmental stage, badly adjusted to the world at large, desperately needing objects to mediate between the self and the threatening external chaos.

I see two problems here. First, if an intense attachment to objects indicates psychological ill health, then in a consumer society it's going to be extremely hard to find anyone who's healthy. For better or worse, we all—even the antimaterialists among us—use objects to define who and what we are. Our patterns of consumption become a basis for our psychological profile, whether we want them to or not. Of course, not all consumers are collectors, but I'm with Russell W. Belk, author of *Collecting in a Consumer Society,* when he says that collecting is essentially a specialized form of consumption.

Belk writes, "It is natural, if not inevitable, that collecting things and displaying things should flourish among individuals and museums in a consumer culture. It is also natural, if not inevitable, that the things we collect and exhibit, whether as artifacts or art, should also increasingly come from the consumer culture in which we are imbedded." One might also add that since sexuality has been so greatly commodified in our society, it's hardly surprising that there now seems to be an increasing number of collectors of sexual commodities.

However, the other half of the problem arises because such large numbers of people do collect things and consider themselves collectors. Different surveys come up with different figures, and certainly there are differences depending on age, gender, income group, and nationality (and I assume race, though I've found no reliable data on race and collecting), but there's convincing research that will tell you

a third of Americans own at least one active collection, and frankly I'm surprised it's so low. Are we to assume that only a third of the American population suffers from insecurity in the face of a chaotic universe? Shouldn't the figure be higher? Say approaching 100 percent?

Of course collectors, of whatever sort, collect things in order to make themselves feel better. Why else would they do it? But again, in consumer societies it's hard to imagine anyone who doesn't do something very similar. We all buy things in the hope that they'll make our lives easier or more comfortable or more fun. We hope that the new car or the new shoes will enhance our lives, lift our spirits, increase our status, and thereby quiet some of our anxieties.

Buying things, owning things, collecting things are all palliatives. And sex can function as a palliative, too. We pursue sexual partners and sexual experiences in the hope and belief that they'll give us pleasure, excitement, and satisfaction, and make us feel more content and less anxious. And, of course, there will be disappointments. Certain sexual experiences may leave us more anxious and less satisfied than we imagined they would. But on balance we'd probably be far more anxious if we *didn't* attempt to calm ourselves in these ways.

However, it seems we're in some danger here of saying that everyone's unhealthy, everyone's sexually anxious, everyone's overattached to objects, and everyone's a sort of collector—a formulation that pretty much makes the subject disappear. If we're all sick, then how do we know what a healthy specimen would look like? And if we're all collectors, then what was someone like William Randolph Hearst? A supercollector? A particularly damaged person? Or something different altogether? And was he different in degree or in kind from the rest of us? And if all collecting is sexual, then how does Hearst differ from, say, Henry Spencer Ashbee, whose commitment to amassing and cataloging Victorian flagellation literature required him to keep a separate household for his collection, and led to the ruin of his marriage and estrangement from his children?

———

What Karl Marx would have had to say about this we can only guess. In identifying commodity fetishism he was surely trying to remove the magical aura from objects. Marx tells us that under capitalism, in an exchange economy, people begin to believe in the inherent worth of things. They believe that value is intrinsic, whereas, he insists, it's only an expression of social relations.

There are times when this seems, to me, to be stating the entirely obvious, that Marx is simply telling us that things are worth only what someone is willing to pay for them, that there is no such thing as absolute value. Perhaps pre-Marx this was less obvious. Certainly we all accept that value must involve a consensus.

Marx also tells us that once value has been established in the object, this value is transferable. Ownership of the valuable object confers value on the owner. This surely applies to all collectibles, perhaps to all objects, but it applies profoundly to sexual ones. A collection always becomes an extension of the self, part of self-definition: "I must be a valuable person because I own valuable things." And perhaps with a sexual collection the notion is, "I must be a sexy person because I own sexy things."

But let's go back to that Freudian letter, where he asserts that old maids keep dogs as husband substitutes and that old bachelors collect snuffboxes as a substitute for sexual conquests. Leaving aside certain obvious objections—that only old women seek companionship and that only old men seek conquest—a bigger issue arises. If collecting is a nonsexual *equivalent,* then what are we to make of collections that are in themselves sexual? What of the man who collects erotic art or pornography? How can that be an equivalent? What could it be equivalent to? And if a life spent as a sportsman conquering mountains is a *substitute* for sexual conquest, then what do we make of

someone whose life is explicitly dedicated to actual sexual conquests? It seems to me we're coming very close to saying that most collectors, or indeed mountain climbers, are repressed cowards. They really want to collect sexual materials, they really want to be Casanova, but they're too inhibited and timid.

For what it's worth, I don't think that's true, and that's because I *don't* think all collections are inherently sexual. I don't see how they can be. I don't think a collection of snuffboxes is remotely the same as a collection of dildos, at least not beyond the obvious fact that they both make their respective collectors happy. And while I recognize there may be some similar satisfaction in conquering a mountain and "conquering" a person, there are an awful lot of far more important, and entirely obvious, differences. And the differences are *sexual*.

Jean Baudrillard tells us that "every object has . . . two functions—to be put to use and to be possessed" and this begs the question of whether a sex collection has any "use" whatsoever. And of course sex collectors would assert that their collections have many uses—educational, historical, anthropological, aphrodisiac. But it's this last quality that surely, definitively, separates sex collections from all the other types of collections in the world.

You can be as proud as you like of your stamp collection, and you can talk about it in terms of passion, lust, appetite, satisfaction, and so forth, but the one thing you can't do (unless you're weird to an off-the-map extent) is get *aroused* by it. And this is one heck of a distinction. Obviously sex collectors don't find themselves in a constant state of arousal as they expand, organize, dust, catalog, or display their collections. But the potential for arousal is always there in a way it just isn't, and can't be, with nonsexual collections.

This, of course, is not an untrammeled blessing. To declare publicly that you're a sex collector involves problems that nonsexual collectors don't have. It requires a certain amount of nerve or indifference to the opinions of others. This last seems particularly

important. Having a sex collection may be your way of demonstrating to the world that you're sophisticated, liberated, a libertine, or whatever, but the world is not bound to take you at your own estimation. The world is perfectly likely to think you're just weird and sad. Of course, some people think all collecting is weird and sad per se, in which case they're likely to find sex collecting weird, sad, and *pervy*. And, why deny it, there are some collectors about whom this is not an unreasonable thing to think. There are some hopeless cases who find solace and relief in a stash of masturbatory material because they can't relate to flesh and blood. This is indeed sad, but I think these people would be a lot sadder without their collections.

All collections say something about their owners, but a sex collection says something particularly personal and revealing. There may be a few completists who collect anything and everything, who want their collections to be representative of the whole erotic world rather than their own tastes, but these people are rare. Will it surprise you to learn that most sex collectors go for what turns them on? Guys who collect Tom of Finland tend to have a liking for muscular, dominant men in leather. Guys who collect Eric Stanton tend to have a liking for muscular, dominant women in stockings and high heels. Which is to say that they're not *only* interested in Tom of Finland or Eric Stanton, but rather that they're interested in certain forms of sex, and these artists help inform that interest.

I've spoken to one or two people who say they have no interest in pornography or erotica, in any representations of sex whatsoever. For them, only sex is sex. One man I met compared reading a dirty book to reading a cookbook. "Sure I like food and I like eating, but why would I want to read a cookbook?" But, of course, people who *really* like food are the ones who really like cookbooks. They like to read about the subject, read *around* the subject, talk about it, maybe even fantasize about it. It's not an expression of inadequacy or fixation but of enthusiasm.

And I think this is what Freud meant when he wrote about "the

collector who directs his surplus libido onto an inanimate object." He wasn't talking about people who are so damned horny they can't be satisfied with the act itself and so have to go out and buy some dirty French postcards. Rather he meant that libido is about more than the act itself. It involves thought, imagination, intellectual curiosity. Sex collecting is just one obvious manifestation of this impulse.

Finally, and for some people primarily, collecting is also a form of preservation, a method of keeping order, a way of keeping chaos and death at bay. Here, for example, is Gilles Neret in his introduction to a book of absolutely filthy pictures by the French photographer Dahmane, called *Art Porn,* of which more later. He writes, "The only antidote to the anxiety man experiences in the face of his own mortality and inevitable demise, is erotic joy."

Personally I can think of a number of other antidotes, but erotic joy is certainly high on the list. If sex and death really are in fundamental opposition, or even if people only think they are, then sex and the collecting of sex both function as a barrier against mortality and oblivion, a rickety and temporary barrier to be sure, but not to be sneered at.

One of the most eloquent expressions I've found of this philosophy is an essay by one Erna Aljasmets, in a catalog for a show at the Museum of Jurassic Technology called *Garden of Eden on Wheels: Selected Collections from Los Angeles Area Mobile Home and Trailer Parks.* The essay makes the case that Noah was the first great natural history collector, and if not a sex collector per se, then certainly one much concerned with reproduction. As with most things produced by the Museum of Jurassic Technology, this document raises plenty of questions about irony and authenticity, about scholarship, subversion and entertainment, but Erna Aljasmets is real enough as far as I can tell, and is described as an Estonian "Keeper of Folk, Traditional and Urban Handcrafts." Aljasmets writes:

Ants Viires, the noted Estonian historian, responding in 1975 to Hubble's view of an ever expanding cosmos, wrote in his Puud ja inimesed: puude osast Eesti rehvakulturis ". . . time ravages everything, our person, our experience, our material world. In the end everything will be lost. In the end there is only the darkness . . . and despite the apparent fullness and richness of our lives there is, deposited at the core of each of us, a seed of this total loss of this inevitable and ultimate darkness."

Against this flood of darkness, against this inevitable annihilation, certain individuals are called upon to preserve what they can. And those of us who hear and heed this call to hold back for a time some small part of existence from the inevitability of entropic disintegration have come to be known as collectors.

You don't need to be a scholar of entropy to acknowledge that we all try to create our own private oases of stability in the face of the preceding and the forthcoming chaos, that we're all engaged in what Walter Benjamin calls "the struggle with dispersion." A sex collection is a highly specialized way of struggling. The collector brings things together in the full knowledge that sooner or later they will be dispersed. But while the collection exists, while the collector controls it, the chaos is being kept at bay. When that collection is a sexual one, there's also the possibility for eroticism and arousal, and, for want of a better term, erotic joy. These may not mean so much in the face of chaos and death either, but for many of us they seem to be the very most important things we've got.

4

COLLECTING THE SELF AND OTHERS

Lotus shoes, fingernails,
art, the penis in plaster.

If, in the late 1980s, you'd been an avid reader of the fetish magazine *Skin Two,* you might have seen an ad in the back advertising for sale a series of fine erotic prints by the Marquis Franz von Bayros. Von Bayros is another of those characters known to anyone with an interest in "erotic art" but who make little impression on the public at large, even the art-loving public. In the Cythera Press edition of *The Amorous Drawings of the Marquis von Bayros,* edited by Ludwig von Brunn (actually a pseudonym for Karl-Ludwig Leonhardt, of whom more later), the introduction calls him a "draughtsman-eroticist," which I think gets it about right. His work is rarefied, rococo, exquisite, deeply perverse, what Aubrey Beardsley might have been if he'd had the courage of his perversions. Von Bayros's eroticism really is (that overworked word) polymorphous. He delineates drapery and upholstery, furniture and statuary, with the same obsessive erotic intensity that he brings to bodies and sexual organs.

So, if you were one of those in the know, you might have answered the ad in *Skin Two* and in due course you'd have received a glossy sales pamphlet about the prints, and if you'd decided you

wanted a framed set, you might quite reasonably not have trusted them to the British postal service, and so you might have arranged a meeting in a London hotel where they would be delivered to you in person by a short sexy blonde in a tight black outfit. This would most likely have added to thrill. The blonde would have been a woman called Jane Marshall. She and her partner were selling an edition of prints.

"Very good with penises, not so good with bums" was Jane's opinion on von Bayros when I discussed him with her, and it's an accurate one as far as it goes, but I actually think that von Bayros was such a master that nothing in his pictures is accidental. If he didn't draw "good" bums, and made them appear flat, skinny, and a bit shapeless, then that's exactly what he intended, and presumably what he liked.

Jane no longer quite remembered what the series of prints was called, but I'm betting it was the portfolio *Die Grenouillere*. It contains an image of a young woman, being kissed on the mouth by a female lover, while a monkey inserts the handle of a parasol into her vagina. The title in English is *In the studio: Oh darling it's as though your tongue and the ivory handle of my parasol were meeting within my body. I'm coming.* Okay, so we can perhaps see why von Bayros isn't on every art-history syllabus, and even Jane's partner decided they'd better omit this monkey image from the set. It sounds as though he and Jane had quite a lively debate about it. Jane isn't the sort of woman to be censored.

It's worth noting that von Bayros, as well as being good with penises, is also extremely good with shoes, and extremely strange with feet. The shoes are always small, pointed, delicate, with a lowish heel. They look as though they'd be made of silk, often with a bow on the front. The feet, when bare, almost always reveal an improbably deep and wide V-shaped cleft between the big toe and the first toe. It's the sort of gap into which someone might insert a tongue or more likely a penis. This becomes all the more intriguing when you learn

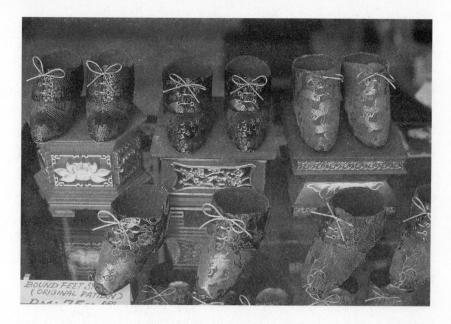

Lotus shoes: size is everything.

that Jane Marshall is a collector of Chinese lotus shoes, and owns what she told me—and I believed her—is one of the best collections in Europe.

"Lotus shoe" is the name given to those strange, delicate, and ornate bits of footwear that used to be worn by Chinese women who had bound feet. The shoes resemble a cone or sheath, and the overall effect is supposed to resemble a lotus bud, though this requires a considerable leap of the visual imagination if you ask me.

The shoes are delicate, papery, pointed little objects that fit all too easily in the palm of your hand. Some have heels or wedge-shaped soles of various heights, devices that contrive to make the foot look smaller still. There are different styles and colors for different occasions and depending on where they were made. They're usually made of cotton or silk, and although some are completely plain, the majority are elaborately decorated and embroidered, with designs

that feature birds, animals, and flowers. Often the design continues onto the soles, confirming that these shoes weren't meant for walking, or indeed hobbling, since foot-binding essentially cripples the woman.

There's no getting around the fact that to most contemporary Westerners, and indeed to many others, the practice of foot-binding seems barbaric, misogynistic, and just plain nuts. For centuries a whole population apparently became crazed foot fetishists, and they weren't content to admire the foot in its natural state: they decided to admire—and create—unnaturally small feet. It was a big commitment. The binding had to begin in childhood, creating pain and trauma of what seems to us a bafflingly unnecessary sort. In Shanxi Province, for example, a place famous for creating especially tiny feet, the foot-binding process began by cutting open the stomach of a live lamb and soaking the child's feet in it for a couple of hours. It had something to do with the softening properties of stomach acids.

This information comes from Beverley Johnson's intermittently authoritative book on lotus shoes, *Splendid Slippers*. Johnson is one of the many writers who'll tell you that men used the cleft on the underside of the bound foot as a pseudovagina, an alternate berth for the penis. But she also says, "Part of the titillation in just looking at the shoes was due to the fact the feet encased inside those shoes were genuinely a total mystery . . . In his mind, they could be as beautiful and desirable as he wished them to be." But how much of a mystery could it have been if he was sticking his penis in there from time to time? And frankly, it seems to me the less accurate the man's imagination, the better off he was. I realize, of course, that beauty is in the eye of the beholder, but to my eyes, admittedly having seen only photographs, lotus feet are just horrible, like a cross between a pig's trotter and a dead fetus. No sane man would want to put his penis anywhere near them.

Beverley Johnson also reckons that bound feet were used in lesbian sex. She tells us, "Those tiny bound feet could prove a versa-

tile substitute for the male organ." Versatile how, exactly, Beverley?

And so I approached Jane Marshall's lotus-shoe collection feeling a little uneasy. Lotus shoes seemed a dubious thing to collect. It was easy to see them as reminders, perhaps even celebrations, of a grim form of female mutilation.

In the interest of journalistic full disclosure I should say that Jane Marshall was the girlfriend of a friend of mine. In the beginning he told me about this wild woman he'd just met who took him to sex clubs where, among other sights, he was able to watch lesbian fisting. He liked that. It turned out she'd once been a professional dominatrix, although when I first met her she was working as a real estate agent, perhaps not an entirely dissimilar profession.

At the time I interviewed her, she lived in a one-bedroom, book-filled flat overlooking a canal in London's Little Venice. I spotted volumes by Helmut Newton and Andres Serrano on the shelves, as well as various books of art and eroticism. "Sometimes you have to buy a whole, very expensive book just to have one image," she said, a remark that has stayed with me.

There were a couple of the von Bayros prints in the bedroom, one of David Bailey's nude portraits of Marie Helvin in the bathroom, and in the living room a surprisingly discreet glass-fronted cabinet containing perhaps a couple of dozen lotus shoes—the tip of the iceberg. You could easily have missed them, and I sensed that Jane liked it that way. Once you'd noticed her collection she was very open to talking about it, but it wasn't an essential part of knowing her.

You'd probably have to say that both nature and nurture played their part in creating Jane's collecting impulses, and they came early. She was born into a family that sold and repaired sewing machines. When customers decided to upgrade to a new model, the company took the old ones in part exchange, and kept them, thereby creating a collection of gorgeous antique sewing machines, a collection that is still in existence.

That Jane should decide to collect something or other was there-

fore not so surprising. As a child, she collected pictures of cats, but far less predictably she also collected bread boxes, a collection that caused some consternation in the family, not so much because of its intrinsic oddness but rather because bread boxes take up so much room.

All the children were put through the family business, which also included a haberdashery side. There were always mannequins in the shops, and Jane has a collection of those, not so very many, she said, just ten to fifteen whole ones, plus a few miscellaneous "body" parts. They live in a garage in Ealing, where I sensed they didn't get visited very often. Pride of the collection was something called a stockman, a female mannequin with leather breasts that form pincushions of a sort, and can be expanded or contracted depending on the size that's required. A sex collection? Maybe.

Jane first heard about foot-binding while she was at school, when she was eleven or twelve years old. It was referred to in a reading exercise she was given, and although the mention was vague and she couldn't quite visualize what foot-binding was or how it was done, she was fascinated and hooked. It took a while before she got round to buying her first pair of lotus shoes, however, not until she was in her early twenties. They cost her forty-five pounds, every penny she had. Her rent at the time was thirty pounds a week, so it represented the kind of punishing yet satisfying acquisition so loved by collectors.

Jane began to show me her collection, first the ones in the glass case, and then she began producing boxes from various corners of the flat, from drawers and cupboards and wardrobes, unpacking them to reveal scores of tiny shoes amid layers of colored tissue paper.

Jane, it should be said, was more concerned with quality than quantity. Certainly I could have imagined larger collections, but I've since seen quite a few lotus shoes displayed in museums, and most of them weren't nearly as fine as most of Jane's. There was no type of lotus shoe she didn't have, she said. Anytime she saw one illustrated in a book or article, it was always of a type she already owned. And to that extent her collection was in a sense complete. There wasn't any-

thing she was actively seeking out, although, of course, she'd still buy a pair if they really caught her eye.

Jane was obviously accustomed to people being creeped out by her collection, and I can see that the creepiness might be part of the appeal, a test, a way of unsettling the straights. And maybe that's a part of any sex collection. If it makes you feel uncomfortable, that's *your* problem. Jane said her interest was anthropological. These objects existed in the world. They were strange and interesting, and so she was interested. Collecting them was no different from collecting anything else. And it wasn't as though her interest in them was in any sense *causing* women's feet to be bound. She didn't see a problem.

Jane was an enthusiast rather than a scholar but she'd come to one or two scholarly conclusions. For instance she didn't have much time for the bound-foot-as-pseudovagina theory. Yes, she could see how you might use the von Bayros–style cleft between the toes, but a bound foot she reckoned not. Of course this is tricky stuff either to prove or disprove. Her evidence came from various books of Chinese erotic art, which she showed me, containing lots of pictures showing both feet and penises, but the two were never in contact. I was inclined to be convinced.

She also showed me that some lotus shoes weren't what they appeared to be. They didn't enclose the entire foot, simply fitted on the very tip, over the toes, with the rest of the foot hanging out over the back. It created the effect of the tiny lotus foot without requiring the mutilation, and when they were worn with a long skirt or robe the illusion could be quite convincing.

This was the first time I'd seen lotus shoes at such close quarters, certainly the first time I'd touched and held them, and probably the first time I'd ever looked at them with my full attention. In the beginning I had to feign a certain amount of interest. Yes, this was evidently a fine collection, but I couldn't quite summon the required enthusiasm for it, though I certainly tried.

I was quite taken, for example, with a pair of white shoes that had a green bat embroidered into the heel; the bat is a symbol of good luck, white is for mourning. Another pair came with a label that read "Loaned by the Exhibition Department Baptist Missionary Society, China." That's the organization that features in the book and movie *The Inn of the Sixth Happiness,* the latter starring a gloriously miscast Ingrid Bergman as the English missionary Gladys Aylward, who tries, with some success, to spread Christianity in 1930s China. Bringing an end to foot-binding was all part of their mission.

But gradually, as I looked at the collection, something very peculiar happened. I came to a realization that these shoes really were quite beautiful. They had something of a Fabergé-egg quality about them, an exquisite, superfluous fineness. There was no reason for them to be so fine, no need. There was really no need for them to exist at all. They were labors of love and obsession. That didn't make the creepiness go away completely, of course. The association with pain, disfigurement, and a bizarre cultural fetish hung in a strange and unequal balance with this undeniable beauty. If the same amount of artistry had gone into a hat or a scarf, our admiration might be great, but it would operate in a quite different way. Lotus shoes were profoundly, quintessentially odd, and that oddness was wonderful.

On the other hand they still seemed strangely sexless. They were fetish objects detached from their culture and context. I was appreciating them as aesthetic objects, as relics. In fact the only ones in Jane's collection that had a recognizably fetishistic buzz to my sensibilities were a pair of plain black leather, bullet-shaped lace-ups, not lotus shoes at all, but shoes made to be worn by women who'd been "freed" from foot-binding. Such women's feet didn't just return to their natural state, and the women couldn't wear ordinary shoes, partly because their feet were still so tiny, but more because they needed lots of all-round support, otherwise they'd collapse completely, hence these bizarre, streamlined pervy little black leather

numbers. They were child-sized, but there was nothing remotely childlike about them.

Since we were sitting there surrounded by shoes, I asked Jane if she had a lot of shoes of her own that she actually wore. She said yes, though they weren't all sexy. For instance she had a thing for green shoes, so she had quite a few of them. And she still owned a pair of thigh boots that she'd worn in her dominatrix days, but she didn't think they amounted to a collection.

I looked at more lotus shoes and then I saw something glinting in one of the boxes, amid the tissue paper, something small, pointed, metallic, and jeweled, not apparently anything to do with lotus shoes. I asked what it was, and it turned out to be a nail guard; in fact there were a dozen or more in there and Jane showed me those, too. Nail guards, for those not in the know, like myself, are the sheaths that Oriental women wore over their long, fancy fingernails, to protect them, and the guards are long and fancy in themselves. These days, if they appear in antique shops, they often have a pin soldered to the back so they can be worn as a brooch. There are people who are creeped out by excessively long fingernails, and I'm one of them, but as objects, these nail guards certainly came without the morbid baggage that attached to the lotus shoes, also without their strangeness and beauty.

Feet, hands, studied artificiality: it didn't seem entirely surprising that Jane collected nail guards as well as lotus shoes. I had already noticed her hands and nails. It was already occurring to me that quite a few of the collectors I'd met paid a lot of attention to their hands. One possible explanation, I thought, was that collectors spent a lot of time touching and holding the objects in their collections. Their hands therefore became a frame or accessory for these objects and they wanted them to look good.

Although Jane's hands were small and unexceptional, I saw that her nails, painted a matte gold, were of different lengths, with one or two much longer than the others.

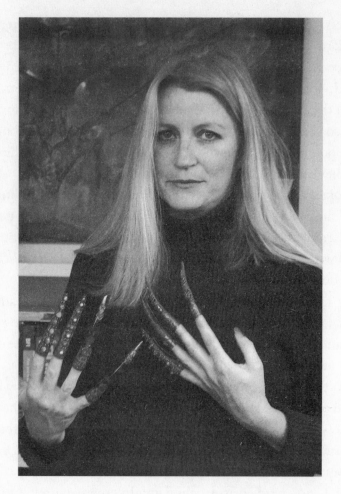

Jane Marshall and her nail guards.

"Oh yes," said Jane, "I used to have *really* long nails." How long exactly? "Four or five inches," she said. She'd been a punk. The nails were painted green, and at least one of them was pierced. She'd done the piercing herself, at home, on the family coffee table with a drill. The really interesting thing, Jane said, was the way the nails curled. She thought it must have had something to do with the moisture in the air. Sometimes they simply hooked over like claws. Other times they turned into corkscrewlike spirals.

Actually, she said, she'd grown only four of her nails that long; just two on each hand, the little finger and the ring finger. She was working in a boutique at the time and she needed the others comparatively short so she could operate the cash register and put things in bags. And then one day all four long ones snapped simultaneously as she was working, perhaps on an unusually dry day, and they flew through the air and landed some distance away.

"Of course," she said, "I kept them. Would you like to see them?"

I so much wanted to see them and so much didn't want to see them that I didn't know what to say. But, of course, eventually I said yes. A search ensued, through drawers and cupboards and wardrobes, in the bedroom, the living room, the hall; and the nails were simply not to be found. It was one of the few times when visiting a collector that I was quite relieved not to be shown an entire collection.

I've discovered only one other collector of fingernails, though I don't doubt there are others. The one I know of is called Shema, and I'm not sure if it's a man or a woman, and given the name, there's every possibility that it's a she-male, and to the extent that I've encountered him or her only in cyberspace, there's every chance that Shema is some sort of creature of the imagination. However, judging by some seriously stomach-turning pictures on the Web site, the collection seems real enough. I don't think I can do much better than quote from the Web site (www.angelfire.com/va3/nails4sale/), and I'm guessing that English isn't Shema's first language.

Hi, Nails in My Collection Frow [*sic*] Various My Name is Shema and I am in the process of developing the First On Line Catalog Web Site especially built to make my Long Nail Collection Available to all Long Nail Lovers and Collectors. I have been collecting Fingernails and Toenails from Mostly People who have a Normal history of Growing Their Finger and Toe Nails to surprising noticable sizes.

This has been an interesting Hobby, Love, Desire, Goal, and

Fetish. I also know that there are many many of you Nail Lovers that also have been Collecting Fingernails themselves. I have Nails in My Collection From Various Long nailed People from All over the world.

Given my squeamish reactions to Jane's fingernails, which I didn't even see, you can understand why I didn't investigate Shema's collection too thoroughly. In any case, collecting your own fingernails seems a rather different business from collecting other people's, just that little bit healthier somehow. And collecting the self, if I can put it that way, is much less unusual than you might think.

I'm standing in the toilet of a private house in Cambridge, England, looking at a crowded display of erotic art on the walls. With me is a man called Tristan Rees-Roberts, an architect, the owner and to some extent the designer of the house that contains the toilet that contains the art.

The toilet is small, as by necessity is most of the art. It isn't easy to get a good view, and you could probably see it much better if you were sitting on the toilet, but I do manage to spot a couple of tiny Picasso prints, from the series he did of artists and models. Tristan tells me they're "genuine" Picassos, but I warm to him considerably when he says he doesn't really know what *genuine* means in this context. Not as genuine as all that, he supposes, since he paid only a couple of hundred pounds for them.

The most intriguing piece of art in the toilet, however, wasn't a Picasso, but a small watercolor that Tristan had commissioned from an artist called Sylvie Jones. It showed a man in a punt (that's the flat-bottomed, pole-propelled boat much loved and used on the waterways of Cambridge), a bit of modern architecture in the background, and in the bottom of the punt were two naked women, one performing oral sex on the other. This was engaging enough, but the painting

changed its meaning considerably when you realized that the man in the punt was Tristan himself, and that the piece of architecture behind him was the rebuilt Trinity Hall library, which he designed. Tristan had commissioned the painting, though I later learned it was based on an extant Sylvie Jones work. My visit was turning out to be stranger, and therefore much more interesting, than I'd dared to hope.

The meeting with Tristan Rees-Roberts took place very early in my research for this book. I didn't know exactly what I wanted or exactly where I was going. I had heard that Tristan owned a serious collection of erotica, mostly illustrated and photographic books. I'd also heard a story from someone who'd been on holiday with him in Amsterdam, about being dragged for hours around various art galleries until Tristan found just the right erotic print he needed to take home with him as a souvenir. He sounded interestingly fixated.

He was more than happy for me to come and look at his collection, but he said he didn't think it was especially large or interesting. I said that was fine by me. I was interested in sex collecting in all its manifestations. I said that bigger didn't necessarily mean better. I said I was just as interested in small collections where intensity and passion thrived: that sort of thing.

Over the phone I took down what felt suspiciously like Tristan's case history. He'd always been a collector, he said, and when he began collecting seriously it was illustrated books from the turn of the century—Rackham, Dulac, Maxfield Parrish. His interest was in the pictures rather than the texts.

He'd been comparatively poor at the time, just starting out as an architect, with a young family, and had been able to buy only imperfect or damaged examples, though they tended to be first editions since that was what his dealer sold. It seems to me that collectors always lie about how much money they spend on their collections. Depending on their character they'll either tell you they paid absolutely nothing or say they spent a king's ransom. Tristan implied

that he hadn't been spending very much on his damaged volumes; nevertheless, at some point his dealer said to him, "Look, Tristan. I've seen this before. You're a potential addict. Watch out."

To the extent that Tristan's family continued to have shoes on their feet and a roof over their heads, he was evidently careful enough, but he certainly didn't stop collecting. He moved on to Rupert Bear annuals, then copies of *Eagle,* then Ladybird books. In each case he was attracted by the illustrations. But at some point he stopped collecting works that were suitable for all the family and began concentrating on erotica.

When, at the end of the phone call, he said that actually he valued his collection only because it was "useful" to him I was intrigued. "Useful how?" I asked. "Oh, in my paintings," he said. That was a surprise. I'd had no idea that he was a painter, but I let it go and didn't think much about it until I got to the house.

The Rees-Roberts home looked modest enough from the outside—a terraced house not far from the railway station. However, in addition to the house there was a two-story shed at the bottom of the garden, Tristan's first architectural project, and then a building that he called the annex, actually a converted single garage.

I stepped into the shed, now Tristan's office, and saw a nude photograph of Madonna on the wall, along with one by Shirley Beljon, a photographer I used to like very much, who did some very erotic work in the late seventies and eighties. This image showed a woman in clown makeup with a rose stem stuck in her vagina. But these pictures weren't part of any serious collection. The Beljon image looked as though it was torn from a book, the Madonna photograph was just a Xerox.

We went into the main body of the house and I saw the work of a clever, imaginative, and not overflashy architect. There were masses of light, interesting angles and cutaway walls that broke up the boxlike nature of the rooms. But it was hard to concentrate on the architecture, since there were so many distractions: plants, books,

interesting objects everywhere, and above all else art—oh yes, lots and lots and lots of art, masses of it, on every inch of every wall of every room of the house. Not all this art was by Tristan, and not all of it was erotic, but the majority was both. When Tristan had said he was a painter he'd really meant it.

Above the dining-room table, for instance, there was one of Tristan's favorites: a large painting of a woman swimming. The artist's viewpoint was half underwater, creating a rear view, the legs apart and about to kick back, a dark crevice visible between them. Elsewhere there were family group portraits, Tristan and his wife, Ingolin—she's Norwegian—with their children around them, in various domestic settings, including in bed, and in most of the pictures they were all more or less naked.

In the bedroom there was a wonderfully clever picture showing Ingolin, naked again, reclining, looking at herself in a mirror, but it also showed Tristan painting the picture, so it was a sort of self-portrait that contained three images of his wife. Other pictures around the house seemed less obviously personal. They were "just" nudes, though they were at least partly portraits insofar as it was easy to identify a number of different female models, with several paintings of each one.

I was overwhelmed by the sheer quantity of painting and of painted flesh, and it clearly needed some discussion, but it didn't seem to be quite what I was there for, so we went to see Tristan's books instead. To an extent he had been right to underplay his collection. There weren't really all that many books, and most of them, although by no means to be found in the average bookshop, didn't seem so fantastically rare.

In those early days I never quite knew how to react to somebody's collection. Of course I showed my appreciation, exaggerated sometimes, but by no means always. You say, oh yes, how interesting, how great. What a fine thing. Tell me about that. And of course if a collector is showing you his collection he generally wants to impress. Tris-

tan would say, "Do you know this book?" and it would be by Araki or Richard Kern, and I'd have to say not only did I know it and like it, I actually owned a copy. Shared tastes in general bring people together, but inevitably, given what I was up to, I was more titillated by things I'd never seen before.

These included books of erotic art from around the world—the expected volumes on India, Japan, and China—but I was intrigued to see a volume called *Hungarian Erotica*. And I was genuinely impressed and surprised by a book of nude paintings by Le Corbusier (who knew?) and another called *Les Pisseuses* by Claude Fauville, staggering black-and-white photographic close-ups of vulvas in the act of pee-ing, very narrow depth of focus, very arty. At the time I'd never seen the book before, although I subsequently seemed to see it every-where.

There was an interesting edition of Frank Harris's *My Life and Loves,* and a book called *Petites cousines* by Par Sadinet which had belonged to a father of a friend of Tristan's. He'd bought it from the family after the old man died. There was a lot of work by an illustrator called John Austin, and books by a photographer-cum-collagist-cum-performance artist called Penelope Slinger, whom Tristan had once, long ago, gone out with.

There were books by Drtikol, Bob Carlos Clarke, Giovanna Carotti, Helmut Newton. "It's funny," Tristan said. "I had the urge to own a book by Helmut Newton, and once I'd bought it I never had the urge again." The one book that he prized most, however, he said, was by the photographer Lee Friedlander, his book of wonderfully fleshy, hairy, slightly overripe nudes. It wasn't an especially rare or valuable edition, Tristan said, but it was the one that moved him the most, and it was the one book he'd save in the event of a fire. And here was an example of the uses to which Tristan put his collection. He opened up the book and showed me an image of a naked woman with her legs pulled up, then showed me one of his paintings of a model in much the same position. Then he showed me a book of illustrations

rsregin0

of the *Kamasutra* and a wooden box on which he'd painted figures who were inspired by, but by no means copied from, the original.

Having seen the house, and Tristan's office, and the room where he painted, we moved into the annex, the converted garage, now used as a guest room, and also as a massage studio. Tristan, I discovered, was also a masseur, trained in Swedish and biodynamic massage.

Need I say that this annex, too, was bursting with yet more art, work that was far more explicit than the stuff in the house. Here, for example, were paintings of people fucking. Were these paintings done from life? I asked. It seemed possible, since the women in these paintings appeared to be the same ones depicted in the nudes in the house. Tristan's answer was yes, but only up to a point. The same female models had indeed posed for these paintings but the men had then been inserted from Tristan's imagination. It seemed like a pretty reasonable, practical compromise to me. In fact he told me about some life classes he'd been thinking of attending, run by Sylvie Jones, the woman who'd painted him in the punt. At these classes the models had sex while a group of artists watched intently and drew or painted them. It struck me as unlikely that any of the people involved would be able to keep their concentration.

Much as I liked Tristan's paintings, and much as I like sex and nudity and explicit art, I didn't think I could have lived surrounded by so much naked flesh, especially when some of it was my family's, my wife's, my own. What do you do, for instance, I asked, when you have your square friends round, or when somebody comes to read the gas meter, especially since to get to the meter you had to go into the very area of the house where Tristan painted, and where he also kept his erotic book collection?

Inevitably Tristan was pretty insouciant about the whole subject, although he thought his wife might have been embarrassed sometimes. When I asked her about it later, she said not, though she admit-

ted that she did wonder what the gasmen said when they got back to the depot. She also entertained the small fantasy that they vied with one another for the privilege of coming to the house and reading their meter, and looking at the naughty art.

That area where Tristan painted was also sometimes known as the playroom, since the kids used to play down there when they were young, and there was a time when Tristan kept there a mannequin he'd made, decked out with pubic hair made of fake fur. "I sometimes like to say that half the neighborhood kids got their sex education from Tristan," Ingolin said.

Although Tristan was evidently not a professional artist, he was far more than an amateur or a hobbyist. He took his painting very seriously indeed. So naturally enough I asked whether he exhibited his work. "No," he said, "I don't exhibit because I don't sell."

He admitted that he did give away the occasional painting, but this had often proved to be a problem. People had a tendency not to prize them as much as he thought they should. They didn't give them pride of place in their homes, often hanging them in the spare room or the attic. He didn't like that. Who would? He recalled one painting that he gave to a couple as a wedding present. It was a portrait showing them in bed together, and he considered it "a little beauty." When he went round to visit the newlyweds he found his painting tucked behind a chair where it couldn't be seen. He was incensed, and took a bizarrely appropriate revenge.

"You know what's wrong with that picture?" he said to them. "It doesn't have enough cerulean blue in it."

The husband of the couple was apparently a big fan of cerulean blue and admitted that Tristan might be right. So Tristan took the painting home to "rework" it. Next day he knocked off a brand-new painting, which he called a "potboiler," awash with cerulean blue, and gave that to the couple, and kept his little beauty for himself. These days, with very few exceptions Tristan paints for himself and keeps his work *to* himself.

In other words, I said, he had the world's greatest collection of erotic paintings by Tristan Rees-Roberts. The fact that he had the only such collection in the world made it that much more special. He was collecting himself. He smiled and said, "I never thought of that." But something told me that he very possibly had.

Cynthia Plaster Caster has been collecting penises for thirty years or so; not real penises, though real ones are certainly involved, and not collecting them in the sense of taking them away from their rightful owners and putting them in her own private stash, but rather in the sense of making replicas by casting them in plaster, hence her name, and her reputation, such as it is. To some of us who grew up in the late sixties she was quite a beguiling figure, a groupie/artist endorsed by Frank Zappa and Jimi Hendrix and appearing in various movies as an example of manifest sixties sexuality. When I interviewed her, only by phone, alas, I felt I was talking to a real celebrity, though I realize that not everybody would feel the same way.

I don't know if you know much about casting techniques. You take an object, encase it in a molding substance, which can itself be plaster, though it needn't be. You wait for the mold to set, then you remove the object, leaving behind a hole that, if you're lucky, conforms to the object's precise size and shape. You put some kind of coating around the inside of the cavity to seal it, then fill it with another material, which can again be plaster but again doesn't have to be. You let it set, open up the mold, and there you have a replica of the object you first thought of.

Cynthia Plaster Caster learned the basics of casting when she was at school, in art class. The homework assignment was to "cast something hard." Art teachers are such gentle, naive creatures. In fact Cynthia cast a vegetable for her homework, a carrot or a zucchini, she can't quite remember which, but the creative seeds had been sown.

She and her best friend, called Pest, who was later replaced by

another friend, Dianne, set themselves up as the Plaster Casters of Chicago, reckoning this would be a great way to meet guys in bands. The sixties, remember? When rock acts came to town, the girls would turn up at their hotels offering to immortalize a part of them in plaster. Pest or Dianne performed oral sex on the guys, Cynthia did the molding. It was the kind of subtle, understated approach that rock guys respect so much.

Cynthia originally got into plaster casting hoping to get laid, but she found that as time went by she got more and more into the casting itself, into creating and collecting the cast of the penis, rather than being concerned with the penis itself, which I guess is a little odd. But in fact it seems to me there's something extremely paradoxical about this whole plaster-casting business anyway, and I can see how a man on the receiving end could find himself having some very mixed feelings. On the one hand here's a woman who obviously likes penises, likes them so much she wants to have actual life-size models of them as souvenirs. This is clearly an appealing thing. And she wants to see yours and get it erect, and then she wants to turn it into art. So far so good.

But then quite a lot is required of the man: getting an erection to order, sustaining it while it's wrapped in aluminum foil (yes, that was part of the early technique), then plunging it into some cold, wet molding medium where it has to stay until the mold sets. Well, I think a man could be forgiven for not quite keeping his end up through all this. In fact I think he could be forgiven if his manhood shrank to the size of a cashew nut. Who can cope with that kind of angst, pressure, and chilliness? Well, evidently some men cope better than others. At the last count Cynthia had cast seventy-one penises.

But another matter springs to mind, inevitable with any collection but especially poignant here—the need to compare and contrast different items in the collection—and when Jimi Hendrix is number four on the list of castees, you know comparisons are going to be odious. And this might be a problem for the caster/collector, too. *Après*

Cynthia Plaster Caster and some of her "sweet babies."

Hendrix, les autres. It's bound to be downhill from then on, isn't it? Noel Redding was number five, and number six was somebody called Don Ogilvie, the road manager of a band called Mandala. Cynthia did get a few cultish big names along the way—the likes of Wayne Kramer, Jello Biafra, Richard Lloyd of Television, Jon Langford of the Mekons—all worthy guys in their way, but none of them a Hendrix. And some of the guys on the list seem the kind that many a self-respecting groupie would turn down flat: more roadies, a tour

manager here, a juggler or independent filmmaker there, Frank Zappa's bodyguard John Smothers. The most recent, at the time of writing, is Bobby Conn, a musician with a reputation in Chicago but not much of one outside.

I suppose we're talking about fame here, about celebrity and cultural resonance, and possibly about aura. It's possible you could argue that a penis is a penis is a penis. But that's not really a concept that satisfies collectors. No two things are ever created precisely equal. That's why you need to collect a lot of them.

Like any artist, Cynthia is familiar with failure as well as success—casts of Eric Burdon and Pete Shelley, for instance, ended up on the casting-room floor—and some of these failures are simply technical. Breakage, leakage, molds that set too quickly or that won't set at all, are all par for the course. These days Cynthia uses a dental alginate, the sort of thing dentists use to make impressions of the insides of people's mouths, and that makes things easier, but success is never quite guaranteed.

When I spoke to Cynthia I suggested that this inherent possibility of failure was an essential part of the process, a welcome degree of risk, something to do with entropy and dissolution, a recognition that even though the phallus has its reputation for being a dangerous, solid, unyielding thing, most of us know that it's a rather fragile, vulnerable thing, too. I think she liked the sound of the symbolism but she said it wasn't intentional. She just wasn't very good at casting. Which is kind of odd, too, I think. After thirty years or so you'd think she'd have got the hang of it by now, but maybe she just hasn't had enough practice. Seventy-one casts in three decades really isn't so very many. Lack of practice does make for lack of perfection.

But let's be positive here. Let's enjoy the imperfections. We've seen plenty of those highly detailed, perfectly molded dildos with every penis curve and vein faithfully reproduced. Cynthia's "babies" aren't like that. Yes, she calls them her babies, sometimes her sweet babies. Yes, it did worry me a little. Anyway, they look like rather

crude, sketchy representations, like something ancient and atavistic. They're not flesh colored, they're ghostly white and rough and knobbly, like they might have fallen off a ruined classical statue and been left lying on the ground for a good long while. That has its appeal.

Another issue, Cynthia said, was finding subjects who were right for her. The people who desperately wanted to be cast almost by definition weren't the ones she wanted to do, and vice versa. Guys who came along saying "Cast me, Cynthia, cast me" were just ruling themselves out. She was particularly annoyed that the band Kiss recorded a song called "Plaster Caster," thereby implying that she'd cast them. She hadn't. She wouldn't have. Back in those days she hated Kiss, thought they were a lousy band. If you don't appreciate the band's music why would you want to cast their cocks?

She referred to her castees as creative superstars, and I suggested that she should have cast a few novelists. Back in the day some of them would surely have been up for it. Maybe not Nabokov and Pynchon, but Roth and Updike, how could they have refused? And how about Norman Mailer? Yes, she liked that thought. Mailer was certainly in her creative superstar pantheon and would have been quite a catch, but rather ruefully she thought it was probably too late for him now. There was also the matter of where and when she'd get the opportunity. A lot of her castings had been done at rock-and-roll parties, at three in the morning, and I suppose that's not the sort of place you're likely to run into John Updike these days.

Over the years, Cynthia has struggled to make a living at all, and certainly not been able to survive just from her plaster casting. This seems to surprise her and she regards it as a bit unfair. So for longish periods she's had to do "straight" jobs, mostly working in offices. These have coincided with the periods when her casting activities have been greatly limited. In the very early days she was briefly financed by Zappa, who enjoyed the idea of what she did, though he

was far too controlled and sensible ever to be cast himself. After Zappa's death there was a dispute with Herb Cohen, Zappa's manager and all-round bad cop, who was "looking after" some casts for her, and seems to have got the idea that he owned them. There was an acrimonious, though let's face it, pretty hilarious, court case which Cynthia easily won, and regained custody of her babies.

In recent years things have got a bit easier for her. A filmmaker called Jessica Villanes made a documentary about Cynthia and the producers paid her for her participation. At the time I talked to her there were also rumors that a Hendrix biopic was in the works. Andre 3000 of Outkast was being touted for the title role, and he was totally into having a plaster-casting scene in the movie. This was potentially good news for Cynthia. She had hopes that she could do some work on the film, get a credit, and be paid to be the plaster-casting consultant, though I'd have thought that Hollywood props departments have pretty well got the hang of plaster casting by now.

She's also constantly trying to think of ways to make some money from the casts themselves. There have been exhibitions in New York and San Francisco, and the good thing is, once you have the cast of a penis you have a highly reproducible resource. You can recast it over and over again, though you might think there was more money to be made from some expensive limited editions. That was the route Cynthia had taken, but it seemed at first they weren't nearly limited enough—a recurrent collectors' problem. The Hendrix, for instance, was offered, in an edition of 199. At $1,500 a pop that would have created some serious income, but now it's being offered in an edition of 30. Cynthia's Web site says she's so busy working on her autobiography that she doesn't have time to do any more casting, but I wonder if it's just possible that there aren't 199 collectors in the world who actually want to own a reproduction of Jimi Hendrix's penis.

Other penises come not singly but in groups or sets. There's the Guitarists Collection (Hendrix, Wayne Kramer, and Danny Doll Rod, he of the Demolition Doll Rods), the Curved Collection (Noel

Redding, Clint "Poppie" Mansell, and Ronnie Burnett), and the Twentieth Century Collection, a four-piece that includes Anthony Newley. There are still plenty of those to be had.

Lately Cynthia's been doing female breasts, which are so much easier, she said, a less tricky shape to cast, no breakages, and no erection to be sustained. I can see that must be satisfying, and I can imagine that plenty of people would be happy to have molds of the breasts of Peaches or Laetitia Sadier from Stereolab, but somehow they just don't seem quite as collectible as penises.

I asked Cynthia if she collected anything else besides penises. Well yes, she said, she did collect penis-shaped objects: you know, lamps, candles, models of skyscrapers, that sort of thing. She also collects models of poodles. They're the most phallic dogs, she said, and then corrected herself by saying no, they weren't phallic in themselves, but they were the dogs whose phalli showed most conspicuously. On the top of her fridge are improvised still lifes where model poodles and cast penises happily intermingle, she said.

And I asked her if she'd collected as a child, and yes, she had. Cynthia was one of those people who began by collecting stamps. She was in a slightly privileged position since her dad worked at the post office and brought exotic stamps home with him. I'm not quite sure how that worked. Did he tear the stamps off letters before they were delivered, or did he ask recipients to steam them off for little Cynthia? Let's assume the latter. The collection is gone now, and Cynthia wasn't sure where, and her father has gone, too. She describes him as a "horny alcoholic." He left Cynthia and her mother quite early on, but she does have one important souvenir of him; it's a blue postal worker's shirt that he used to wear. In fact she wears it herself when she's doing a casting.

Is that a bit odd or is it just me? Most of us, I think, wouldn't want to be reminded of our fathers while grappling literally or metaphori-

cally with another man's penis. It gets odder still, I think, when Cynthia reveals, to me or anyone else who asks her, that her father died of tertiary syphilis. Those people who enjoy joining up the dots between psychological impairment and the sexual collecting impulse might have a field day here with Cynthia Plaster Caster. I'm very pleased to say that I'm not one of those people.

THE NUMBERS GAME

Hatred, repellent behavior, a scoreboard,
a garment of shame, a melancholy archive.

D ear Collector, we hate you."
Those aren't my words, but
Anaïs Nin's, writing in her diary in December 1941, and the specific
collector she's addressing (in his absence) is Roy Melisander John-
son, otherwise known as "the old man." He was a man who couldn't
bear to read the same piece of erotica twice, or at least couldn't get
aroused by it more than once, so having consumed everything in
English, he had to commission new works. That's how he earned
Nin's hatred, by paying her a dollar a page to write smut. She'd inher-
ited the gig from Henry Miller, whose powers had failed him after
too long a spell on this pornographic treadmill. Johnson's initial
response to Nin's writing (according to Nin) was "It is fine. But leave
out the poetry," which strikes me as pretty much any sane person's
reaction to the whole of Nin's writing. But poetry was everything to
Nin, and when Johnson insisted he just wanted the sex, she became
distressed and frustrated, and imagined him saying, "Give me every-

thing she writes. I want it all. I like all of it. I will send her a big present, a big cheque." Yeah, right, Anaïs.

And so she learned to hate him, and she writes in that same unsent address, "How much do you lose by this periscope at the tip of your sex, when you could have a harem of distinct and never repeated wonders." Nevertheless, her diary says she still managed to crank out ten to fifteen pages of the stuff per day.

Since I find it hard to take any of Anaïs Nin very seriously, I don't think that when she writes about "never repeated wonders" this is something she's ever given any serious thought to. But a moment's consideration suggests that a sex life consisting of never-repeated wonders would be as bizarre as it would be exasperating, to say nothing of impossible. The whole point of sex, surely, is that it's all about repetition. We know what we like, what gives us pleasure, and so we repeat those things. There'll be variations and novelties, there'll be inventiveness within the form, there'll probably be a few surprises, but the idea that every sex act might be some previously unexperienced and then unrepeatable form of ecstasy is just plain silly. If it's any good, why wouldn't you *want* to repeat it?

This is a relevant and awkward matter for a sex collector. Sex, however wonderful and special, is anything but rare. At any given moment large swaths of the world's population are engaging in some form of it. How refined and recherché can it be? Most of us make peace with this fact. For the sex collector, however, rarity and refinement are everything. He or she isn't interested in the commonplace, the quotidian, in the things that affect large swaths of the world's population. Does that make Anaïs Nin herself some exceptional and highly developed type of sex collector? Oh, very probably.

In the London *Daily Telegraph* of October 11, 2000, there was a headline that read "Lecturer's Reputation in Tatters" and beneath that a subheading "Judge Denounces 'Repellent' Behavior of Man Who

Kept Notes on His Sexual Conquests." This was some time before
I'd started writing a book on sex collectors, but I was already making
my own collection of newspaper cuttings on the subject. The report
went on to tell the story of Russell Griffiths, "a former pupil from a
Swansea comprehensive school" who'd become a lecturer at the Uni-
versity of Lincoln and Humberside and was now charged with drug-
ging and raping one of his female students.

It turned out he'd made sexual notes about her, and given her
marks out of ten for attractiveness and how good he'd found her in
bed. In his summing-up, the judge told the jury that this was "unat-
tractive, repellent and disgusting." What the jury weren't told was that
Griffiths had kept a list of ninety women he'd had sex with, and given
them all marks in a similar way. The student he was alleged to have
drugged and raped was number 84. Griffiths admitted making the list
for his own "gratification." Its existence was kept from the jury
because, according to the judge, the information would have been
"overwhelmingly prejudicial" to the defendant and, according to the
Daily Telegraph, would have made the jury "despise him."

In fact the jury—six men, six women—cleared Griffiths of rape,
having decided that the sex was consensual. Despite the judge's opin-
ion, I find it impossible to guess how they'd have reacted if they'd
known about the list. The defense's line that he was "a bit of a bas-
tard" but that didn't make him a rapist would still surely have been
valid. But in any case, as I read the report I couldn't help thinking that
this form of list making, of counting up the numbers, wasn't espe-
cially evil. Isn't it pretty much what most people do? Isn't it a very
common form of sex collecting?

Much later I found myself intrigued by a Web site called
cum2oasis.com, featuring a woman by the name of Oasis, and run by
her and her husband, Lance. In cyberspace nobody needs a surname.
Oasis looked to be a smiley, wholesomely good-looking woman in
her midthirties, an orgiast, a swinger, an amateur. Devoid of fake
breasts, dyed hair, and makeup, she didn't look like anybody's idea of

a porn star, not even a "sex worker," but that's certainly what she was.

In her own words, her site contained "all original images of me, ranging from my first PG rated bikini pix to my first nudes to full hardcore sex photos including girl/girl, double-penetration, groupsex orgies, anal sex, blowjobs and plenty of cumshots! I'm an exhibitionist at heart and I love to flash people and have sex in public places! See my entire transformation from prude New England girl to the fuck slut I am today!"

A reviewer of her video *L.A. Gang Bang* remarks, "One of Oasis' greatest attributes is her ability to take a cumshot on the face. In this movie she takes about twenty three shots to the chin, and she makes every shot look as fresh as the first. You would think she'd stop smiling after the first couple of spurts into her eye, but she just keeps on."

Most intriguingly for our purposes, she kept a "scoreboard" of the men she'd had sex with. When I last checked it read "199 Fucked, 448 Sucked." These numbers refer only to activities done in front of the camera for the benefit of the Web site. Anything done in private somehow didn't count. This, I suppose, was a score rather than a list, a tally rather than a collection, but I do wonder if the judge in the Griffiths case would have found this sort of thing any less repellent in a woman than in a man. Possibly he'd have found it more so. And to be fair, Oasis didn't give the guys marks for their sexual prowess, though this may have been because most of the sex seemed to take place fleetingly and anonymously, in groups, in bars, and at parties where she probably wasn't in any position to be critical.

I dropped her an e-mail to ask if she considered herself to be a collector, and got the following reply,

hey geoff—
sorry to disappoint, but i'm not a collector of much of anything . . . sexual or otherwise. we have the scoreboard online because its good promotion and the fans from the site like to keep track of it. its much more for them than it

is for me. i'm not worried about the numbers, i just like to have a good time :)

 i've actually tried to start a few collections in my life—but i've never kept at it. i think my biggest collection of anything to date was a collection of candles—of which i have about 10. a serious collector would surely scoff at me!

Oasis

I thanked her for her reply, tried not to think crass thoughts about collecting candles, and moved on. But to prove that it's not only bastards and "fuck sluts" who make lists of their sex partners, here writes Charis Wilson, the sometime model, muse, and wife of Edward Weston, in her book *Through Another Lens: My Years with Edward Weston:* "On the return trip to Carmel, we talked about friendships, loves and affairs. Could we catalogue every sexual experience we'd ever had? We started taking turns: No. 1 for Edward and No. 1 for me, and so it went. This was the exercise by which we discovered that as far as totals went we were nearly equal—I believe the tally came to about two dozen lovers apiece."

An equal number on both sides of the equation would seem to be good for a relationship, but it's worth remembering that when this discussion took place, in 1934, Charis Wilson was nineteen years old, while Edward Weston was pushing fifty. On the other hand, Weston seemed to have enjoyed his experience of sex while Charis Wilson's had brought her "extreme frustration and near-frigidity." Perhaps that evened up the score a little.

The chances are, you probably don't want your spouse going public on how many, or how few, sex partners you've had. Take the case of Georges Simenon, who boasted that he'd bedded 10,000 women, but then his wife went and said it was only (only?) a tenth of this number. This seems an oversubtle form of belittlement on her part, and both figures seem a little too vague to be totally convincing. If

Simenon had said it was 9,982, and his wife had said it was only 997, I'd be far more persuaded. Round numbers suggest a lack of attention to detail, a lack of obsession and the true collecting spirit.

Considerably more impressive, though unfortunately anonymous, was a female member of an English eighteenth-century orgy society called the English Aphrodites. She listed 4,959 partners, including 93 rabbis, 288 commoners, 119 musicians, 342 financiers, 420 society men, 117 valets, 47 Negroes, and 1,614 foreigners. But I find these statistics confusing. I mean, are musicians and commoners mutually exclusive categories? Weren't some of the officers also society men? Was none of the "Negroes" a foreigner? Are we imagining a series of tightly overlapping Venn diagrams here? But at least she gave a precise number. And more precise still was one Mlle Dubois, an eighteenth-century French actress from the Comédie-Française, said to be the model for de Sade's Madame de Saint-Ange in *Philosophy in the Bedroom*. She claimed 16,527.

The feminist agony continues over whether de Sade's heroines can be considered "liberated," and if so then how their liberation is different from simply being sexually available to men. For de Sade, to be free from morality, church, state, God, and the rest means that you're free to have sex with anybody and everybody. It's only in the imperfect "unliberated" universe that people resist and therefore need to be coerced, drugged, raped, and so forth. In the Sadean utopia, male and female lusts are equal and infinite, and numbers don't come into it. It isn't a matter of scoring or notching up numbers. Everybody has sex with everybody simply because they want to.

These things were much on my mind when I went to Paris to interview Catherine Millet, the author of the glorious and infamous memoir called, in English, *The Sexual Life of Catherine M*. She tells us in the book that she's had a lot of sexual partners, really an awful, awful lot. To give you an idea, there was a time in Catherine Millet's life, quite

a long time actually, when she regularly had sex with more people in a single night than I've had in my entire life. This, I admit, shocked and titillated me, and made me a little envious. And I reckoned it made her a collector, which is why I went to Paris to interview her.

Her book recounts her sexual experiences over a period of thirty years or so, experiences involving group sex, orgies, swing clubs, free-for-alls in the Bois de Boulogne where she'd take on several carloads of men at a time, and much else besides. Edmund White tells us, "This is the most explicit book about sex ever written by a woman." The idea that Edmund White spends much of his time reading sexually explicit books by women is an intriguing and I would say unlikely one, but he may well be right.

The book was made doubly titillating, for some people anyway, by the fact that before its publication Catherine Millet had a reputation as a serious art critic, and as editor of a magazine called *Art Press*. Readers were faced with the knowledge that she wasn't just a slut; she was an articulate, intelligent, *thinking* slut. That really pushes all the buttons.

It was fairly obvious to me that she was going to deny being much of a collector, not least because in the book she writes, "I was not a 'collector' and I thought that the boys and girls that I saw at parties mauling and being mauled, and mouth to mouth kissing until their breath gave out with as many people as possible so that they could boast about it the next day, were somehow offensive." In the French original "collector" reads as *collectionneuse,* a much sexier word than its English equivalent. The original also tells us that this offensive boasting went on at school (*au lycée*), evidently a bit of information that was considered too shocking for the editions in English.

But this denial in print didn't deter me, first, because the mere fact that she hadn't been a *collectionneuse* when she was at the *lycée* hardly meant that she was bound to stay that way for the rest of her life. Second, I believe in trusting the tale not the teller, and my reading of the book suggested that a collector was indeed what she was.

For instance, she describes a sexual fantasy of being fucked serially by a variety of tradesmen who drift indifferently through her own bedroom while she's watching a pornographic video, a fantasy inspired by a scene in the Eric Rohmer movie called, wouldn't you know, *La Collectionneuse*.

Millet also gives the title "Numbers" to the first and longest section of her book, and in it she describes an early fascination with numerical possibility—how many husbands a woman might have, how many children, indeed how many lovers her own mother had: seven, "not that many." She also tells us about orgies of a hundred and fifty people where she had sex with, or, as she puts it, "dealt with the sex machines of," a quarter to a fifth of them. You do the math. She also tells us that among her literally countless sexual partners there were precisely forty-nine men whose identities, though not necessarily names, she knew. I thought I was onto something.

On the train to Paris I was trying to read, or more properly reread, both Catherine Millet's book and Henry Miller's *Quiet Days in Clichy*. (A warning to the curious reader: Henry Miller's idea of a quiet day may not be the same as yours.) I had once, a long time ago, been a big fan of Miller's writing. I'd found it both erotic and profound. Sorry about that. I'd certainly had no idea back then that *Quiet Days in Clichy* was a stitching together of two pieces he'd written for Roy Melisander Johnson.

In fact, on my first trip to Paris, I'd stayed in a hostel in Clichy simply because of the title of Miller's book. The boulevard de Clichy is now the home of the Parisian Musée de l'Érotisme, which I intended to visit on this trip. It was also the location of a boutique that sold S&M gear, in which by her own account Catherine Millet had once been fucked simultaneously by one of her lovers and the boutique owner (a "midget," she calls him) while a kohl-eyed assistant watched.

Now, on the train, as I tried to read Henry Miller's descriptions of sex, I wondered what I'd ever enjoyed about his writing. It all seemed so ham-fisted, so utterly improbable, that you wondered if the man had ever had sex at all. *Quiet Days* contains an account, so painfully incompetent, of a sexual encounter that it almost achieves a kind of unassailable grace. It ends, "Then bango! it burst like a sky rocket." Well, at least it wasn't like a periscope.

I was in need of distraction to get through the train ride, and it came in the form of the family sitting across the aisle from me. A middle-aged couple was traveling to Paris with their grown-up daughter for some sort of musical event in which she was playing. She was probably twenty or so, slim, blond, and fine-boned, while they were plump, disheveled, and worn-out-looking. On the table between them was a wooden box, which, I learned from eavesdropping on their conversation, contained the daughter's bassoon. They talked mostly about music. Dad was what we in England would once have called "nicely spoken," meaning that he was trying, and failing, to cover up humble, working-class origins.

Then, apropos of nothing, he stopped talking about music and said, "I've just bought a book by de Sade."

"Oh, Daddy, that's disgusting," said the daughter.

"Is it?"

"Yes. He does all these horrible things with his mother and daughter and everyone."

"Does he? I thought he was just sadistic."

"He *is* and it's revolting. Do you really want me to tell you what happens, because I will if you want."

"No, no," said Dad. "I'll read it and find out for myself."

You couldn't, and I definitely didn't, make this up.

Catherine Millet and I met in a restaurant close to the Pompidou Center. She was already there when I arrived. I, of course, knew from

the press coverage what she looked like. Some of her previous, negative interviewers had described her as looking frumpy, but then that's the kind of thing a negative interviewer *would* say, isn't it? Perhaps they had expected her to look like a sex kitten or a ruined libertine, but the book suggests otherwise. She makes no claims to ever having been a seducer, much less a flirt. She just got on with it.

She was a good-looking fiftyish woman, slim, wearing a corduroy trouser suit with a knitted sweater underneath. When her face was still it looked a little heavy and inert, but it was never still for very long, and when it moved it was extremely alive and expressive. None of the photographs I've seen of her show that, including the ones taken by her husband, of whom more later.

We immediately discovered that we'd been mistaken about each other's linguistic competence. She thought I spoke reasonable French, when I can only just about read it. I thought she spoke perfect English, which to be fair she more or less did, but the idea of discussing complex ideas in a foreign language obviously put her into a panic. We got through it, but to ease the pain I tried to imply that I wanted her general input on the subject of art, collecting, and sexuality, rather than the truth, that I wanted her as a specimen. Such is the duplicity of writers.

Naturally we began by talking about her book. In some ways it is so utterly explicit that asking the author any questions at all might seem beside the point. Everything is supposedly revealed. And yet there are gaps and lacunae, deliberately so, I think. Time, place, and character are subject to an obscuring drift. For one thing, it wasn't absolutely clear to me whether she was still involved in the world of anonymous, orgiastic sex.

No, she said, she wasn't. She thought she couldn't have written the book while she was still doing those things. It was only as she began to extricate herself from that life that she began to think about writing the book. Indeed the book seems to have been part of that process of extrication, a way of drawing a line.

I'd also been unsure about her husband's part in all this. She says in the book that she'd always been good at finding, apparently by chance, men who encouraged her promiscuity, and I had assumed her husband—Jacques Henric—was one of these, and that he'd been there egging her on, deriving his own pleasure from her activities. It turns out I was quite wrong. I mean, obviously he knew she was up to something. They had an open relationship. He knew she wasn't just slipping away to art-world private views. But he seems to have thought she was up to something comparatively tame, having garden-variety affairs, rather than the truth, that she was taking on whole football teams at a time. Anyway, when she came to write the book, she decided it might be a good idea to clue him in on the contents before it hit the bookstores. He must have got the shock of his life. It was, she said, "a difficult time." But they got over it.

The fact that their relationship survived these revelations says something about the strength of their marriage. At the very least it confirms that Jacques Henric is not the jealous type. In fact, he could be forgiven for experiencing forms of jealousy quite other than sexual. He, too, is a writer, another art critic, a novelist and essayist, author of such works as *Adoration perpetuelle*, *Carousels*, and *Le Roman et le sacré*. These books, for obvious reasons, have sold rather less well than *The Sexual Life of Catherine M*. But, as I say, more of him later.

After a few preliminaries I came straight out and asked Catherine Millet whether this sex life of hers hadn't been a form of collecting, that she'd been collecting experience, collecting different types of sexual partners. No, no, she said, that had never been part of the enterprise. She wasn't on a quest. She wasn't looking for anyone special, or even anyone in particular, not sexual athletes or members of specific groups—society men, musicians, foreigners, for example. She just wanted to be able to fuck *anybody*.

In collecting terms I suppose this makes her a universal collector, an extinct breed, you might have thought, that died out more or less with the Renaissance. And yes, of course I could see that to be indis-

criminate, to be universally accepting, is the very opposite of collecting. But I wasn't to be put off so easily.

What about those forty-nine men she referred to in the book? The very act of making the list was indicative of some sort of collecting impulse, no? No, no, she insisted. She'd made the list only when she started working on the book. It was research. She'd taken a large diary and made a note of all the men whose identities she could remember: Paul, Eric, Claude, Lucien, "a man of about thirty-five who looked like an estate agent," the owner of the sex boutique in the boulevard de Clichy, and so on.

It must, I suggested, have taken quite a feat of remembering. Had it been a pleasure to think back? Was there erotic gratification in the very act of recalling, then writing about all the sex she'd had in the past? She evidently found this suggestion preposterous. The job of writing was hard work, she insisted. There had been some pleasure when it was over, in knowing that she'd found the right words to express herself. But the act of recall had not been a pleasure, not at all. There was no sense of emotion recollected in tranquillity. Indeed, she said, the fact of what she had done, the actual sexual experience she'd had, was not in itself interesting at all. It was not what you did but how you described it, transforming the experience into something interesting or beautiful or funny.

Well, up to a point, Catherine, up to a point. For what it's worth, I happen to think *The Sexual Life of Catherine M* is a very good book. The writing in it is intense, eloquent, and original. For instance, there's a passage where she describes watching herself on video rubbing sperm over her breasts, then she wonders if this is an act she's performing naturally or if she's just mimicking something she's seen in other videos. This seems to me a very astute observation about sexuality, about its spontaneity or otherwise, and I don't think I've ever read it anywhere else, certainly not in those terms. Even when she gets a bit too philosophical about "Space," "the pleasures of telling," "the body in pieces," and whatnot, I'm happy to go along with her.

She's French after all. And what I like best about the book is that at no point does it ever suggest that sex is fun. Sex is far, far more serious and important than that.

But I do think it's a little disingenuous to pretend that the subject matter's irrelevant. When a female writer begins a chapter with the sentence "I really like sucking a man off," I don't doubt that she's chosen the right words to engage the reader, but I also think she's chosen a pretty engaging subject, too.

I battled on with my attempts to convince her she was a collector. How about clothes, for instance? Oh yes, since her success she'd bought herself many jackets and many pairs of shoes. I perked up. What kind of shoes? Sex shoes? Killer heels? No, no, nothing like that, and she drew my attention to what she had on her feet, an extraordinary pair of alligator-skin cowboy boots. They weren't standard sexy footwear but they were far from neutral or sexless.

She also admitted that being in the art world meant she owned many artworks that had been given to her by friends and colleagues, but she insisted these hadn't been sought after or collected. They had simply arrived. And naturally her job brought a great many books her way, and inevitably there were lots of papers and magazines around her home, and she had trouble throwing them away. And of course she had copies of her own book, all the foreign editions, now translated into thirty languages, and yes, she admitted there was pleasure to be had in seeing all the different covers, and observing how different cultures and jacket designers interpreted the book.

And now that she thought of it, one of the greatest pleasures her success had given her was the chance to travel. Promoting the book had taken her to a lot of different countries, and yes, she had some sense that this was perhaps a form of collecting. She liked maps, and there had been a time when she'd put pins into a map of the world to mark those places where she'd been.

Sex and travel: in one model, what they might be considered to have in common is a kind of invisibility. You emerge from sex with,

at most, a few scratches and bite marks. You return from your travels with a suntan. Sooner or later they all fade away. But not everyone wants this kind of invisibility. When sex and travel are over, you may still wish to have a keepsake—a ring, a locket, a tattoo in the case of a sex partner; a model of the Eiffel Tower or a pack of lewd playing cards bought at the Musée de l'Érotisme as a souvenir of your travels. And very likely you will have photographs: pictures of the loved one, pictures of what you did on your holidays. These are ways of preserving the traces of a potentially all-too-traceless experience.

On my way to the restaurant I'd stopped off and bought a book called *Légendes de Catherine M.* It was written by Jacques Henric, Catherine Millet's husband, and it may be seen either as a love poem to his wife or as an attempt to muscle in on her success, or both. It is a very, very French book. The text is studded with big names: Bataille, Breton, Man Ray, Lacan, Sollers, with references to Henric's own novels, with chapter titles like *"Infiniment plus nue,"* and *"Il n'y a qu'un sexe, le féminin."* Interestingly there are also a few references to Edward Weston, including one about Charis Wilson, specifically about the hairs of her legs and armpits.

It is a serious book and an intellectual book, but even the most rigorous intellectual is likely to be distracted by the book's illustrations, consisting of fifty or so nude photographs of Catherine Millet. None of them is large, and some of them are minute, being tiny reproductions of contact sheets. Most of them are surprisingly decorous. They show Catherine posing against wrecked vans, astride a small child's rocking horse, "flashing" in the railway station at Port Bou, in Spain, a place richly associated with Walter Benjamin. Catherine Millet describes the taking of these pictures in her own book.

Some of the photographs are perfectly good, one of them even made it to the cover of some editions of *The Sexual Life of Catherine M,* but most of them are, let's say, amateurish. The blurb on the book tells us that these images "don't pretend to have any artistic value," but that's a disclaimer which can't fend off all criticism. Apparently

Henric has taken thousands of photographs of his wife over the years, and you do find yourself thinking that if these are the "best" then what on earth must the others be like. But no doubt we are talking about something other than aesthetic values here.

I put it to Catherine Millet that if she wasn't a collector, then her husband surely was. He collected images of her. The fact that he also created them, or at least captured them on film, gave it an added twist. She smiled and nodded as I said this, as though it was something to which she'd already given some thought. So, I asked, what did he *do* with all these photographs, apart from printing a minute selection of them in his book?

Well, she said, some of them were in boxes, some were in drawers, but an awful lot of them were up on the wall of their living room. It hadn't been her idea, she said. And I asked, as I'd asked before, how she felt when the meter reader came round. Was she embarrassed? Of course, I knew that she wouldn't be, but even so her answer surprised me. She said, "I am not my body," a phrase that I'm sure would have sounded even better in French, and which I suspect may be a quotation, but I haven't been able to find out who or what from.

To clarify matters she later sent me an article she'd written for *Art Press* about Andy Warhol. In it she relates Warhol to the Gnostics. The Apocrypha, she tells us, contains an account of Saint John, a man who had never seen his own image; we're talking parable, okay? A disciple presents him with a painted portrait, but inevitably he fails to recognize himself. Someone brings a mirror to help him compare, and John says, "This image is a likeness. Not of me, however, but of my fleshly appearance." You'd have wanted to slap him, wouldn't you?

Millet also tells us that some Gnostics refer to their body as a "garment of shame," and that some engage in "frenetic libertinage" in order to "exhaust" the flesh. This seems to have rather more to do with Catherine Millet than it does with Warhol. His flesh seems to have been exhausted from day one. His art is infinitely sexualized,

perhaps the life, too, at least at the level of thought and imagination. But Warhol claimed, perhaps confessed, possibly even boasted, and very possibly lied, in a 1980 interview with Scott Cohen, that he was still a virgin. Whereas Catherine Millet may have lost track of the number of her sexual partners, poor old Andy Warhol never even started counting.

Once Catherine Millet and I had said our good-byes, I, of course, thought of a lot of questions I should have asked her, chiefly about her wanting to be able to fuck anyone. Why, I wondered, would she want that? I subsequently asked her this by e-mail. Her reply, every bit as unsatisfactory as I expected, was as follows.

"Dear Geoff, I am sorry, the good question is not 'why I had sex with anybody', the good question is 'why not with anybody?' "

There is, of course, no answer to that, or rather there are thousands of answers and none of them is likely to mean much to someone who formulates the question in the first place. Perhaps to be totally indiscriminate is to be totally free, though frankly I doubt it. It's certainly an idea that permeates a certain kind of male sexual fantasy. Men, we are told, and sometimes we even tell ourselves, are always ready for sex, always prepared to take on all comers. Women, we know, in general are not. Why, we ask ourselves, can't they be more like us? If we were women we'd behave like complete sluts.

Should you need an example of this point of view, here's Josh Homme, of the band Queens of the Stone Age, and a man generally reckoned to be at the more thoughtful end of the rock sensibility, being asked by *Playboy* magazine, "If you were a woman for a day, what would you do?" Homme replies, "I'd fuck everybody, just to see what the deal is. I'd go get shit-faced, have everyone buy me drinks, and just take on the Navy or something. I would be indiscriminate. Come one, come all." Of course one might argue that this is in fact a

homosexual fantasy, but let that pass. The fantasy is that he'd be just like Catherine Millet.

In fact there were just one or two moments reading her book when I couldn't help wondering whether the whole thing was made up, and therefore not just a fantasy, but a con; I'm thinking about an episode where she has sex with her dentist and his assistant that seems to have more in common with pornography than lived experience. If this were really the case, the book would represent one of the most successful and startling literary hoaxes in a very long time. But I don't really believe that's the case, and I'm sure I don't want it to be.

Catherine Millet's book is the visible souvenir of erotic travels. And I still reckon it's her collection, her cabinet of curiosities, not a secret cabinet, obviously, and not a locked one, either. Books open themselves to readers. If you believe her, it's just a collection, an arrangement, of the right words. If you want my opinion, it's a startling collection of thoughts, feelings, and narratives that relate to more or less transgressive sexuality. If it were just a collection of sexual fantasies, that would be simply unbearable.

Afterward, as planned, I went to the Musée de l'Érotisme. I'd suggested to Catherine Millet that we might stroll along there together, but she declined. A shame in some ways. If nothing else I could have asked her in which of the many sex shops in the boulevard de Clichy she'` had her experience with the boyfriend and the midget. Instead I walked along by myself, being aggressively hassled by men who wanted me to come into their establishments and see live girls. These guys didn't seem to know many words of English, although "You English?" and "live girls" were foremost among them.

It did occur to me that I was perhaps being a little pathetic, spurning real live, warm, naked women in favor of their depiction in a museum, in art. But then again I wasn't sure how live and real and

warm—or even how naked—these advertised women would actually have proved to be.

I guess I was a little disappointed by the museum. It was a bit too arty and white walled for my tastes, but perhaps after lunch with Catherine Millet anything was bound to seem a little tame. So yes, I had a quiet day in Clichy, and not at all Henry Miller's idea of a quiet day.

One of the most melancholy books I own is called *Henry Miller: A Personal Archive*. It's a sale catalog listing the contents of Henry Miller's study as it was left on the day he died in June 1980. The catalog is dated 1994, and a "General Note to the Reader" tells us that the archive was valued at over $1.2 million in 1993, though they don't say by whom. I'm entirely prepared to believe that figure, and yet a great deal of the archive seems like the kind of "worthless" disjecta membra that might clutter up any of our lives and studies: a membership card from the Southern Poverty Law Center, address books, newspaper clippings, old theater programs, certificates of vaccination, unused aerograms, a computer-generated horoscope.

More melancholy oozes from items such as a letter to Santa Claus written by Miller's son Tony; a promissory note from Miller's third wife, Lepska, and her new husband; documents relating to Miller's attempts to lobby for a Nobel Prize. But inevitably it's the stuff relating to sex that's truly depressing, indeed heartbreaking. There's an eight-by-ten photograph of Henry Miller "reading a sex magazine," photographs of erotic art "not by Miller," a questionnaire from *Penthouse,* dated 1978, complete with answers. I suppose there must have been some people in 1978 who still cared what Miller thought about sex, but not many, I think. Without wishing to be too ageist about it, you have to remember that Miller was born about a decade before the start of the twentieth century.

And then comes the saddest of clinchers—a collection of 134 pho-

tographs filed under the title "My Girl Friends." And there they are, or were, pictures of women, some well known like Elke Sommer, Erica Jong, Jennifer Jones, Anaïs Nin (of course); some less so, such as Brenda Venus and Yu Shinoda; and quite a few of them aren't identified at all. "Includes some nudes" the catalog tells us, and also that there are "few, if any, duplicates." Why that "if any"? I wonder. It wouldn't have been such a big job to determine whether there were duplicates or not, would it? But perhaps the task would have been too melancholy for anybody. One hundred and thirty-four is a pretty good collection of "girl friends," but I do wonder how many, or how few, of that number, how many on that list, poor old Henry Miller actually had sex with.

6

SOME EROTIC BIBLIOGRAPHERS—
BLOOMSBURY TO SANTA ROSA

An erotomaniac and an erotomane.

It would be interesting to study the bibliophile as the
only type of collector who has not completely with-
drawn his treasures from their functional context.

—Walter Benjamin, "The Collector," in
The Arcades Project

Bibliography, in the modern sense, is literally the describ-
ing of books. Since there is no end of the making of books, there is
equally no end to the describing, listing, and cataloging of them.
Some bibliographies and bibliographers are inevitably more scholarly
than others, and when it comes to erotic works, the scholarship is
likely to be especially eccentric. The greatest Victorian bibliographer
of erotic literature, also one of the greatest collectors, was Henry
Spencer Ashbee (1834–1900), a wealthy London-based merchant
with interests that took him all over the world. He wrote three formi-
dable, curious, and rather wonderful works of erotic bibliography. If
you were to turn to the first of these, entitled *Index librorum prohibito-*

rum, and looked up "Bibliography" in the index you'd find, among over two hundred other citations, the following:

Bibliography
 An infant science
 Unremunerative and thankless
 Compared to a potato field
 Other sciences more honoured
 Neglected in England
 A difficult pursuit
 An elevating pursuit
 Bare catalogues comparatively useless
 Every collector deceived at one time or another

Ashbee was a man who knew about these things.

I'm sitting in the Rare Books Room of the British Library in London, looking at that first book of Ashbee's, which in full is called *Index librorum prohibitorum: Being Notes Bio-Biblio-Icono-graphical and Critical on Curious and Uncommon Books.* That main title, even in my poor schoolboy Latin, translates easily enough as "An Index of Forbidden Books" and of course it echoes the Vatican's own index. The book is a descriptive list of a few hundred volumes of obscene, erotic, or indecent books, from *The Accomplished Whore* to *The Voluptuarian Museum,* by way of *The Amorous Quaker, The Dark Side of New York Life,* and *Madame Birchini's Dance.*

In fact Ashbee's name doesn't appear on the book's title page. The author calls himself Pisanus Fraxi (a pseudonym that only schoolboy Latinists are likely to find very daring or amusing), but even in his own time, anybody with an interest in the subject would have known that Ashbee was the author.

The copy I'm looking at is Ashbee's own, a first edition, published

in 1877, which he broke up and split into two volumes—each with his bookplate showing an ash tree and a bee—and in which the bookbinder has interleaved the printed pages with blanks so that it becomes a sort of scrapbook, leaving room for Ashbee's personal notes and additions. There are plenty of these. There are bibliographical annotations for instance: since publication he's discovered that the publisher of *The New Epicurean* was one D. Cameron, and he sets this down opposite the printed entry. Elsewhere, tipped into the blank leaves, are portraits of de Sade, Napoléon III, Lord and Lady Byron, Thomas Macaulay, and the Earl of Sandwich, among others, and there's even a photograph of Ashbee himself. There are three proofs of early versions of the book's title page, with some hand-drawn reworkings. There are personal letters and a photograph of the tomb belonging to his friend John Camden Hotten. There's a clipping from a book catalog and several newspaper cuttings, including one on necrophilia.

It seems that as time went by Ashbee got distracted from his task, and the second half volume (as it were) is far less annotated than the first. Presumably he was busy striking ahead with the further two volumes and didn't have time to further annotate what was already finished. This, at least, suggests that Ashbee wasn't a complete and absolute obsessive. A different sort of bibliographer might have spent the rest of his life correcting and improving that first volume.

If you're any sort of book lover, the chance to handle this first edition of Ashbee's first great work is a real thrill. To know that he owned, touched, and wrote in it, and that he so obviously valued it, is the stuff bibliophiles live for.

After that first volume, there was *Centuria librorum absconditum,* published in 1879, which translates as "A Hundred Books Deserving to Be Hidden," and in 1885 he published a third, *Catena librorum tacendorum,* "A Chain of Books Which Should Not Be Spoken Of."

By any standard these are strange and extraordinary books: highly erudite in their way, obsessive, pedantic, sometimes ridiculous, occa-

sionally delirious, but always compelling, with the feel of an earlier, more eccentric time. They read like cousins of Robert Burton's *Anatomy of Melancholy* or Aubrey's *Brief Lives*.

Across the three volumes Ashbee lists many hundreds of works. Sometimes he doesn't do much more than name them, and in these cases the title seems to say it all: *The History of a Rake, Adventures of a Sofa, Fast Life in London and Paris, The Two Lovers: or Fred in a Fix,* which actually sounds like a P. G. Wodehouse title to me. And my favorite of all, the one that still makes me snigger ignobly, *The Virgin's Oath: or the Fate of Sontag. An Historical Drama, in Two Acts.*

But in general titles aren't enough for Ashbee. More usually he gives some description of the cited work's contents and sometimes he goes into extraordinary detail, giving a plot summary, publishing history, and even a substantial extract. To this extent his books are an anthology of erotic literature, with chunks taken from, for example, Rochester's *Sodom* and *The Romance of Chastisement* by "An Expert." Where Ashbee is dealing with foreign texts, he quotes in the original, and when the original is French he quotes at great length. There are also exhaustive, and it seems to me pretty pointless, verbal descriptions of numerous erotic prints by Thomas Rowlandson.

This is all scholarly enough in its way, but Ashbee is also providing a consumer's guide. *Captain Stroke-All's Pocket Book* is dismissed as "a string of insipid, commonplace, yet improbable adventures . . . The tale is told in a clumsy, inartistic manner, and in language gross and frequently ungrammatical." He's far more approving of *How to Make Love, or, The Art of Making Love in more ways than one, exemplified in a series of letters between two cousins,* Cythera Press, 1823, which is praised for its "12 obscene engravings, fairly well executed."

Elsewhere in the three volumes you'll find references to *Fanny Hill,* the *Kamasutra,* Boccaccio, *The Pearl,* and to works by de Sade, with references to his "marvelous but degrading career." But Ashbee has a wandering and speculative mind, so he does more than just list and describe books. He pontificates about the erotic book trade and about other col-

lectors. There's a brief biography of his friend Hotten, "the only respectable English publisher of tabooed literature" whose "private library of erotic literature was extensive and was, at his death, purchased *en bloc* by a London amateur." There's also a fair bit of gossip, about sensational sex cases of his era, and he's got a lot to say about the different sexual preferences of different countries: it was the Bulgarians who introduced sodomy into Western Europe apparently.

Ashbee describes each of his three volumes as a miscellany, which is essentially true, especially of the first volume, though in the later two there are more specific interests. *Centuria* deals with a lot of anticlerical volumes, *Catena* is mostly concerned with fiction. Ashbee shows some familiarity with Defoe, Dickens, Restif de la Bretonne, and de Sade, but only the last makes it into the bibliography.

However, there's one subject that's never far from Ashbee's mind, and that's flagellation. Reading the index of any of the three books is enough to show you the intensity of his interest. Here are just a few citations from the index to *Centuria,*

Flagellation
 Female culprits whipped at Bridewell,
 A powerful aphrodisiac, J. Davenport quoted,
 Enjoyed by boys,
 J.J. Rousseau describes his whipping by Mlle. Lambercier,
 Old men crave for it,
 Shadwell and Otway introduce it in their plays,
 Women are fond of administering the birch,
 Some cruel women instanced,
 Elizabeth Browning beats Mary Clifford to death,
 Female whipping club in London depicted,
 A female pantaloon slapped,

Actually there are times when I think the indexes are the best part of, and possibly even an excuse for, the whole enterprise. If you look

up "Copulation" in *Catena,* for instance, you'll find "See also Forni-
cation, Incest, Love, Marriage, Men, Polygamy, Rape, Seduction,
Prostitution, Sex Virgins, Seigniorial rights, Women." If you look up
"Women," you'll find "See also Adultery, Brothels, Copulation, Flag-
ellation, Hermaphrodites, Trials, Tribadism." You can amuse yourself
like this for quite a while.

Henry Spencer Ashbee was part of a coterie of Victorian biblio-
philes, collectors, and sexual adventurers who shared a theoretical
and practical interest in flagellation. The most famous was Sir
Richard Burton, translator of the *Kamasutra* and *The Perfumed Garden,*
and very possibly the discoverer of the source of the Nile. There was
Richard Monckton Milnes, a Member of Parliament, a man who
unsuccessfully proposed marriage to Florence Nightingale, and who
is now thought to have been the author of *The Rodiad,* which Ashbee
praises by quoting Hotten: "The author describes all the varieties of
flagellation—domestic, scholastic, penal, and eccentric—and is very
enthusiastic in his praise of the Rod."

On the fringe of the group, a dealer as much as a collector, was the
Paris-based Frederick Hankey, an all-round scoundrel by most
accounts. He was the one who supposedly set Burton the task of find-
ing a female human skin to bind his copy of *Justine.* We can safely
assume it wouldn't have been a white skin.

It may be tempting to think this was just Hankey playing the stage
villain, but when the Goncourt brothers met him in 1862 they cer-
tainly thought he was the genuine article. They called him "a mad-
man, a monster, one of those men who live on the edge of the abyss."
By contrast, Swinburne, who was also one of his customers, approved
of him and said of his collection, "Nothing low, nothing that is not
good and genuine in the way of art and literature is admitted."

The idea of this group of rich, serious, outwardly respectable Vic-
torian men getting together to discuss flagellation, no doubt in a

bookish, scholarly, high-minded way, strikes me as infinitely depressing. It may have struck Ashbee's wife, Elizabeth, in much the same way, though no doubt she took it a lot more personally. In his introduction to *Prohibitorum* Ashbee tells us that flagellation "has caused the separation of man and wife" and I suspect there's a deliberate ambiguity there about whether he means its occurrence in books or in real life.

Ashbee was a Bloomsburyite long before there was a Bloomsbury group. When he was first married he lived in a street just off Bedford Square, then in the square itself in a bigger house, number 53—now an expensive and soulless set of offices. He had a library in his home, and his collection of erotica was initially kept there, but after a time he decided to move it into a home of its own. According to Ashbee's biographer, Ian Gibson (the biography is called *The Erotomaniac*), the collection resided at 4 Gray's Inn Square—an address that doesn't quite exist today. In a corner of the square—large, pleasant, containing a garden with an armillary sphere and lots of expensive parked cars—there's now a single doorway marked 4/5 and inside there are sets of rooms, one "pair" belonging to Sir Roy and Lady Wilson when I visited. I contacted Gibson to see if he knew which set was used by Ashbee and if he could shed any light on the change of numbering. Since he didn't reply perhaps he couldn't.

No doubt the character of the buildings and their inhabitants has changed over the years. Nevertheless, Gray's Inn Square was and is still at the center of London's legal institutions. Ashbee may well have taken some pleasure in knowing that his obscene and possibly illegal book collection was stored and concealed there.

Ashbee's decision to move his collection out of the family home doesn't, in itself, seem so very significant. A lot of people don't want their spouse's hobby cluttering up the house. Keeping it at arm's length, off premises, is often a very good compromise. In Ashbee's case, however, the move seems to have indicated a more profound set of problems. Having a husband who's obsessively interested in flag-

ellation may not be the recipe for a happy marriage, regardless of where he keeps his collection. In due course Elizabeth Ashbee moved out of the house, too.

Many years after the event, their son, Charles, wrote his own account of the breakup. He seems to put it down to "artistic differences." His mother liked the work Rossetti, Burne-Jones, Wagner, and Swinburne, he says, and his father didn't (though surely he was wrong about his father not liking the work of fellow whipping enthusiast Swinburne). Charles wrote, "And so it came that one day she just passed as moving sunlight out of the house." I've heard less convincing accounts of the breakdown of a marriage, but not many. Ashbee was left with a big house and a big collection, and just possibly with a mistress who lived in Stoke Newington.

If you walk the mile and a half from Ashbee's home in Bedford Square to his collection in Gray's Inn Square, the chances are your route will take you by the British Museum. As Ashbee walked past this great depository of knowledge and empire, he would have known there were significant gaps in the library's holdings, gaps that he could fill. To have a personal collection that's better than the national copyright library's would give satisfaction to any collector, and Ashbee decided that after his death his collection would go to the BM, but it wasn't to be a straightforward bequest. It so happened that Ashbee was also a major collector of Cervantes and Quixotiana and had a world-class collection of those books, too. His deal was that the BM could have the Cervantes collection only if they took the smut, too.

The received wisdom is that the Victorian officials at the BM found this a tricky proposition, but Paul James Cross, the author of the history of the BM's Private Case (essentially the erotica collection), says there's no real evidence for that. According to Cross, Ashbee's books filled twenty cases, 8,764 works in 15,299 volumes. Of

those about 1,000 works in 1,600 volumes were reckoned to be erotic or obscene.

Certainly there's some evidence that the museum didn't take the very best care of Ashbee's collection, though I suppose once they'd accepted it they regarded it as theirs, not his, and therefore felt free to do whatever they liked with it. In 1914, for instance, a keeper wrote that some duplicates had been "recently destroyed," and at the same time 267 items were given to the Bodleian Library in Oxford. But perhaps there were conflicting feelings about Ashbee's legacy. In 1900 they bought from a French collector called Louis Constantin two hundred volumes that had formerly been owned by Ashbee.

Ashbee was the first to admit that he didn't own copies of all the books that appear in his bibliographies, but there's one notable and scarcely explicable omission from both the bibliographies and his collection, and that's *My Secret Life,* published between 1888 and 1894, the great Victorian eleven-volume, two-and-a-half-thousand-page, infinitely obsessive and detailed account of one man's genuinely extraordinary sex life.

Patrick J. Kearney, of whom more later, says that *My Secret Life* "is probably the most collectible and desirable of erotic texts, but certainly not the rarest." It was first published in Amsterdam, though the book itself claims to have been published in Belgium. In the text we're told it was supposed to be an edition of six, but there's no particular reason to believe that's true; it may be just another part of the literary superstructure. In fact it seems that twenty to twenty-five first editions were printed, the extra ones having allegedly been run off by the unscrupulous Amsterdam printer.

Previous owners of examples from that first edition are said to have included the Satanist Aleister Crowley, silent comedian Harold Lloyd, movie director Josef von Sternberg, and George Mountbatten, the second Marquess of Milford Haven. It's per-

fectly possible that some of these people, especially the Hollywood crowd, owned the same copy at different times. Today I believe there are copies in the British Library, in the Kinsey Institute, in the private hands of Karl-Ludwig Leonhardt, and in the library of the late Gerard Nordmann. The New York dealer, collector, and curmudgeon C. J. Scheiner tells me he has done a "census" of the whereabouts of all the existing copies, but he's declined to tell me where or if this research was published, and nobody else I've spoken to has ever heard of his census. There are those who also think Scheiner himself may have a copy.

I've handled only one first edition and that's the one in the British Museum—part of the Charles Reginald Dawes bequest. In fact I've handled only six-elevenths of the edition. They bring you only six of the eleven volumes at a time, which in reality is plenty, and they didn't look as though they had been much read, or even well thumbed.

There's room for debate about whether *My Secret Life* is an autobiography or a novel. To me it reads like the latter, although I'd guess it's based on extensive personal experience. Certainly it has the artful, considered feel of a literary creation rather than of a true confession, though I'm well aware that these forms aren't mutually exclusive.

There are plenty of things in the book that are offensive to a modern reader, though no doubt they aren't the same things that would have offended our ancestors. Walter, the book's narrator and hero, is, alas, a man of his age. Women, and quite a few men, exist only for his gratification. He's rich, the objects of his lust are poor, they've got something he wants, and an exchange of money and/or the exertion of Walter's power are the means by which he usually obtains it. Dismaying though this is, it sounds authentic enough and thoroughly honest. If the book were a more straightforward pornographic fantasy, then women would fall at Walter's feet for no reason except his sexual desirability and prowess. This, of course, may well be a fictional technique in itself.

Walter's sexuality is singular. He's polymorphous, or at least bisex-

ual, in a manner that seems some way from the pornographic norm. He has his sexual failures, he's reflective, he says with some amazement that he can now commit sexual acts that would once have disgusted him. This suggests to me a psychological depth, development, and self-awareness that's unheard of in pornography. Characters also have conversations that aren't always straight out of the handbook of well-known pornographic phrases and sayings.

But let's not pretend that *My Secret Life* is anything other than a dirty book. That's what the author's trying to write, and he succeeds. The book's sexual descriptions are relentless and explicit, and the language is obscene enough for anyone's tastes. The author, if not precisely a collector, is certainly something of a cataloger. In volume ten he "classifies" the different kinds of female genitalia, and he does a reckoning of the number of women he's had sex with, of many nations and ages, though usually from very much the same social class, and he comes up with the number 1,200. There's an editorial note where he tells us, "In the manuscript the names of the various places where I had the women with the dates were mostly set forth, but to do so here would disclose too much." This strikes me as the kind of self-referential bluff and double bluff that would be perfectly at home in any modern work of metafiction.

Actually there are times when I think the book's index is the best part of, and possibly even an excuse for, the whole enterprise. You might, for instance, look up "Spending" and find the following citations:

> my first
> involuntary
> on writing paper
> on a silk dress
> on silk stockings
> against a looking glass
> against a door

in a woman's hand
copiously
baudy ejaculations when
is the most ecstatic moment of life
happiness of dying whilst

And so on. This is great stuff, and it reminds us of Ashbee's indexes. In both cases, of course, it's perfectly possible that the authors of the books weren't the compilers of the indexes.

The absence of *My Secret Life* from Ashbee's bibliographies and his personal collection is certainly hard to fathom. Given his central position in the world of Victorian erotica, it's inconceivable that he didn't know about the work, and its very absence has led some people, including Ian Gibson, to believe that Ashbee is the author, though I can't see any logic in this. In ignoring the book, Ashbee may very well have been trying to prove or hide something, but at this distance it's impossible to see what.

Gibson also finds some linguistic similarities in the two prose styles. Personally I don't see them. The author of *My Secret Life* is witty, clever, with a sense of humor, and despite the sexual boasting, he shows a fair amount of self-deprecation. Ashbee, for all his appeal, is not like this at all. He's pompous, pedantic, and largely humorless.

But it seems to me that the indexes themselves give plenty of evidence that the works are by different writers. If you go to the index of *My Secret Life* you'll find very, very few citations for flagellation (four mentions) or any of the words associated with it; actually the only one I can find is birching (three mentions), no beating or spanking or whipping or references to "the rod." There are actually one or two mentions in the text that the index misses, but even so, given Ashbee's obsessive enthusiasm for the subject, I find it hard to believe he could get through more than two thousand pages, whether fictional or not, with so few mentions.

For what it's worth (quite a lot actually), Patrick J. Kearney doesn't believe that Ashbee wrote *My Secret Life,* though he thinks he may have been involved in its publication. Kearney is himself one of the great contemporary bibliographers of erotic books. It's not exactly a crowded field, though it does include a few quirky stars, including Sheryl Straight, who runs the Web site called the Erotica Bibliophile, and Peter Mendes (father of Sam), author of *Clandestine Erotic Fiction in English 1800–1930.*

The mainstream publishing world has never exactly fallen over itself to publish bibliographies of any sort. Kearney's *The Private Case* appeared in an edition limited to a thousand copies from the maverick publisher Jay Landesman. His *The Paris Olympia Press,* an annotated bibliography of Maurice Girodias's great publishing house, was issued by Black Spring in an even smaller edition of 750. Both these books are now collector's items and suitably, though not outrageously, expensive.

The Internet is therefore a great boon for both creators and fans of bibliographies, and Patrick Kearney's current activity is centered on his own Web site called the Scissors and Paste Bibliographies. It contains checklists and bibliographies for various publishers and writers of erotica, often French, mostly from the earlier part of the twentieth century, though occasionally from the end of the nineteenth, and some of it is pretty obscure. Here, for example, you'll find lists of erotic works written and/or edited by the likes of Pierre Louÿs, Louis Perceau, and Pascal Pia. There are bibliographies for publishers such as Maurice Duflou, René Bonnel, Isidore Liseux, and Brandon House. There's a checklist of the Bibliothèque Curieux, with titles by Feydeau, Flaubert, and Cydno La Lesbienne. There's a section entitled "Notes Towards a Supplement to L'Enfer of the Bibliothèque Nationale."

If this is the sort of thing you like, you're going to like this sort of thing a lot. I claim no expertise in these matters, indeed I'd never

heard of some of these people and publishers before I started reading about Patrick J. Kearney, but my understanding is that his work is as accurate as it is sometimes arcane.

I suppose all bibliographers have to contend with the accusation that they're somehow missing the point. Yes, yes, they the know dates and places of publication, they know the book was bound in half buckram and had marbled endpapers, but what was it *like*? Was it any good? Was it actually erotic? Kearney gets round at least some of the problem by having a sense of humor. In the 1980s he published a quite populist volume called *A History of Erotic Literature,* which contains the cracking line "By special request this book is not dedicated to my parents." The Scissors and Paste Bibliographies contain a couple of galleries showing the covers of books like *I Am a Hollywood Call Boy* and *Sherbet and Sodomy,* this latter written by one Gordon Glasco and published by the Olympia Press in the Other Traveller Series and originally called *Sorbet and Sodomy,* until Maurice Girodias decided that title was "too sophisticated."

A bibliography also becomes a good deal less theoretical when it describes the bibliographer's own private collection. There's a section on Kearney's Web site called "An Erotomane's Library Catalogue." He is the erotomane in question, and the library is his. It's an amazing list: loads of de Sade, Bataille, Apollinaire (mostly in the original French); smatterings of Rimbaud, Restif de la Bretonne, and John Wilmot, Earl of Rochester. There's plenty of Aleister Crowley, multiple editions of *Fanny Hill,* and some items that had once belonged to Gershon Legman. And as is often the case, there are some titles that you feel couldn't possibly live up to their titles: *Le Nécrophile,* by Gabrielle Witkop, *La Vie sexuelle de Robinson Crusoe,* and *Copulation: An Anthology of Russian Erotic Literature.* By any standards it was obviously quite a collection, and I set off to meet Patrick Kearney in hopes of seeing it.

I knew that these things had to be handled gently, and so when Patrick suggested that we meet on neutral territory I wasn't surprised.

He didn't know who or what I was. Despite all my charm, and my attempts to write winning e-mails, I realized that when it came right down to it, he might not want to show me his collection.

That's why we met in the bar of the Flamingo Hotel, in Santa Rosa, a town about an hour's drive north of San Francisco. Patrick had suggested the Flamingo on the basis that it was easy to spot. I'll say. The hotel itself was ordinary enough at ground level, but a fifty-foot-high tower with a revolving neon flamingo on the top was truly unmissable. This was a recent restoration, and some of the locals had denounced it as a tasteless eyesore. Not Patrick. He wasn't that kind of guy. He found it a good joke.

His e-mails to me had been witty and friendly, though they had all come with a quotation from de Sade: "Happiness does not consist in enjoyment, but rather in the destruction of the barriers that have been erected against desire." However, seeing him waiting there for me in the bar of the Flamingo, apparently very much at home, he looked like nobody's idea of the Sadean man. He was a cheerful, tubby, sweet-faced character of about sixty. He had on a corduroy cap, which made me assume he was bald, but later he took it off to reveal a full head of smooth, steely-gray hair.

We introduced ourselves and exchanged some stilted pleasantries. I'd imagined he might be a teacher or academic, but, no, he assured me, his job was blue-collar, and that was his pickup truck outside. (It was rear-ended a few days after I met him, by a woman he referred to as "some moo.") His voice sounded entirely English to me, a London accent, not remotely posh, this despite his having lived in the States for twenty years or so with his American wife. It had been love at first sight back in London, apparently. "I went out to buy a newspaper and I came home with an American wife," he said, leaving it at that.

This wife was not in evidence now. In fact, when we'd set up our meeting, he'd said he might bring a friend along, and he did: Julie, a plump, blond woman, cheerful, too, in her own way, though with an aura that told you life hadn't been very kind to her. I was uncertain

what sort of relationship she and Patrick had, and to a large extent I remained that way.

It appeared she didn't know Patrick very well, and as I asked him questions, she'd sometimes throw in one of her own. I felt she was learning about him at the same time I was. I also felt that the fact I wanted to interview him made her see that he was a somebody, and that pleased both of them.

I wasn't surprised to find that Patrick had started out as a stamp collector. Many have. However, he'd hardly been your typical schoolboy philatelist, since he'd collected only one stamp, though far more than one example of it. At this point, forty years after the event, he couldn't be absolutely sure what the stamp was, French certainly, possibly something called Ceres, the one with the woman in a field scattering seed. In any case, there was nothing at all rare or fancy about this stamp; it was produced for many years and by the million. However, the stamps were all produced from the same printing plates, which gradually deteriorated with use. By looking at an individual stamp, you could see the state of wear, and therefore it was possible to make a stamp collection that was in effect a record of the plates' steady deterioration. I found this rather wonderful: further evidence of the connections between collecting and oblivion, should more evidence be needed.

Patrick's involvement with erotica started when he first read *My Secret Life*. Of course he remembered the edition: the abridged, one-volume Grove Press paperback with the introduction by Gershon Legman. He said he'd been looking for help with his masturbatory fantasies, and I was impressed by this confession. It was one of the few times that I found a collector who came right out and admitted that an interest in erotica might have anything whatsoever to do with masturbation. But the text of *My Secret Life* didn't get the job done for him, whereas he found the Legman introduction enormously stimulating, if in a different way, intellectually, bibliographically, and this was what really got him interested in erotic literature as a subject for serious study.

When I put it to Patrick that he was at heart an "erotic bibliographer," he balked a little. He said the world of the bibliographer was so rigorous that he preferred to lower the bar a little and call himself a mere cataloger, which was suitably modest of him, but a little disingenuous, I think.

Having seen the catalog of his library online, I assumed he had to be pretty competent in French, but he said no, his French wasn't of the highest order, but he could, with difficulty, struggle through a French text so long as it wasn't too stylistically complex—Céline, for instance, defeated him completely—but he was okay with the sort of French found in bibliographies and the like. I'm going to assume he was being modest again, because otherwise he'd be fairly close to saying that he couldn't read the books in his collection, and that would be nuts, and Patrick didn't seem at all nuts.

Of course I had to explain myself and the nature of the book I was trying to write. I said I was interested, always had been, in collecting and obsession. With a roll of her eyes and a nod toward Patrick, Julie suggested that if I was looking for an obsessive I'd come to the right place. And it wasn't just books he was obsessed with. There was a woman, too.

I'd had some vague hint of this already. Patrick's Web site is dedicated "to the memory of Linda Troncelliti Perkins, January 15th 1943—July 21st 1989," and there's a blurry, smiling snapshot of a young woman, not looking at all like the subject of an obsession. Her name also appears in the acknowledgments of *A History of Erotic Literature,* where Patrick writes, "without her I wouldn't have written a line." Clearly she had died comparatively young, but according to Patrick, she'd been murdered. This happened quite some time after their relationship ended; she and Patrick remained extremely close friends and stayed in touch almost to the day she died.

What on earth do you say? Julie had seemed to imply that Patrick was the sort of eccentric who'd become obsessed with some woman for no good reason. She herself had lost someone two years ago and

she was getting over it just fine. Well, nobody can dictate how long it takes anyone to get over anything, and even if fifteen years was a long time, it seemed to me that the least obsessive man in the world might find himself obsessing about a woman he loved who'd been murdered. It also seemed to give Patrick some comfort to think that the murderer was still alive, perhaps because it meant there was still a hope for justice and revenge.

You might have thought this revelation would have put a damper on the conversation, yet it didn't. Patrick was a humorous man, of the "if we don't laugh we cry" variety, he said. He was also an anecdotalist, and he had a pretty good, if ultimately inscrutable, story about meeting George Melly, the English jazz singer, writer, and surrealist, trying to pick him up sometime in the early '60s. One night Patrick had been standing outside the Lyons Corner House next to Charing Cross Station, in London, reading Paul Eltzbacher's *Anarchism,* with which he was having a hard time. Yes, yes, I know this seems wildly improbable, but for the sake of the story, I'm going to assume he was waiting at a bus stop. Then the thoroughly recognizable George Melly came along and said, "I've got a friend who's interested in anarchy. You might like to meet him. His name's George Melly." To which Patrick naturally replied, "Wait a minute, *you're* George Melly," which rather took the wind out of Melly's sails. For Julie's benefit, Patrick also told the story which appears in Melly's memoirs, of Melly having sex with E.L.T. Mesens's wife, Sybil, while Mesens watched and cheered him on by yelling, "You're fucking my wife! You're fucking my wife!"

It appeared we were getting on fairly well, so I took the step of asking whether there was any chance of seeing Patrick's collection. To my delight he said that I could, so we all got into my car, and Patrick directed me through the Friday-afternoon Santa Rosa traffic to his home, where the collection was kept. By then I'd picked up a few more clues about Patrick and his wife. He sometimes referred to her as his ex, but Julie pointed out that they were still married. It had

taken them twenty years to find out they weren't compatible, he said. She was still living in their house, and he'd had to move out. He'd taken the important parts of his collection with him, but he'd had to leave some of his biographies and reference books behind. The split was amicable, he insisted, and they were likely to stay married for the foreseeable future since she needed the medical plan that came with his job but not hers. On the way to Patrick's place he ruefully pointed out the real estate office where she worked.

By now we were close to Patrick's home, and following his directions, I found myself driving through the entrance of a trailer park. Yes, Patrick Kearney's world-class erotomane's library was housed in a single-wide trailer. It occurred to me for a second that perhaps he kept his collection here while he lived grandly elsewhere. But no, unless he was far more devious than I gave him credit for, this seemed to be home. I suppose if Patrick had shown any signs of embarrassment or sadness at his reduced circumstances, then I'd have felt the same, but he was in far better spirits about his situation than you could imagine anyone being.

I've visited relatively few trailer parks in my life, but this seemed like a pretty good one. It was very clean, neat, and orderly, and although I suppose nobody lives in a trailer park if they're well-off, there was no sense of poverty about this one. Inside Patrick's trailer there was fake wood, gray carpet, and not much light, but that's no bad thing for a book collection. I also noticed there was a Viagra promotional clock on the kitchen wall—a present from his ex-sister-in-law, he said, who is in the medical profession.

California is a big and diverse place, where you can find all manner of strange things, so I hesitate to say that Patrick Kearney is the only man in the Golden State who lives in a single-wide trailer with a complete set of every book ever published by the Paris Olympia Press, but if there's another I'd certainly like to meet him. And so would Patrick, I'm sure. In fact you might argue (though not for long and pretty fruitlessly) about whether or not it was an absolutely com-

plete collection. Patrick certainly has every Olympia Press title, every first edition, and although he's missing a few fourth and fifth printings, he has most of the subsequent editions, too. The collection is subdivided into various imprints—the Traveller's Companion, the Ophelia Press, Ophir Books, Othello Books, the Atlantic Library.

Displaying such a collection would be a problem for anyone; it runs into hundreds of books, most of them looking very much the same, in their anonymous, understated, elegant green covers. But Patrick had not solved, indeed had not addressed, the display problem. His Olympia Press books lived in neatly labeled, more or less identical cardboard boxes in the built-in wardrobe in the spare room where he did his ironing. The boxes were stacked on top of one another, and the contents were therefore largely inaccessible, but I knew that packed in there must be prized first editions of *Lolita* and *Naked Lunch, The Story of the Eye* and *The Story of O.* It could easily cost you $25,000 to acquire just those four titles. To amass a complete collection could certainly cost you as much as any number of new trailers.

In fact I did see Patrick's copy of *Lolita,* a two-volume set, kept snug in a little library box he'd had specially made. And I also saw *Quiet Days in Clichy,* part of a small, separate Henry Miller collection, given to him by a former girlfriend, Janet Ellis, who lived in Golders Green. (Her father had a complete collection of Jack London first UK editions that he kept, for some reason, in the linen closet.) *The Air-Conditioned Nightmare* contained an inscription, partly written in shorthand, that Patrick said he'd never been able to decode.

He began to show me more of his collection, taking books from shelves and out of glass-fronted bookcases, and opening up more of the trailer's built-in cupboards. He said the books were mostly unillustrated because he couldn't afford the high prices you had to pay for illustrated books, but this proved not to be absolutely true. I was knocked out by a book called *Pibrac* by Pierre Louÿs, published in Paris in about 1935, with gorgeous rich watercolor illustrations by

Marcel Stobbaerts, sexy and humorous at the same time, often featuring wild coupling in the foreground while a bunch of old codgers looked on.

Patrick also showed me a few items that had previously belonged to Gershon Legman. The most intriguing of these, and I confess I'm relying on Patrick's catalog here rather than my own memory, is a book by Laurent Tailhade called *Poésies érotiques*. It contained a note from Legman about a reprint of the work, describing it as being identical to the first edition "save for p. 1 on which the letter 'f' in 'Chateau d'if' is *not* broken as it is in the first edition." Will it surprise you to learn that Legman once wrote something called *The Passionate Pedant*?

Patrick and Legman had been good friends, and Patrick had recently bought these books from Legman's widow, Judith. I find it hard to imagine exactly how relationships go between erotic bibliographers, but Patrick did remember a moment of coolness between himself and Legman, admittedly the only one in a long association, after he'd pointed out a bibliographical error Legman made relating to *The Whippingham Papers*. Legman reacted by demanding to know just why Patrick was so interested in *The Whippingham Papers* anyway; was he a pervert or what? This struck me as a low blow from one erotic bibliographer to another. If they started accusing each other of being perverts then the whole house of cards would fall down.

Patrick and I certainly did our best to avoid appearing perverted. There was a good deal from him along the lines of "I think you'll find this is a handsome volume," and a good deal from me along the lines of "Oh yes, that's very fine indeed." But let's not pretend it was all entirely high-minded. He also had some early copies of *Color Climax,* the garishly colored and (whatever your standards) entirely pornographic sex magazine. It's still in production today, but these copies were from the very early seventies. I opened one at random and saw a photograph of a couple having fairly standard pornographic sex, but the man, who otherwise might have passed for a bank manager, was

heavily tattooed in the area that a pair of underpants would have covered, had he been wearing any. The tattooing went all over his penis, including its exposed head. Patrick and I winced in sympathy and reluctant admiration.

"Hey," Patrick called to Julie, who was keeping out of the way, at least as much as you can in a single-wide trailer. "Do you want to see a man with a tattooed dick?" It turned out she didn't, and at one point she muttered, in a scolding yet affectionate way, "Ah, little boys and their dirty books."

I found myself saying, "Well, all they want is a little girl to share them with."

"That's very rare in my experience," Patrick said. "Very rare."

Finally I asked him, as I'd asked other collectors, what single item he'd try to save in the event of a fire, and he thought about it for just a second before saying he probably wouldn't try to save anything. He'd just throw himself into the flames instead.

<div align="center">7</div>

EX LIBRIS AND AN EX-ACTRESS

The commissioner and the commissioned.

I'm sitting in the study of a solid, four-square, light-filled house near Carlisle, in the north of England, handling a book that once belonged to Adolf Hitler. The book is entitled *Rasse und Heimat der Indogermanen* by Otto Reche, published in 1936, and it's full of puzzling photographs of skulls and skeletons, with diagrams and measurements superimposed over them. Naturally, I assume the book is espousing some eugenics theory, but given my lack of German, I can't be sure, and neither for that matter can the book's present owner, Gordon P. Smith, my latest sex collector, although I know he'd be uncomfortable with the term and there was nothing inherently sexual about his ownership of this book, nor anything remotely pro-Nazi, as he was very quick to tell me.

We knew the book had been Hitler's because it contained a bookplate, featuring his name, a swastika, an eagle, and an oak sprig. There were also six small pencil annotations here and there throughout the book, and although neither Gordon nor I could be absolutely certain that these were done by Hitler himself, we reckoned they probably

were, on the basis that the presence of the bookplate suggested the book had come from Hitler's personal library, and by 1936 surely nobody would have been stupid enough to borrow a book from the Führer and then doodle in it.

The bookplate design also appeared to contain a remarkable and presumably unconscious Hitlerian giveaway. On the bookplate a single acorn dangled from the oak sprig; highly significant, given the popular understanding of Hitler's testicular arrangement. However, there was apparently a variant of this bookplate, and Gordon P. Smith, being a scholar of these matters, had made a photocopy of the variant and tucked it into the book. In this second bookplate the oak sprig had two dangling acorns rather than one. Too little too late, you'd have to say, and perhaps an indication that bookplates may have a sexual significance not immediately obvious to their original owners, although Gordon assured me that historians had considered the possibility that the bookplate designer had intended a deliberate (and no doubt suicidal) insult, and concluded that it was unlikely.

Gordon P. Smith is one of Britain's most enthusiastic and active collectors of bookplates, or "ex libris" as bookplate collectors prefer to call them. I've been surprised to find how many people have no idea what a bookplate is. For their benefit, then, suffice it to say that a bookplate is essentially a label stuck inside a book indicating who owns it. They originated in fifteenth-century Germany, at a time when books were rare and valuable and, in their printed form at least, newfangled. A bookplate denoted wealth, prestige, connoisseurship. It was also a way of identifying a book if someone "borrowed" it, although not all that difficult to remove if the borrower had criminal intentions.

There are some doubts about what was the first bookplate, but if you were to say it was the hand-colored woodcut belonging to a Cis-

tercian monk called Hilderbrand Brandenberg, few would argue with you. This plate dates from 1470–80 and shows an angel holding the coat of arms of the Brandenberg family. Gordon owns one of these plates, but it was on loan to an exhibition in Germany when I visited him, so I didn't get to see it. This was a great shame. It isn't every day you get to see up close, and possibly even handle, a piece of paper from the fifteenth century.

The truth, however, is that quite a lot of bookplates are really not all that interesting to the uninitiated viewer. Like the Brandenberg plate itself, all too many of them are what are called "armorials," pieces of heraldry, displaying crests and coats of arms from families, libraries, and institutions. I know that some people are fascinated by heraldry, but even Gordon, who has infinitely more time for it than I do, sees there are other, more compelling aspects to bookplate collecting.

For my money, it's only when bookplates are designed by artists that they really get interesting, and some great artists have indeed designed them. Lucas Cranach, for instance, designed one in about 1530 that shows the Crucifixion. Gordon has one of those. Eric Gill, Jean Cocteau, Kate Greenaway, Franz von Bayros, Aubrey Beardsley, Felicien Rops, René Lalique, Arthur Rackham, William Morris, and Edward Burne-Jones all designed bookplates, and Gordon owns at least one example by each of them. In the case of von Bayros he owns a whole album full. As that list of names suggests, only some of these bookplates could be construed as erotic, and inevitably those were the ones I was interested in on this occasion.

Gordon was very keen that I shouldn't misrepresent him as some-one solely interested in sex. As he himself said, "The main thing really that I would like to emphasize is that the erotic prints and books that I have, and the books are very interesting to me because of the beau-tiful artwork in them, are, whilst being very important and a subject that I love very much indeed, representative of only a small part of my

collection. My collection is not large. To some people it would seem large, it's about sixteen thousand artworks, and the majority are book-plates, of which only fifteen percent are erotic."

That's how Gordon talks. To be fair, he knew I was taping our conversation and that I intended to quote him, which can make any-one's speech a bit stilted, but he spoke pretty much like that all the time. For example, he left me an urgent-sounding phone message the day before I set off to see him. There was something I really ought to know before I made the long journey and visited his house, he said. I was fearing snarling dogs, initiation rites, a mad relative chained in the cellar. In fact he had simply called to warn me that he and his wife kept a no-smoking household. I thought I could deal with that.

So, I think Gordon would want me to report that although he's a sex collector, he's not *only* a sex collector, and I'm more than happy to do that. In fact he's not only a bookplate collector. He collects prints, engravings, and original artworks, too, what are known to ex libris collectors as "free graphics." In his time he's also collected guns, wine, stamps, and silver. On the other hand, anyone with 2,400 erotic art-works (that's 15 percent of 16,000) in their house is a sex collector as far as I'm concerned, and therefore well worthy of attention.

In fact Gordon also admitted there was some crossover, perhaps even some ambiguity, between the sexual and nonsexual items in his collection. The Hitler bookplate, for instance, was part of his subcol-lection of ex libris belonging to the famous and infamous, the likes of Charles Dickens, Thomas Carlyle, the Queen, Edgar Allan Poe, Albert Einstein, and so on. The Queen certainly doesn't go in for smut, but the Edgar Allan Poe bookplate, for instance, shows a naked woman, a cat, and a skeleton. I thought it was wonderful. But did the mere presence of a nude woman in a bookplate define it as a piece of erotica?

"It depends upon what you call erotic," Gordon said. "What some people call erotic other people don't think of as being erotic at all, even though it's got a nude in it. So lots of collectors on the Conti-

nent wouldn't say they collect erotic work but they do have erotic work by my definition of erotic."

Making initial contact with Gordon had been easy enough, and we'd had a couple of longish telephone conversations before we met. On the one hand he was clearly happy to talk to me. In fact he said he was probably the only collector of erotic bookplates in England who'd be prepared to talk to me at all, though I didn't test out this thesis. On the other hand he seemed to fear that I might be trying to make fun of him in some way. He said he had no time for those who were flippant, salacious, or hypocritical. I reckoned I was only occasionally the first of these, and I did my best to reassure him of my high seriousness. He then said he would want to see what I'd written about him before the book was published. I replied that as a courtesy I was prepared to do this, but that I couldn't guarantee to change what I'd written just to suit him if he didn't like it. I wondered if this was going to be a deal breaker.

By the time of our next phone call he'd spoken to a lawyer friend of his, a Queen's Counsel, and it seemed he'd contemplated drawing up a legal document for me to sign. The lawyer had advised against this as a waste of time and money. I was very relieved. Gordon had also, he said, done some research, spoken to one or two people about me, and the general opinion, he reported, was that I was sound. I naturally shared this opinion, though I couldn't imagine who these people were who'd vouched for me. On this basis I was invited to Gordon's home to see his collection.

I, in turn, had done some research of my own. Gordon P. Smith crops up on the Internet as honorary membership secretary of the Bookplate Society, a post from which he's now resigned. He is also a donor of books to the Malbork Castle Museum in Poland. But more than that, I'd also talked to some other collectors about the ex libris crowd, and the received wisdom was that they were a rum lot. They

were like stamp collectors, I was told. I didn't see how that was much of an insult coming from one group of collectors to another, but it was certainly intended as such. Worse, some said bookplate collectors weren't really collectors at all. Why not? Because they made their own bookplates, commissioned designers, had them printed up in tiny editions, and then swapped them with one another at meetings. Where was the sport in that? Another part of the argument ran that the things these people collected weren't even bookplates in the true sense of the word. A real bookplate had to go in a book. These guys kept their bookplates in files and albums or had them framed and put on the wall.

I could see how you might object to some of this and consider it cheating. And yes, I could see that an item that wasn't used for its intended purpose was a bit artificial, like those stamps from unlikely islands showing Marilyn Monroe or Elvis Presley that never get put in the post. But none of this really mattered very much to me. Since I was committed to an interest in sex collecting per se, notions of collecting purity were neither here nor there. It might also be said that given the extreme explicitness of some erotic bookplates, they're probably more at home in an album than in a book, even an erotic book.

And so I made my trip to Carlisle, with a set of exhaustingly thorough directions from Gordon on how to get there, but they were very good directions. I already suspected that Gordon lived in some style. I knew his background was in accounting and property management, and he'd done well enough out of it to take early retirement when he was in his midfifties. He was glad to be finished with work. He'd "had enough of dealing with pieces of paper," he said. Yes, he really said that. Retirement had come some fifteen years ago. Since then he'd increasingly devoted himself to his collecting. To live comfortably for fifteen years without working, while also putting together an extensive and expensive collection, suggested he was doing very nicely.

I knew he had to be in his seventies, although when he greeted me at the door of his large, redbrick, vaguely Art Deco house, he looked much younger than that. He was largely bald but his hair wasn't white. He had a saggy, benign jawline, but there was nothing decrepit about him. He had a slight limp, though I probably wouldn't have noticed if he hadn't pointed it out and apologized for it.

Again I tried to assure him that I was free of flippancy, salaciousness, and hypocrisy and he seemed to accept that. Indeed he was now surprisingly casual about the whole business. "Luckily I'm seventy-two years of age," he said, "and I no longer have concerns about how people may view me. Nobody is in a position to blackmail me and therefore I am perfectly happy to be frank with people who are interested in the subject." The notion that a man might be blackmailed for his bookplate collection was a startling one, but perhaps Gordon was old enough to remember a time when such things were more likely.

Our telephone conversations had led me to expect that Gordon would be a careful, fastidious man, perhaps a bit pedantic, and I wasn't wrong about that. What I wasn't prepared for was his enormous generosity. Straightaway he said he was going to give me some things that would help me understand the nature of his collection, and in the course of the day I was regularly delighted and sometimes overwhelmed to receive a number of bookplates and small pieces of art. True, none of them was unique or fabulously valuable, and all of them were parts of small editions he'd had made, but he had absolutely no obligation to give me anything at all, and I appreciated it greatly. And if I'd been the grasping sort, a pack rat, a hoarder, an obsessive collector, I could certainly have taken advantage and persuaded him to give me a good deal more than he did.

We began by going into his study, a place filled with books and art. The books were a mixed bag. In one bookcase were hardback novels by Frederick Forsyth, Harold Robbins, Wilbur Smith, which didn't seem especially promising, but in another bookcase were big leather-

clad volumes, quite a few by John Buckland Wright, and some published by the Erotic Print Society, many of which Gordon had had specially re-bound by local bookbinders. One I saw was embossed with his own design, a line drawing based on Courbet's *The Origin of the World*.

On the walls were works by artists with whom I was almost entirely unfamiliar, though by the end of the day I would come to feel I knew some of them quite well. The study also contained a lot, but by no means all, of Gordon's sixteen thousand bookplates. They were kept in specially made albums, lots of them, much like photo albums, with black pages, tissue-paper interleavings, one bookplate glued to each leaf, the whole album then contained in a slipcase.

Gordon was well prepared for my visit. He handed me a list of all the bookplates he'd commissioned, a list of the major artists whose work he owned, and a piece of paper with a quotation from Franz von Bayros, which read, "I have always sought out beauty and have attempted to find it in situations which cannot be mentioned in prudish circles—but which prudish hearts cannot do without. I repeat what I shall say on the day of my next trial; I have never served anything other than beauty, that divine beauty that I discern in the least of all mortal creation, that I worship in all its personifications, especially in man. And, dear ladies and gentlemen who may chance to read these lines, that man as I see him is that cultured creature who cannot be endangered by gazing at a 'shameless picture' or reading an erotic book."

There was quite a bit more along these lines. The words actually come from von Bayros's essay "On My Morality." The passage ends with the words "I say that a man eating with his knife or mashing up his food on the plate is far more offensive to my sensibilities than the offence they claim is caused by looking at my pictures."

I can only imagine what a conversation between Gordon and Franz von Bayros might be like; wordy no doubt, and evidently much concerned with beauty. Reading this passage, I had the first indication

that Gordon would spend considerable amounts of time discussing beauty, or possibly Beauty. He said his favorite kind of art was Art Nouveau. "It's a period of beautiful, beautiful art and also exemplifying women, or 'Woman,' as I prefer to call it."

I ran my eye down the list of artists he'd commissioned to make bookplates for him. I knew only a couple of the names, and those not very well. This was not a great surprise. Artists who are quite big wheels in the bookplate universe can remain more or less unknown outside it. So I think it's forgivable that I wasn't familiar with Jelena Kisseljowa, Konstantin Kalynovych, Peter Velikov, Vasyl Fenchak, et al. These are not exactly household names, unless your household is Gordon P. Smith's.

I asked how he found his artists, and the answer was at meetings of bookplate collectors. "Last year I went to about eight or ten meetings. I was away for a week each time as well. All over Europe. One year I went twice to Belgium, once to Poland, the Czech Republic, once to Germany, once to France, once to Italy. I did travel a lot." And do the artists actually turn up at these meetings? "They do if they want to get commissioned."

Bookplate collecting, like stamp collecting, is often, necessarily, thematic. The number of examples in existence is so vast that any kind of general or indiscriminate collecting would be just meaningless. So bookplate collectors go for chess or wine, owls or Vanitas, and so on. Eroticism is a theme in itself, but for Gordon it breaks down even further, into various subthemes that appeal to him: the Three Graces, the Judgment of Paris, dueling. The process of commissioning, he said, could be a hit-and-miss affair; you selected your artists, briefed them, and then you had to sit back and wait. He admitted there had been disappointments, but asked me not to name names.

I wasn't sure if I was going to challenge Gordon about the extent to which a bookplate ought to live inside a book, but he brought it up himself. "The purists would say that an ex libris is first and foremost to go into books," he said, "and discount and even criticize any other

motive for having an ex libris, but I don't have it for that reason at all. Mainly I have them because I like the artwork and it is an affordable way of collecting fine art, because you can order an edition of maybe forty, fifty, sixty, a hundred sometimes, those are the kind of number people have. I have known one to be two hundred, but then they assume a lesser importance to collectors. They don't like things that are done in huge editions, they don't seem to hold the same fascination. That doesn't apply to me because all I'm interested in is the imagery and it has to satisfy my own criteria of beauty, and beauty for me, I think, is a very important thing, not just in Woman, which is what we will be discussing later, but also in everything else in life. Beauty I love. I cannot bear, I don't wish to even look at, things either in life or nature or anything else which is ugly. People will say that's tunnel vision but I'm not concerned with other people's views in that way." I nodded.

There was one name on the list of bookplates that I'd come across while reading around the subject, and that was Mark Severin. He was born in Belgium in 1906 and had a very successful career as a mainstream graphic artist, mostly as an engraver. He did posters for Imperial Airways and British Railways, designed postage stamps, illustrated books such as *Women in Detail* and *Eve's Moods Unveiled* for the Golden Cockerell Press. He also designed five hundred or so bookplates in his life, many of them erotic.

"Mark Severin, I think, is the finest artist of modern years to draw the female nude," Gordon said, and he showed me some examples. Suffice it to say I don't entirely share Gordon's high opinion of Severin, but so what? My opinion didn't matter to Gordon, and Gordon's enthusiasm was all that mattered to me.

Across the bottom of one of Severin's bookplates are the words "Woman, nature's highest achievement." "That quotation exemplifies my feelings about Woman," said Gordon. "I think that's just a lovely sentiment. Throughout history women have been really put down and quite often they've never been shown respect and I feel the

exact opposite. I think that women can be the most glorious creations." Only a fool would have disagreed.

Mark Severin died in 1987, and Gordon didn't start commissioning bookplates until 1991; nevertheless, on Gordon's list there were five bookplates attributed to Severin, with titles like *Eyes, Indian Love Poem, Young Girl Seated*. Yes, some bookplates have titles. So these were all, so to speak, posthumous commissions, and had involved Gordon getting in touch with the Severin family, obtaining the extant printing plates, and then adding "Ex Libris Gordon P. Smith" to them. This, as much as anything, shows his energy and dedication, and maybe obsession, as a collector. He said that nobody in England commissioned bookplates in such numbers or "so lovingly" as he did, and I believe him. Enthusiasm is not exactly rare in collectors, and lust is common enough, but love, that's something different altogether. And I think Gordon had it.

At the time I met him, he'd commissioned 160 or so bookplates by about forty different artists—I'm sure it's more by now. Some were just single, one-off commissions, but as I looked down the list, certain names inevitably recurred. Three who caught my eye, from whom he'd obviously commissioned in quantity, were all women: Elly De Koster, Patricia Nik-Dad, and Lynn Paula Russell, this last being the only person on the list, apart from Severin, whom I'd actually heard of. She was responsible for seven bookplates and also for another thirty or so works in a series called *Modern Love Poems,* illustrations to the *Kamasutra,* an idea and a title that she shares with Severin. There was also a lot of framed artwork by De Koster, Nik-Dad, and Russell all around the house. At my prompting Gordon said there was no particular significance to the fact that he'd commissioned so many bookplates from female artists, but I didn't quite believe him. Frankly, in his position I think I'd do the same. I'd much rather have my custom-made erotica created by women than by men. What heterosexual man wouldn't?

He became quite animated about Lynn Paula Russell, for instance.

Bookplate by Lynn Paula Russell, illustrating an autobiographical
moment from Gordon P. Smith's life.

"She does the most wonderful work. Have you seen her female
nudes? They are beauty personified. Absolutely gorgeous they are.
And the funny thing is as a general rule she doesn't draw from mod-
els. She lies in front of a long mirror. She doesn't draw them as self-
portraits, but it's surprising how often you can recognize her face in
them." She had also, though I didn't hear this from Gordon, briefly
had a career as a porn actress, usually under the name Paula Mead-
ows. How much more titillating can you get?

At least a couple of the bookplates in Gordon's collection have an autobiographical significance for him. One of them, by Lynn Paula Russell, shows a girl sitting on the grass, knees and skirt raised with nothing on underneath, something Gordon saw when he was a very young man. "I was young, gauche, little more than a boy, and totally inexperienced. That was the most erotic sight I'd ever seen and to be honest it's a memory I'll never forget."

Another, by Frank-Ivo Van Damme, shows a couple having sex on a beach. "That is something that forms one of my fantasies. I've never, ever made love on a beach, not that I think I would want to, the sand would be most uncomfortable."

If this suggests a certain timidity in Gordon, he was more than brave enough to address some weighty issues, like "art versus pornography." I got the feeling he'd been rehearsing his statement for years.

"My idea of pornography is not going to be everybody else's idea of pornography," he said. "Some people will think it to be totally okay and other people not. Having said that, I myself don't object to the word *pornography* and just because I'm not concerned about the way other people will view what I am saying, I don't mind referring to or using that word for some of the artwork that I have collected. For me I prefer to use an expression which I only recently read from a Japanese artist who uses the term *heavily erotic,* and actually I think that's more descriptive and more accurate because pornography makes some people think that means even obscene items. Now, I like the erotic and the most important thing for me, if an item is to be deemed pornographic by some people, is that it might still be something I really like, appreciate, admire, and respect. That would be if it is beautiful. The most important thing for me in all erotic art is that it has to be beautiful. If it is not beautiful, then for me, yes, it's certainly pornographic, and unacceptable pornographic material, going right down to obscenity, all of that I find totally unacceptable. For me, if I find something which is truly erotic, it can be totally explicit so long as it is beautiful. That for me makes it not just acceptable, it gives me great pleasure."

Gordon had something of the showman about him, and like any showman he wanted to save the best till last, and perhaps also leave me wanting more, which he successfully did. Toward the end of the afternoon he produced a very large album, this one with the following words embossed on the front: "Beautiful Erotic Art By Contemporary Artists, Original Engravings, Etchings & Drawings, From the collection of Gordon P. Smith."

This was bigger than any domestic photo album, bigger than the other albums I'd seen containing bookplates, and it was absolutely bursting at the seams. It was a sort of scrapbook, a sort of greatest-hits collection, the things that Gordon P. Smith found most beautiful and most erotic, some of which he'd commissioned, some of which he'd obtained as swaps or purchased. Again the items were stuck in, one to each black page, with the titles and artists' names written underneath in white pencil.

"I've got too many in here," he said, with incorrigible delight, "nearly two hundred items. There are a few that are very raunchy indeed but they still follow my rule of beauty." Time was getting on and I knew I'd have to leave before too long, since I had a long drive home ahead of me. I had always known it was likely to be that way, it always is when you travel to see a collection, but in any case, as Gordon told me, "you'd need a week" to see it all properly.

And so for the rest of the afternoon Gordon showed me his favorite pieces of erotica, two hundred or so works of, in every sense of the word, graphic art. As I turned the pages of the big album and looked, Gordon continued to deliver commentary, observation, and his own brand of insight.

"I do think that beauty is an important aspect when it comes to erotic art," he said, "and I also believe it demands the highest of artistic ability."

Some of the things in the album were certainly what you might call "tasteful," reclining nudes, women bathing, women fondling

cats, women in mythological scenes. But some of them were far more explicit, showing people having sex in larger or smaller numbers, in more or less ornate combinations, and some of these were just plain dirty. Here were depictions of couple sex, threesome sex, group sex, with lots of lesbianism, including a depiction of two nuns exploring the penetrative possibilities of a crucifix. Another bookplate that particularly sticks in my mind was made for someone called Gerd Kaelhert, and it shows one woman licking and fingering another woman's pussy. It was a dense, complex image, all painted nails and labial folds, complicated further by genital and nasal piercings, with rings and chains, one chain connecting the licker's nose ring to the ring through the lickee's clitoral hood.

"I don't usually like to see a plate with, funny enough, with a penis in it," Gordon said. "It doesn't hold any interest for me."

If that was really true then there must have been quite a lot in the collection that didn't hold his interest. The album contained penises galore, mostly huge, and all of them were being thoroughly appreciated by women. One memorable one showed a facial close-up of a Gypsyish-looking woman embracing two penises with hands and mouth, and a couple of fantasy images showed women gamely hanging on to penises that were literally as big as themselves.

Some of the art was great. The work by Patricia Nik-Dad had charm, sensuality, and playfulness without ever being remotely dirty. There were some wonderful retro-ish nudes by an artist called Paul Emil Necat. And I was knocked out, and still am, by a bookplate that shows two naked women fencing. Well, I say they're naked, in fact they have on stockings and shoes, but these obviously wouldn't be much protection from a rapier. The bodies are just slightly exaggerated, muscular, a bit superheroine-ish, but they're anatomically possible and the women have convincing, big-eyed facial expressions. Of all the many things Gordon offered me that day, this was the one I really, really wanted, and I got it, and I felt really good about that, and

I continue to feel that way. The artist is Peter Velikov, a Bulgarian. The plate's called *Une Affaire d'honneur* and my copy is number 46 of an edition of 60. I have it here framed next to my desk. I love it. Thanks, Gordon.

Just before I left the house I chatted briefly with Gordon's wife, Iris, an amused and amusing woman, somewhat younger than Gordon, I'd have guessed. She'd stayed out of the way for most of the day, had even gone out for a couple of hours to watch a Johnny Depp movie. She treated her husband's collection the way I think most women treat most men's hobbies. She didn't quite understand it, but then she didn't need to. She was indulgent and accepting. "My wife has seen everything in my collection. She wouldn't always say it was what she would choose, but she's not shocked by any of it." said Gordon.

I remembered a picture on the wall of the study that Gordon had pointed out to me at the beginning of the day. It was by Frank Martin, the artist who designed Gordon's first six commissioned bookplates, and it showed a naked young woman on a chair, sitting cross-legged, leaning back, arms raised above her head. Although it wasn't a portrait of Gordon's wife, he assured me it could certainly have passed for one. He'd seen it many years ago in Martin's studio and developed the urge to have it.

"Iris actually bought it for my birthday, and we joke about it, that I kept her short of money when we first married and she had to do modeling."

I asked whether Iris recognized herself in the picture.

"She's very much a realist and she thinks that is a romanticized memory of mine of her, but in fact that is very accurate."

At moments like that it seemed to me that Gordon P. Smith was actually quite a clever and wise man in all the important ways. His life contained romance and good memories, an absorbing collection, and a wife who was more than tolerant. Does it ever get any better than

that? He sees himself as a patron of the arts, and if he's not exactly a Guggenheim, there are nevertheless a number of artists who have a lot to thank him for.

I asked him if he had any plans for what should happen to his collection after his death.

"That is one of the most difficult questions," he said. "I think the safest answer is to say to you I've still not been able to think of the ideal place to put it. I don't want to see the collection sold because I think it would be very difficult to put together my existing collection again."

He was, however, clear about one posthumous arrangement. "The statement to go on my tomb, it would be, 'In search of beauty,' " he said.

Given Gordon P. Smith's enthusiasm for Lynn Paula Russell and her work, I decided I should find out more about her. It turns out she's best known as an "S&M artist," which I know is a term that begs a lot of questions. When she isn't making bookplates for Gordon she's illustrating sex guides and spanking magazines, and drawing comic strips with titles like *The Exploits of Mitzi* and *Sophisticated Ladies*. She also edited *Februs* magazine, "bringing her own slant to the world of punitive and erotic corporal punishment," and collections of her drawings have been published by the Erotic Print Society: titles include *Painful Pleasures* and *A Sexual Odyssey*. You get the idea: lots of spanking (both straight and lesbian), beatings with whips and canes and hairbrushes, scenes in which young, good-looking women are treated to rough sex by groups of grubby-looking men. And again, often in these pictures, one of the female characters will have a face very much like the artist's own.

And the funny thing was that every time I saw that face in those self-portraits I increasingly had the feeling that I knew her from somewhere. I didn't know where and I thought that maybe our paths

had crossed at some party or other in London, but I asked around and nobody could make the connection.

I decided to get in touch with her because I wanted to ask what it was like for an artist to be collected the way Gordon P. Smith collected her. We communicated only by e-mail but she came over as warm, smart, and good-humored, and she gave some great answers.

"I have had only one other major collector of my work, apart from Gordon, so I can't speak in general," she said, before speaking in what sounded very much like general, "but most collectors of erotic art have a particular interest which they pursue. Artists can find themselves creating work that they think will please the collector, and this can gently push them in a direction that isn't necessarily their own. Sometimes, of course, it can result in the artist discovering new directions. Both these things have happened to me. The ideal collector is the one who just happens to love the artist's vision of the world."

I asked her why her own face appeared so often in her work.

"My work is deeply personal," she replied in her e-mail. "I always felt that visualizing and drawing something was a way of assimilating the experience I was having. Some of the symbols in the paintings might occasionally contain insights into future developments or psychological circumstances in myself. An idea for a drawing or painting would sometimes come out of the blue and depict something that was pure fantasy, but embodied the emotional tone that I was searching for. Sometimes it is an unconscious process. Sex is a powerful drive in our lives and my art is a way of looking at it as a drama between people, observing what is going on in a relationship. Yes, some of the drawings show things I have actually done, and I do use myself as the model, partly because I have myself to work from and that is convenient, and partly because I am telling my own story so naturally I put myself in the picture. I have to admit, too, that I have a tendency towards being an exhibitionist!"

From this, and from other sources (such as an online interview in which she tells a story, presented as true, about an evening in Paris, in

an apartment filled with the works of de Sade, in which her master used his soft leather martinet on her: "One moment it caressed me as if I were fragile glass, the next it cut across the rump and I reared like an excited pony!") I gathered that her life and her art weren't entirely separate, so I thought she might have something to say about the collecting of experience as well as of art. She did.

"There are people who collect experiences," she said, "and always want to add to it and notch up more. It doesn't necessarily follow, though, that the collectors of objects accumulate their possessions as a substitute for experience, although there may be those that do. There are those who do neither and there are those who collect both experience and possessions. At any rate, sexual experience can't really be collected: once it has [happened] it remains only as a memory, becoming dimmer as the time passes and subject to rewriting in retrospect. This is why the collector of experiences must surround himself with visual memory joggers to keep this sort of collection intact; albums of photos of past lovers and various objects they associate with each episode. On the other hand, the collector of objects can overrule the time factor by keeping his collection always pristine and preserved, as it was when he acquired it."

This was as smart as anything anybody has ever said to me about the nature of sexuality and collecting. I was pleased and grateful. And naturally I couldn't pass up the chance to ask her about her career as a porn actress. I wondered for example if anybody collected her films.

"I have no idea how widely the videos were or are collected. I made them for my own reasons, and having taken a few steps into that world, I retired from it to get on with my illustrating once more. I don't own any of these films and have no interest in seeing them now because they belong to a past era when I had different needs. I mainly enjoyed those colorful experiences but my attitude has changed now because I have grown and (hopefully) matured. Come to think of it, there could be people collecting these videos because my appearances were probably unusual and relatively rare; at the time

there weren't many English girls with rather 'proper' accents doing this sort of thing. The whole thing makes me smile now."

And then suddenly it clicked. I knew where I'd seen her before: on-screen in a porn movie, a slightly preposterous one, set against a background of the fashion industry, with lots of putting on and taking off of dresses, and although the star was Nina Hartley, you did indeed notice the Englishwoman with the posh voice who looked a little out of place but was nevertheless incredibly up for it. And the reason I'd seen it was that my girlfriend used to own the video, had it as part of her collection. I subsequently searched and searched through cupboards and boxes, but I couldn't find the damn thing. It must have gone into the reject pile when we moved house: another reason never to throw anything away.

Since then, without by any means becoming a collector, I've looked into the porn career of Lynn Paula Russell, aka Paula Meadows. Some of the films she made were fetish, such as *You'll Love the Feeling* or *Happy Birthday* (both spanking), but some of them were quite mainstream—titles like *New York Vice, Good Girl/Bad Girl,* or *Sexually Altered States.* The movie I'd seen was called *Fashion Fantasies.*

Online I found an interview with her, in which she sounded very sane about it all, not at all regretful but not exactly nostalgic, either. And once again she said something I thought was very smart. "Some things are obscene," she said. "It doesn't mean you mustn't do them."

That would have been a perfectly good last word but then I got a letter from Gordon containing a document, a single sheet of paper, an essay or an extract with the title "On the Psychology of Collecting," written by one Wolfgang Müller-Thalheim, a name I'd never heard of at the time. The piece said that bookplates were a marriage between the commissioner and the "artist's sensitivity and creative faculties" and that no other art form allowed the two of them a better opportunity for "self-expression, self-projection and a striving for the ideal." This seemed a bit much, but there were other things that seemed far less excessive. Müller-Thalheim said that collecting wasn't a hobby

but an essential component of being, that collectors were caretakers of the culture, and that he who does not collect, scatters his heritage to the winds.

I can see that a lot of people would think this was an exaggeration, almost a form of boasting and self-aggrandizement. However, by then I'd reached a point in my research, and had met enough collectors, where I thought it sounded not only perfectly reasonable but completely and utterly true.

NEW YORK BOYS AND GIRLS

Connoisseurs, trade, sanity, and order.

Sex doesn't feel the way it looks.

—Ralph Gibson

I'm sitting with the photographer Richard Kern on the couch in my house in Los Angeles, trying to interview him for this book, to discuss the extent to which he is a collector, and the extent to which he is collected. It seems a fruitful area, but perhaps I know Richard a little too well for either of us to treat the occasion with quite the seriousness it deserves.

Suddenly Richard says, "Man, this is so gay."

"What is?" I ask.

"You know, two guys sitting together on a couch."

Given some of the photographs in Richard's portfolio—portraits with titles likes *Bruce La Bruce with His Hands on His Hips, Jake Sitting on a Bed, Lyle Sucks His Toe*—I can think of many gayer things than this, and Richard evidently had no trouble dealing with them. But perhaps that was art rather than life. In any case, it seems very telling.

It suggests that Richard Kern isn't quite the bad-boy polymorphous metrosexual that his work might make you think he is.

So he gets up from the couch and takes a few photographs of the house, then says that these will be the only nonsexual images in his camera. He's been in L.A. shooting naked girls and having what he calls "adventures." And he says that if I'm thinking about buying a digital camera, I should definitely get one like his, with a swivel viewing screen, because that makes it so much easier to hold the camera at arm's length and compose a shot when you want to photograph a woman giving you a blow job.

A part of me would be intrigued to see the images stored in Richard's camera, but I'm reluctant to ask because it seems to me that one guy showing another guy the pictures he's taken of naked girls, one or more of them possibly giving him a blow job . . . well, that would be REALLY gay.

I first became aware of Richard Kern's work in the early 1990s. Back then it was perceived as "fetish photography," which is one of those terms that don't mean much to begin with, and lose their meaning entirely after you repeat them a few times. Still, I think we all know what we mean by it: images that tend to be all about the props—shoes, bondage gear, ropes, latex, rubber and leather, corsets, clamps, piercings, tattoos, and so on. A lot of the more recent stuff strikes me as incredibly weary and formulaic, but as a style it's proved to have a surprisingly enduring appeal. Richard, fortunately, has moved on.

Even back in the nineties his photographs never quite fit the fetish mold. The girls in them always looked more individual than the form allowed. Their bodies were great but flawed. There'd be high heels and bondage, but there was also a certain amount of imperfection, deliberate it seemed to me: chipped nail varnish and smudgy mascara that a more orthodox fetish photographer would have touched up and made more generic. It seemed that in Kern's work neither pho-

Richard Kern in his New York studio, holding a Terry
Richardson photograph from his collection of swaps.

tographer nor models were quite playing the game, and they looked
as though they were playing at something rather more interesting.

One of Kern's major contributions to the fetish genre was having
girls stick lighted candles into their three main sexual orifices. This
seems at best a subversively incorrect imagery, and I suppose there-
fore a subversively incorrect activity. I remember seeing these photo-

graphs in a commercially produced book, in a perfectly mainstream bookstore in London, and thinking to myself, with a thrill of shock, "Wow, so you can show that stuff in a book these days." Kern says that once these images were extant every model he ever worked with said to him enthusiastically, "So, are you going to put a lit candle in my ass?" Sometimes he didn't.

Having your images between book covers is one way to confer status on them. Richard recalled that when he was young and impressionable he saw books by David Hamilton, the photographer of unspeakably lame soft-focus nudes of girls who look prepubescent though for all I know may not be, and although Richard knew there was something dubious about those images, he thought they must be all right because there they were in a book.

Richard Kern's *New York Girls,* which remains my favorite of his books, contains a Q&A interview, more of a conversation really, between Kern and Kim Gordon, the singer and guitarist with Sonic Youth. Gordon says she has a fantasy of Kern selling his photographs to . . . and she hesitates about what to call them. "Perverts," Kern suggests, obviously keen to get that one in first. "Well," Gordon says, "fetish . . . connoisseurs."

It's not easy to gauge the tone of the interview, but this exchange seems to make Kern angry, I hope playfully so. The interview is taking place in Kim Gordon's home and Kern says, "Look, there's a big fucking fetish right here on your walls. You know, collecting hardback books." A short, rather low-powered discussion takes place about whether collecting books can be construed as a fetish. "Why collect records?" Kern says. "Why collect anything?"

"Well," says Kim Gordon, "anything can become a fetish, yeah, that's true."

Well, no it can't, except in the vaguest, sloppiest sense of the word. But the idea of the pervert or fetish connoisseur snapping up

Richard's work is an interesting one and begs the question "So who collects Richard Kern?"

According to Richard, at one end there are guys who see his work in magazines and write to him offering a few dollars if he'll send them a photograph of the girls they really like. Richard declines, not too politely, if I know Richard. And I suppose you could argue that in this case the guy is trying to "collect" the girl rather than the photograph, but not entirely since he obviously places more value on a "real" photograph than he does on one printed in a magazine.

At the other end are the "serious" collectors. I know of a coroner in New York who owns a Kern print, and among the famous, I know for example that John Waters and Baby Jane Holzer, the onetime Warhol Superstar, are both Kern owners.

Richard, however, seemed rather reluctant to accept that these people were sex collectors. "I don't think people are buying it as erotic art," he said. "I think they're buying it as portraits. I've met a few of the collectors and they seem to be buying it 'cause they like the image, not to wank off to. I hate to say it but I think they're buying the photos 'cause they think they're art. Have you wanked off to your shot by the way?"

Ah, "my shot." In the interests of full disclosure I should probably say that to a very limited extent, though to my great pleasure, I seem to be a collector of Richard Kern's work, though I'm a long way from being a completist. I own most of his books, some exhibition catalogs, and I have a large stash of magazines featuring his works. The magazines are a very diverse bunch: fashion, porn, music, fanzines. Whether any of these will ever prove to be valuable is a matter for debate. Vince Aletti, the photography critic of *The Village Voice,* reckons that before very long, as the demand for photographic collectibles grows, and once the truly desirable items have all been snapped up, people will start paying good money for magazines that contain work by name photographers. Since he's one of the more obsessive magazine collectors I've ever met, I can see why he would want to believe

this. More of Vince later. Richard did tell me that a friend of his had bought a copy of an old Kern fanzine called *Valium Addict* for fifteen dollars on eBay, which suggests the market has some way to go.

The pride of my Richard Kern collection is a large black-and-white limited-edition print called *Monica in Elevator,* a gorgeous, not quite comfortable image of a naked "New York girl"—skinny, pierced nipples, dirty feet—striking an angular, slightly contorted pose on the floor in the corner of a freight elevator. She looks tough but not hard-bitten, self-possessed yet vulnerable. There's something strong and vital about the image and the model, and it's a very sexual picture, but as far away as it could be from the conventional pinup or glamour shot. And as a matter of fact, no I haven't "wanked off" to it, but then I suppose I would say that, wouldn't I?

The best thing about owning this photograph is that it was given to me by Richard for services rendered. I wrote a short introduction for a book of his and got the print in exchange. It was a novel experience for a writer like me, but in the world of the visual arts this is apparently what painters and photographers do all the time. They trade work with one another, thereby creating collections without ever having to lay down any money.

I've talked to various artists about this, and it seems to be a surprisingly tricky business. Notions of value and worth, status and reputation, certainly enter the picture. You may think you're better than the person who wants to trade with you, or vice versa. Even if you regard yourselves as equals you may still think the other guy's trying to unload second-rate work while taking some of your best stuff. Richard Kern's own collection includes erotic work by other photographers such as Terry Richardson, Dave Naz, Eric Kroll, and Spenser Tunick. It also includes lots of nonerotic work, so I guess Richard isn't a sex collector any more than the people who collect Richard Kern.

———

Perhaps it's crass of me, but whenever I look at a photograph that involves sex, I can't stop myself speculating about the narrative behind it. How does this picture come to exist? Is it made for love or money, and to what extent are those things mutually exclusive? What's the relationship between the photographer and the model, or models? Is it a sexual one? Do they regard each other with lust or affection or professional indifference? And can I really tell any of these things just by looking at a photograph?

Well, right or wrong, I often think I can, and this detected or imagined narrative does affect my enjoyment of the photographs. If I think I'm looking at a piece of commercial, industrial pornography, then I know the narrative is a fairly banal one. This picture was taken as part of a financial transaction. If money hadn't changed hands, the photograph simply wouldn't exist.

Far more enjoyable are those images that seem to exist as part of a sexual experience, what A. D. Coleman has called "the photo-erotic": "the use of camera and film by consenting adults as an instrument of sexual play." And, of course, showing off the resulting photographs may also be part of the play.

Historically such photographs have been private and hidden, and the majority of them probably still are, but our ideas of decorum and the permissible have changed so much lately that dealers at entirely mainstream paper shows in California now sell them quite openly, which inevitably suggests the existence of collectors, and of course these private pictures can now be shown and shared digitally via the Internet.

A few years ago a book was published called *Naked Pictures of My Ex-Girlfriends,* which purported to be casual shots taken by photographer Mark Helfrich of his former squeezes. The pictures were intimate and benign, though there was perhaps something not quite right about having them all collected together in one book. How many women would want to be cataloged as just an ex-girlfriend? But

then it turned out they weren't his ex-girlfriends after all, just models, which I thought could have made it even better, a sort of conceptual sexual double bluff. But then Helfrich went and blew it all by saying that even though they weren't his real ex-girlfriends the pictures had the same emotional timbre, or some such nonsense.

I asked Richard Kern if some of the models in *New York Girls* were *his* ex-girlfriends. "Define *girlfriend*," he said. "Some were, and some were girls I hung out with, however briefly." And I asked whether he thought the intimacy between photographer and model showed in his photographs. His response was, I think you'd have to say, contradictory. "I don't know. I don't think it shows." And then, "I have photographed women who have just had sex and it's pretty obvious in the photos when you compare the shots to ones in which they're just 'modeling.' " So, I guess the answer is maybe, and of course ever since then I've been trying to work out which of his New York girls look authentically postcoital and which are just modeling.

Richard told me he used to be an avid collector of records, books, and especially of furniture. He had a particular enthusiasm for the French designer Jean Prouvé and traded some of his photographs for work by him. These days, however, his collecting is all done through the camera. "It's collecting people in some way," he said.

I spoke to him the day before he was due to shoot a Japanese model, and he was obviously excited about it in ways that he couldn't quite explain. It wasn't even as if the girl was especially attractive. "I've just got to get photographs of her," he said. "I *have* to experience the situation of photographing her." It seems to me there's a way in which photography is always a form of collecting. The photographer, even the most modest and unsophisticated one, collects images, collects light, collects evidence of places visited, and people and things seen. Using an image to prove that you had sex with some attractive people who let you photograph them naked strikes me as one of the more harmless uses to which photography can be put.

At some of his exhibitions, Walker Evans would show photo-

graphs, say, of a sign on an abandoned building, and then the sign itself would be there in the gallery. This strikes me as collecting of the most extraordinary and extreme sort, and raises a lot of questions for a photographer. Why wasn't it enough just to collect the image? Why did he need to collect the thing itself, too? A somewhat similar thing can happen at a Richard Kern exhibition. You'll be looking at a photograph on the wall that shows some nude model flossing her teeth or stanching a nosebleed, and then standing right next to you, very much alive, and very much dressed, will be the model herself.

Richard Kern is also the maker of various short films and videos, some of which are available on a DVD called *The Hardcore Collection*. I'm not sure that they really constitute a sex collection and very few of them are genuinely hard-core, but in the course of writing this book, just seeing the word *collection* in almost any context was enough to set my pulse racing. Basically Kern's work is experimental film, with some gore, some noirish elements, some very bad acting, and some great-looking women who take their clothes off rather more listlessly and infrequently than you might like, though they look spectacular when they do. The films have titles like *Fingered, The Bitches, Stray Dogs,* and *I Killed You First*.

These last two films feature the photographer, writer, and painter David Wojnarowicz, who was a buddy of Richard's, though it seems to have been a tricky relationship. When they went traveling together Wojnarowicz wanted them to share a bed, and Richard wouldn't. "I don't like sharing a bed with anybody I'm not fucking" was his explanation. Wojnarowicz was deeply offended.

Mention of Wojnarowicz brings us back to Vince Aletti. He knew Wojnarowicz and was a good friend of his partner, the photographer Peter Hujar. I first heard about Aletti from Karen Wright, the editor of *Modern Painters* magazine. She told me he worked for *The Village Voice,* was a journalist, art critic, and sometime exhibition curator, special-

izing in photography. He also happened to be gay, if not necessarily "so gay," and that seemed like it might bring some welcome diversity to my research. Karen said Vince "collected men" and was putting together a book to show off his collection. Without delving into the man's private life, about which I know next to nothing, I think it's fair to say that in this context at least, she meant that he collected *images* of men, mostly though not exclusively photographs. And, of course, we were talking about sexual images here, not some dignified, masculine, Karsh-like portraits of Churchill, Hemingway, and their ilk.

Karen said she'd been to Vince's apartment in New York, where she'd been confronted by a huge photograph of a tattooed man with a huge penis. It was obvious she'd found this off-putting, even intimidating, and I didn't think Karen was the kind of woman to be easily intimidated. I was intrigued.

When I spoke to him by phone, Vince had no trouble fessing up to being a collector, which was a welcome change from some of the hemming and hawing and denial I'd heard from others. But he thought his collection was more about desire than about sex, and he said that many of the pictures he owned were essentially portraits. Now, where had I heard that before?

All this sounded fine to me, but Vince still seemed a bit cagey about letting me see his collection. When I planned a trip to New York I wasn't sure that I'd get to see it at all, and I said I'd get in touch when I arrived, expecting to have to do further negotiating. However, when I called him, and suggested he might like to meet me first on neutral territory, he said, a bit snippily it seemed to me, "What would be the point of that?" I explained that I was just being polite and giving him the chance to look me over before letting me into his life. "Oh, it's too late for that," he said, which was not precisely a warm welcome, though it was good enough. He met me at the door to his East Village apartment. He was a gay man in his late fifties, plump cheeks, toothy, a gray mustache, hair that was receding yet plentiful. He seemed much more friendly in person than on the phone.

He was one of those blessed New Yorkers who live in rent-controlled apartments, with low rents—sometimes amazingly so—that can be raised only slightly each year. And like every other such apartment I'd ever been in, it was absolutely exploding with stuff. This, it seems, is what happens when you have a rent-controlled apartment: you know you're never going to be able to leave—you're getting too good a deal and if you ever go you'll never be able to afford to come back—and so you begin acquiring and accumulating, following your pack-rat instincts.

Vince's apartment, however, was very orderly indeed, which at least suggested that he was the type of collector who wants to be able to access the things he owns once in a while, rather than the type who simply takes pleasure in ownership. It was a form of decor I'd become familiar with: walls of books, glass-fronted bookcases, various cabinets and chests of drawers, piles of magazines arranged into skyscrapers at strategic points around the floor, and many, many pictures of men all over the place.

We sat down opposite each other at a table on which were various items from Vince's collection. It wasn't clear whether these were laid out for my benefit or whether they were simply his latest acquisitions. I suspect it was a bit of both. The first things to catch my eye were some digest-size physique magazines from the 1950s and 1960s. This seemed like a good place to start. They had titles like *Mars, Big, Vim, Vital, Strength and Health, The Grecian Guild Pictorial*. The men in these magazines look like bodybuilders or chunky athletes, greased, butch, trying to look classical. They're generally engaged in manly pursuits: archery, climbing ladders, playing the trumpet, pulling on ropes. Of course they look utterly camp, sometimes hilariously so. And none of them, from this era anyway, is showing any genitalia. The posing pouch is the garment of choice, though occasionally you'll find one in jeans and boots, or sailors' bell-bottoms.

Most of these magazines, Vince explained, were one-man operations, the product of a single photo studio. The same man performed

the functions of editor, publisher, and photographer. This meant that each magazine had its own particular, idiosyncratic style, and like many a collector, Vince became interested in the odder, more eccentric end of things, specifically a magazine called *Physique Pictorial* run by Bob Mizer, under the aegis of the Athletic Model Guild.

Vince described this as the "nuttiest" of the studios. Mizer seemed to have a sense of humor, Vince said, and he seemed to work incredibly hard, photographing hundreds, maybe thousands, of models. There was also quite a lot of writing in *Physique Pictorial,* in which Mizer revealed himself to be cranky and opinionated. This writing, usually printed in minute, obsessive text around the edges of the photographs, expressed his own eccentric worldview in mini-essays, sometimes just a hundred words long, with titles like "Do Pictures 'Speak for Themselves,'?" "The 'Big Basket' Fraud," and "Don't Fall for the 'Dirty Picture' Mail Pitch."

The terms *gay* and *homosexual* never appeared in the text of these magazines, and I suppose it's possible that a truly innocent eye might have seen them as an uncomplicated celebration of the healthy male body. But if you were a gay man you were glad to have no such innocence. For Vince, Mizer's stream of consciousness convincingly described what it was like to be a gay man and a physique photographer. This was not a worldview you could find in many other places at the time.

Since these magazines were the product of a photo studio they also operated as a kind of shop window for that studio's other products. If you particularly liked the look of "bike boy David Stubbs, 23, 5'11, 155lbs. Works as a roofer. Loves to swim, wrestle," you could send off for further mail-order photographs of him. This, I suppose, is the same impulse that inspires "collectors" to write to Richard Kern offering a few dollars for "real" photographs of the girls they've seen in magazines.

Vince owned a few thousand of these mail-order photographs. There was a pile of four-by-fives on his table, from a studio in Den-

ver called the Western Photography Guild. There was something very appealing about these glossy black-and-white images, quite regardless of how you felt about the subject matter. They were desirable objects. They fitted so nicely in the palm of the hand. And they were good-quality prints, very crisp and clear, on good-quality photographic paper.

The men posing in these photographs were physique models of the more or less conventional type. Later Vince showed me a much more curious set, taken by Bruce of Los Angeles, of smiling young cowboys, apparently taken at a rodeo. There were dozens of them, the guys fully dressed—Stetsons, chaps, leather waistcoats—and they seemed to be the genuine cowboy article, not some male-model simulacrum. The fact that the boys looked so natural, so apparently oblivious to Bruce's motives, made the pictures all the more intriguing and fetishistic.

Vince also showed me some transparencies by Bruce. I said I'd seen some of his 3-D slides, and Vince said, "Oh, they're very rare," perhaps just a little impressed. There were also three Bruce of Los Angeles 8-millimeter movies that he'd recently bought at a flea market. The dealer had had a whole table of them, and Vince said he knew it was one of those moments when he should have bought everything, but he didn't. When he saw the dealer's stall a couple of weeks later they'd all gone. Someone else had obviously had the same idea.

Vince had started collecting in the mid-1970s. In New York at that time there was a store in the Village called Gay Treasures, but he'd found their prices too high. He'd preferred an establishment called Physique Memorabilia, and although the name suggests a degree of openness, the business still had a clandestine feel to it. It was run by a man called Kent who kept parrots and was suspicious of new customers unless they came with a recommendation. Once you'd established your credentials, however, you could go there and peruse the merchandise while Kent held a sort of salon, and would sometimes

serve homemade soup. The things Kent sold were precisely the things Vince was then collecting: muscle and physique magazines, and the accompanying photographs, 8-millimeter movies, brochures, and so on.

In fact, as a young man, Vince had seen some of these magazines on newsstands, and bought them as an aid to masturbation. When he became a collector he sometimes found himself buying the very same issues he'd once bought before. This brought on a thrill of nostalgia, but now his purpose in acquiring them was quite different.

By that time homosexual imagery, which had previously been coded or veiled, was becoming familiar to society at large and easily "read" by those who were not part of gay culture. This coincided with the images becoming far more sexually explicit. Although much was gained by this, from a collector's point of view, for Vince Aletti anyway, something else had been lost.

The images in those early physique magazines were much more formal, closed, stylized in a way that excluded those not in the know. The clandestine nature of the form, and the restrictions placed on the photographers, had created its own aesthetic. It's an aesthetic, as with "fetish photography," that has endured. It's easy to see how it influenced, for example, the far more serious, far more "artistic" photography of George Platt Lynes; and the influence almost certainly went up from below rather than down from above, since Lynes's erotic work was unknown until much later. Vince owns some of Lynes's vintage prints. The aesthetic survives today, too, in the work of Bruce Weber or in Abercrombie & Fitch catalogs. Vince collects both of those, too.

Eventually the Physique Memorabilia store closed down; Vince suspects money troubles, but by then he'd moved on. He was making more money and had started collecting things from higher up the cultural scale: photographs by name photographers, which were on display in his apartment when I visited. With a certain amount of

prompting I was able to identify the work of some well-known and important photographers: Steven Meisel, Larry Clark, Danny Lyon, John Dugdale, and Lon of New York, among others.

There were quite a few photographs by Wilhelm Von Gloeden, but these weren't the usual nudes in a landscape for which he's best known. Vince had begun by collecting those but found himself increasingly enchanted by Von Gloeden's portraits, often tightly cropped shots that included little more than the subject's head. Vince had decided to trade in the more familiar figure studies he owned in order to form a more focused and unusual collection of the portraits.

I was surprised, and a bit baffled, to find that a lot of the photographs Vince owned weren't displayed on the walls but were kept in the hall, stacked five or six deep on top of a long, low bookcase. In order to see them you had to riffle through them, like pictures at a market stall. Even so, this seemed to be an improvement on a previous arrangement when Vince had had them laid out on the bed in the guest bedroom.

I did my usual thing of asking what part of his collection Vince would save from the flames, and he said he'd take something by Peter Hujar. I'd never heard of Hujar at this point, though I had heard of his boyfriend Wojnarowicz. I've looked at Hujar's work since, especially a book called *Animals and Nudes,* which I think is absolutely great. But whether I knew his name or not, there was no missing one of his photographs that Vince was displaying in his living room. It showed a naked man seated on a chair sucking his own big toe. It has elements of the comic as well as the sexual, and I'm prepared to believe it's a very good portrait of its subject, too. It also bore a considerable resemblance to Richard Kern's *Lyle Sucks His Toe.*

Vince said he'd save a Hujar from the fire, because they'd been such good friends. They'd lived across the street from each other and Vince owned over fifty of his photographs. Some were gifts, a few of them were commissioned photos of friends.

The men in Hujar's pictures look like real people, not greased, not Grecian, not perfected, not like models. Maybe this is what Nan Goldin meant when she said that looking at Hujar's male nudes is as close as she ever came to experiencing what it is to inhabit male flesh. But I'm not sure. This is an interesting one, especially for somebody who actually does inhabit male flesh. Inhabiting male flesh doesn't feel like much of a visual experience to me, which is perhaps what Ralph Gibson meant when he said that sex doesn't feel the way it looks.

In fact Vince thought the most valuable single item in his collection was a collage painting by Wojnarowicz, but that wouldn't need to be saved from the fire, at least not at that moment, because it was on loan to a gallery.

Hujar and Wojnarowicz both died of AIDS-related diseases, the former in 1987, the latter in 1992. Weston Naef, curator of photography at the Getty Museum in L.A., has pointed out that the worst years of AIDS in America coincided in a curious way with the rise of photography as a major art form. "For reasons that cannot be fully explained," he says, "both on the collecting and creating sides, there were a disproportionate number of individuals who eventually came to be impacted by the AIDS crisis." Probably the greatest collector of photographs during that period was Sam Wagstaff, the sometime lover and mentor of Robert Mapplethorpe, both of whom had AIDS-related deaths in the late eighties.

I'm still not wholly convinced that sex is the polar opposite of death, but is it conceivable that the closeness of unexpected mortality created the impulse to collect? Photographs from that intensely AIDS-stricken period are certainly awash with intimations of mortality; and not simple reminders that we all have to die, but rather more subtle and intense reminders that some people die far too soon. When you look at these collected images of young, healthy, sexually active men, you can't help wondering what happened to them, how they

lived, whether they died, and if so how. The presence of their photographs in a collection like Vince's might be a form of localized immortality, I suppose, though they could have been similarly immortalized even if they'd lived much longer.

As we moved around the apartment looking at images of men, it became obvious that Vince was a multiple collector. He had an impressive collection of photography and art books that was concerned with far more than sexuality, and there were groupings of Grove Press books, and many issues of the *Evergreen Review*.

There was plenty of evidence, too, that Vince had once been a music journalist. Actually, he wrote a famous piece for *Rolling Stone* called "Discotheque Rock '72: Paaaarty!" which scholars of these things reckon was the first article ever to take disco music seriously. Consequently he'd collected some serious vinyl, and he'd recently donated a couple of thousand disco records to the Experience Music Project in Seattle. If this had created any space in the apartment, his other collections had rushed in to fill the vacuum, and in any case he still seemed to have a pretty formidable record collection.

Then there were all the magazines: music magazines, art magazines, photography magazines—including a run of *US Camera* he'd inherited from his father—and above all fashion magazines, especially *Vogue* and *Harper's Bazaar*. These were a real passion, he said. I asked if he owned a complete set and he confessed, a little sheepishly, that he probably just about had two complete sets. And not just American *Vogue,* but British, French, and Italian, too. "Australian?" I asked. "No," he said, "nobody cares about Australia."

And he was continuing to buy them. If he saw a back issue of *Vogue* for sale on eBay, and it was attractively underpriced, he'd usually buy the duplicate. Then, when it arrived, he'd treat it like a new magazine, read it with great renewed pleasure, have a fresh experience of it, even

though he could have gone to his shelves and dug out the copy he already owned. Does this seem like an odd thing to do? I really don't know anymore.

You could make too much of this, but I think it's probably fair to say there's something similar between the stylization of the images in the old physique magazines and those in fashion magazines, and perhaps this applies to a great many images that are successfully erotic. They're all concerned with desire and presentation. They both seem to deal with a heightened, artificial, rarely obtainable reality. There are some guys who look good in posing pouches, just as there are some women who look good in a skimpy little nothing from Alexander McQueen, or in nothing at all, but these men and women are few and far between. That's why the images appeal and entice, and also frustrate. They show a world that's much sexier and more intense than the one we actually live in.

I asked Vince if he could describe the special pleasure of glossy magazines, not least because it's a pleasure I share, a slightly guilty one at that, and one that I've never been quite fully able to understand. Vince did his best. He said that lying in bed with a fresh magazine, and turning the pages, was a wonderfully comforting and familiar feeling. Nothing at all sexual there then, obviously.

And what of the photograph that had so startled Karen Wright? It had been taken down, Vince explained. Actually it had fallen down. When Karen had been there it had occupied a prominent place in the living room, perched on top of a waist-high bookcase, and one day it had simply tumbled off. Surprisingly, given its size and weight, it had survived the fall unscathed. Realizing this was a bit of luck, Vince had decided to keep the photograph at ground level, and it, too, was now in the apartment's hallway. It seemed that he'd also realized it might be a bit of a challenge to certain people who came to the apartment. A female book editor who had planned to bring her six-year-old daughter on a visit had caused a certain amount of rethinking on his part.

Its new place in the hall guaranteed that it couldn't really be seen. It was a big photograph, perhaps three feet by four, and the hall was too narrow to allow you a good view. Nevertheless I did my best to get an eyeful. It was a portrait of a seated, tattooed young man, tough and scary-looking, with a shaved head, hunched over somewhat, and displaying a gigantic, really gigantic, erect penis that stuck out at a diagonal, giving the picture a strong and surprisingly traditional sense of composition. It was by Matthias Vriens, one of a series of photographs of black and Hispanic men, all similarly endowed and erect, that was originally shown in a gallery in Harlem. Although the photo in Vince's apartment is actually called *Untitled (2002)*, the subject is known as Tony—and that's the name he uses when he advertises his services as an escort in gay magazines. I imagine he's a very busy boy.

By New York pack-rat standards Vince and his apartment were models of sanity and order. But then he and all other New Yorkers have the celebrated case of the Collyer brothers, Homer and Langley, hanging over them as a terrible warning of what can go wrong. In 1947, after an anonymous tip-off, police broke into the reclusive brothers' Harlem brownstone. They found an all but impenetrable labyrinth of junk arranged into corridors, alleyways, and tunnels, made up of grand pianos, an early X-ray machine, human medical specimens preserved in jars of formaldehyde, bundles of newspapers and magazines, dressmaking mannequins and pinup photographs—not exactly a sex collection but certainly evidence of uncontrolled obsession.

The police found Homer's body straightaway. He was an invalid, blind and crippled, and had died quite recently of starvation. It took three weeks of hacking through the mass of possessions before they discovered the dead body of Langley. To keep out burglars, he'd created booby traps all around the house, then set one of them off by accident, and it had killed him. He'd been dead for a long time, which

was why his brother had starved. Langley was the one who went out to buy food.

After police had removed both bodies, they then removed the possessions. One hundred and thirty-six tons of stuff was taken from the house. Some was auctioned off, but only the most desirable items, 150 of them, and they brought in a mere $1,800. There's certainly a horror that attaches to dying alone and having nothing, and yet the prospect of dying alone surrounded by mountains of essentially worthless possessions hardly seems any more attractive.

At about the time I visited Vince Aletti, the papers were full of the story of a forty-two-year-old man called Patrick Moore. He lived in a New York apartment surrounded by his vast collection of SF and pornographic magazines. There were so many of them that, like the Collyers, he'd had to create narrow makeshift corridors among the stacks. And then one day the walls of magazines collapsed and buried him.

He kept yelling for help, but for a long time nobody came, largely because he was the kind of guy who did a lot of yelling even when he wasn't trapped. He was there for two days before neighbors finally called an ambulance crew, who had to remove the front door of the apartment since the avalanche of magazines inside prevented it from being opened.

After the event, in a rather unsuccessful attempt to prove that he wasn't some miserable shut-in, Moore claimed that he earned about $300 a week selling items from his collection, thereby suggesting that he was a dealer rather than a collector, and also suggesting that, in his mind at least, someone who made money from his sex collection was somehow more dignified than someone who collected for the joy of it. As we'll see in the next chapter, it's a bit more complicated than that.

THE DEALER AND THE DEALT WITH

Statistics, aesthetic consolidation, cynicism, the conveyor belt of acquisition.

With few exceptions, I've found sex collectors to be a literate, articulate, and well-read bunch, but only one of them has ever quoted Joseph Stalin at me in relation to collecting. That collector was Eric Godtland, and the quotation was "A single death is a tragedy; a million deaths is a statistic." He then delivered his own variation: "Owning five men's magazines means you're a pervert. Owning eighty thousand men's magazines means . . . well, it means you're in it for something different."

Indeed. Eric Godtland is a serious collector of a great many things, both sexual and nonsexual, but men's magazines are far and away his main interest, although *interest* sounds much too gentle and moderate a term for how he feels and what he does vis-à-vis magazines. He acquires systematically, constantly, relentlessly, and in bulk. He is a collecting black hole into which every men's magazine published between about 1920 and about 1980, every *Penthouse, Hustler,* and *Screw,* every *Club International, Lui,* and *Sheer Delight,* every *Flirt, Rogue, Scamp,* and *Duke,* to say nothing of every *Adam, Swank, Venus, Mer-*

maid, Cavalier, and every other title ever conceived of anywhere in the world, must eventually fall.

That number of eighty thousand, although only a ballpark figure, was Eric's best guess at how many he owned when I first met him. He certainly has more than that now. In fact he probably acquired more even as he was talking to me. A network of friends, dealers, fellow collectors, and Internet auction sites ensures that the number is ever increasing: by the day, by the hour, by the second.

Eric Godtland was the youngest sex collector I'd met, although since he was in his late thirties he wasn't exactly a fresh-faced kid. But he said he'd never met a younger one either. He'd also been collecting for a shorter time than anyone else I talked to, only about four years when we first made contact, pretty much from the time that the rock band Third Eye Blind hit it big. He's their manager, a rock-and-roll guy, though as someone who'd studied economics and industrial engineering at Stanford, he probably wasn't ever destined to lead the authentic rock-and-roll life. He looks straight and sober, intelligent and decent, which may or may not be a help when it comes to drawing up rock-and-roll contracts.

I'm constantly amazed by both how much and how little money it's possible to make from rock music, but Eric seemed to be doing just fine, and success had led to a hectic few years, full of acquisition on an epic scale. He not only owned his vast magazine collection, and various other collections besides, he also owned the building in which he kept them, a San Francisco warehouse that was formerly a Seamen's Hall where merchant sailors had once lined up to get work; and that was where I went to visit him and his magazines.

The warehouse was in a fairly rough part of town, between the freeways and the dry docks, and it was easy to spot because of Eric's battered—nay, mutilated—1960s Chevy Impala parked outside. His collection of cars is comparatively small, but it does

Eric Godtland in his San Francisco warehouse.

include a Volkswagen Beetle that belonged to his wife's parents—
the car in which they drove to the hospital when Eric's wife was
being born. He also owns a 1961 Chevy 409, tuned up by a previ-
ous owner to such a ridiculous pitch that Eric feels it's too hot to
drive on the street. So it was resting there inside the warehouse,
looking pretty fabulous to my eyes.

In fact the whole warehouse interior was a certain kind of man's
idea of the perfect playroom. Eric's management company operated

out of the premises, too, but you couldn't help feeling that the place existed as a home for his collections and obsessions rather than his business. It was painted all silver, a nice Warholesque touch, and different areas were set up as showplaces for Eric's more minor accumulations.

For instance, Eric is quite keen on midcentury modern furniture, so in one corner there was an arrangement of kidney-shaped coffee tables, Swedish teak-framed sofas, and butterfly chairs. And at some point this merged into his tiki obsession: a bamboo bar, hundreds of mugs in the shape of Easter Island heads, gigantic columns from some demolished Polynesian watering hole, a Booze-ometer to measure how drunk you are, a lamp made out of a Japanese bomb. Then there was what he referred to as the *Clockwork Orange* room: lots of seating molded from red and white shiny plastic, optical-fiber lamps, a stereo deck that looked like a flying saucer.

There were a few small rooms in the warehouse that contained the management-company files, but in there, too, were rows of big blue plastic boxes full of other collectibles. I didn't get to see into those boxes. It wasn't that Eric was reluctant to show me, it was just that we'd still be there now if we'd had to go through everything.

Around the place were bare metal, glass-fronted medical cabinets full of robots and space toys, antique barware, Spinal Tap action figures. And here some of the sex collection began to appear. There were lots of sexual knickknacks: mugs with handles in the shape of naked women, board games called "Office Party" and "Sip and Go Naked," a plastic hip flask with a woman's detachable head for a cap, painted with the slogan "Your Hot Nip to Keep You Warm." These were all very amusing in their kitsch, Americana-ish way, but they weren't magazines, and above all I was there for the magazines, and so far I hadn't seen any.

Before my visit, Eric had hesitated a little, ironically as it turned out, and said he wasn't sure that he qualified as a collector. He said he thought of himself as an "aesthetic consolidator," bringing things

together that out of necessity must coexist under his close supervision. He didn't covet, acquire, and fawn, he said. He deigned to purchase and curate. Collectors were sweaty and fidgety. Consolidators were discriminating and Bondesque. He soon admitted that he was bullshitting and trying to be funny, but as with all the best bullshit there was a good deal of truth in it. Because in some ways it seemed to me that Eric wasn't simply making a collection of things he liked or wanted, or that recorded certain interests or trends or themes; he simply wanted to acquire one of each of everything, a copy of every single issue of every men's magazine that had ever been, making him a kind of pornographic, or at least cheesecake, Noah.

The magazines weren't in the main part of the warehouse. I think they'd have been too exposed and vulnerable there. They were in a room on the upper floor, to which Eric now took me. What exactly do eighty thousand men's magazines look like? Well, they fill, more than fill, a room that's maybe a hundred feet by twenty. Eric had the majority of his magazines in standard-size, lidded magazine boxes, which are about eight inches by twelve inches by two feet, and hold about fifty magazines each. Yes, that would be sixteen hundred boxes, call it twenty-five hundred cubic feet of smut, packed tight on the metal shelving that ran from floor to ceiling all around the walls. Of course, with this boxed arrangement there was nothing much to see, and the only indication of the contents were Eric's tiny pencil annotations on the ends of the boxes.

Fortunately a lot of magazines hadn't made it into boxes yet. They were in piles that started on the floor and towered up to head height, or they were stacked up on the workbench that ran down the center of the room. Eric was doing some sorting and putting away while I was there, a Sisyphean process, though one he obviously relished, but the room was so crowded that gaining access to any box involved a major rearrangement of numerous other boxes.

It's easy to think you know it all and have seen it all when it comes to men's magazines. Eric Godtland is here to tell you that you've seen

absolutely nothing. You haven't seen more than the tip of the tip of the iceberg.

In this room, in this warehouse, were, of course, all the titles you know, but it's the ones that you don't know, the ones you can scarcely even believe ever existed, that really make his collection what it is. Here were *Raw* and *Coquetta*, *Belly Button* and *Bike Broads, Sparkle* and *Madcap* and *Broadsville*. Here were *Spot On* and *Nuff Sed* from England, *Beauté* and *Paris Tabu* from France, *Varidades* and *Vea* from Mexico, *Venus* and *Tamburin* from Germany; hippie sex mags like *Groovie* and *Get It On,* naturist magazines like *Metropolitan Jaybird* and *Nude Mood,* magazines with boozy themes like *Cocktail* and *Highball,* and a magazine, surely a one-off, called *Warm Wet War Whore.* Here were long runs of humor magazines called *Chicks & Chuckles, Cheesegirls,* and *Maybe You're Screwy Too.*

Frankly there were quite a few magazines where it seemed the title was the best thing about them, but some were genuine oddities and fascinating for that reason. I loved a magazine called *Rally Girls,* which was full of naked girls and 1960s classic sports cars, and a magazine called *Lasses & Glasses* stoking those fervent librarian fantasies. And so on and on and on, by way of *American Aphrodite, Blighty, Cad, Dude, Exotique, Frolic, Girl Pageant, High Heels* . . . well, you get the idea. Eric hadn't calculated how many different *titles* he owned, but he thought it couldn't be fewer than five thousand, and might be as high as ten thousand. For every magazine that had had a long run, there was another that had lasted only an issue or two.

When a collection gets to this size, it inevitably becomes less personal. It would be hard to guess at Eric's personal preferences from looking at his magazines, since just about every preference is represented. The collection's heft and inclusiveness, its very promiscuousness, is the whole point. Things aren't in the collection because Eric happens to like them, but simply because they happen to exist. He doesn't determine the content; that has already been determined by generations of publishers, editors, photographers, and models.

Yes, the models. I couldn't help thinking a lot about them. When you saw the sheer quantity of magazines that had featured nude or seminude models, you realized that the number of women who had taken their clothes off and been photographed over the decades must run into hundreds of thousands, maybe millions, all posing and pouting, reclining or on tiptoe, topless or bottomless, the girl next door or the girl from the brothel, slutty or wholesome, soft-core or hardcore, older and younger, elegant or gauche, some simply gorgeous, some frankly not, but all of them enlisted in this women's army, invading and annexing men's imaginations.

Who were they all? Well, there were some genuine "name" models, the Bettie Pages, June Wilkinsons, and Candy Samples of the world. But given the numbers involved, the majority were inevitably unknowns. They weren't literally anonymous (even though we do know that Coco from Paris may well in reality be Brenda from Scunthorpe), and certainly not faceless or without personality—but still, in the main, they were unidentified and inscrutable.

At this point I began to think that Stalin's murder analogy didn't quite hold true. We weren't looking at a statistic, and certainly not at a tragedy, but at an archive revealing more than sixty years' worth of sexual mores and culture, a catalog of sexual possibilities. This was an impression Eric was keen to foster.

Eric's story, and it's a good one, is that his collection charts a sexual revolution. This revolution, he says, can be dated from any number of moments, from the First or Second World War, for instance, and more obviously from the sixties. His magazines record the revolution's progress, thoroughly and exhaustively, but none of them is an accurate or reliable or disinterested record (who knows what psychosociological phenomenon is being demonstrated by *Rally Girls*?); rather, each magazine was an experiment in personal style and obsession.

Some editor or publisher got an idea in his head and thought it might work, so most of the magazines also represent experiments in

publishing, too. The layouts were done by hand. They were precomputer, so they had a roughness, an old-world craftsmanship to them. They'll never be made that way again. Today, Eric said, everybody can get what they want direct from the Web. The supply of images is endless. There's certainly no reason to collect magazines. The idea of a few well-thumbed magazines, carefully stashed under the bed, that mean something to you personally is just quaint. He also wondered whether at this point in history, pornography had to be mobile. Still imagery didn't seem to do it for today's young men.

And all this was the very reason for his collection. Modern pornography is so generic, he said. It's all been worked out. It's efficient and industrial, whereas the historical record of men's magazines shows endless stutters and wrong moves, lurches in improbable and sometimes absurd directions, based on all sorts of personal quirks and inefficiencies on the part of the producers. That was the real fascination for him.

He said he was also fascinated by all the things in the magazine images that *weren't* the woman's body: the clothes, the shoes, the makeup, the hairstyles, and of course the backgrounds. He loves those midcentury sets: the satellite clocks, the mushroom chairs, the deep shag carpets.

Did this sound like a convincing explanation for Eric's collection? Well, yes, and I certainly didn't see it as my business to psychoanalyze someone I scarcely knew, but I was left with the feeling that it explained the collection without quite explaining the collector.

For instance, Eric told me how he'd recently bought a houseful of pulp novels. The story was a long and convoluted one, and Eric wasn't sure he knew the whole of it, but it seemed that a pulp distributor or wholesaler had gone out of business and stored, or possibly hidden, the stock he was left with in his sister's house. There were about thirty thousand books. She'd been happy enough to have them there for a couple of decades, but when Eric came along offering to take them off her hands for about ten cents each, she accepted.

Since the books represented stock rather than a collection, there was plenty of deadwood. There were a thousand copies of certain titles, and not the ones you'd most have wanted a thousand copies of. Nevertheless, there were some gloriously camp, kitsch classics like *Caper at Canaveral!* and *Faggots to Burn,* with the shout line "Is the 'Third Sex' taking over Hollywood?"

I understand the fascination of pulp novels, especially the covers, and I can see that Eric probably got a bargain. There's a market for pulp these days, and even allowing for all the deadwood, there were probably enough collectible volumes there to make a profit. But buying up those books didn't seem to have anything to do with forming a collection or telling a story of culture and sexuality. It had far more to do with the pleasure of acquiring and having. That might also apply to Eric's collections of 8-millimeter films or mambo records—his vinyl collection is awesome—and it's a pleasure familiar to most of us. But that's rather different from the pleasure Eric seems to get from his magazines. I really do think that in creating his vast, mad sexual archive, Eric really is doing something wonderfully unusual, utterly fascinating, probably ultimately very important, and, dare I say, heroic. And he knows it.

Given the sheer size and scope of Eric's collection, you might think he'd be tempted to employ one or more assistants, but the fact is, he doesn't. He's not even all that willing to let other people touch his treasures. A helpful filing clerk or librarian would be a barrier between him and his obsession. In this enterprise he is a solitary hero.

The question of what you actually *do* with your eighty thousand men's magazines is a very good one. Do you sit down and read them, for instance? Browse through them, get to know their contents? Maybe. But that would be a massive task. Let's say you devoted eight hours a day to reading your collection, spending ten minutes with each magazine. Well, if you worked seven days a week, it would take

you five years to get through them all: a task for your retirement or dotage possibly. I don't see Eric doing that in the near future. Unless his business crashes and burns and he has no money, or unless he undergoes some profound psychological transformation, he'll be too busy buying more magazines to read the ones he's got.

The last time I saw Eric he'd just bought a modern automaton, something called "Torquemada's Nocturna" by an artist named Thomas Kuntz. It came in an ornate wooden box, about fifteen inches square, and it opened up to show two finely modeled figures, a redheaded satyr lying on top of a very white-skinned, dark-haired female. The hand-cranked mechanism caused the satyr to pound up and down on the woman, who seemed compliant enough if not exactly enthusiastic. Meanwhile an oval peephole in the automaton's base showed part of the mechanism, and a tiny devil who appeared to

An automaton from Eric Godtland's collection.

be doing the cranking. It seemed as though a whole new area of collecting might be opening up for Eric.

The automaton had cost him a few thousand dollars, but he explained that was money he *had* to spend. It was the end of the tax year and his accountant had told him he needed to get rid of some money, quite a lot of money it seemed to me, and although automata were all very well, it was, of course, his magazine archive that was really going to benefit from this enforced expenditure. The financial workings of the rock industry have confused wiser heads than mine, but a business that requires the buying of large amounts of erotica at year's end strikes me as wonderful indeed. All over California you could hear erotica dealers rubbing their hands in anticipation.

Dealers: a peculiar bunch in my experience; grumpy, cranky, sometimes hostile. And cynical, too: they know the price of everything and then they double it. I tried to make contact with one or two of them, because I wanted to discuss collecting from the "other side," as it were.

I tried Michael Goss of Delectus Books. He asked for money before he'd see me. I suspect he was just being facetious and curmudgeonly, and he did soften after that, and said we should have a drink together, but by then the luster had been taken off the transaction.

Then I tried to ingratiate myself with the fearsome C. J. Scheiner. The *C* stands for Clifford. As well as dealing, he used to be an emergency-room doctor, and his name appears in the credits for Stanley Kubrick's *Eyes Wide Shut* as "medical advisor." He used to advertise his catalog in *The New York Times Book Review,* and if you sent off a couple of dollars you received a photocopied checklist that was quite a few years out of date, and I've been told that nothing you tried to buy was ever available.

I contacted him by e-mail, and at first he said he was "disinclined to participate" (yes, that was the tone he used) because he'd already

written on the subject and because he was working with a graduate student in a "related area." But if I e-mailed him a list of questions he "might consent" to answer them.

You can imagine how thrilled I was at that prospect. But since he said he'd written on the subject it seemed only good research to ask him for some chapter and verse. Could he tell me where and when this piece of writing of his had appeared? No. He said he didn't know, that it was in "the 1970s or 1980s or early 1990s." He said he didn't keep track of these things.

This seemed both odd and unlikely, so I asked for clarification. As a scholar, writer, and collector, did he really not have some record of his publications? No, he said, he didn't keep track of the thousands of times he'd been published because he was "not writing an autobiography."

He did let out one or two bits of information about his collection, however: that it consisted of 350,000 items, "most everything in the genres of erotica and sexology." He also described his collection as "a completely private research archive" and that one of its pleasures was that he could shut it down when he didn't feel like dealing with it. "Now is such a time," he said. He also said that if I left the subject line of my future e-mails blank they might be "disregarded unread." Believe me, this proved not to be a problem.

And then, in London, I met someone who'd actually seen Scheiner and his collection. It was Jamie Maclean, another sometime dealer, this time of very high-end erotic art, though when I met him he was far more of a publisher, being the brains behind the Erotic Print Society. He said he'd first met Scheiner in the late 1980s, when he'd bought things from him to put in an exhibition. Jamie's exhibitions had names like Forbidden Images, Forbidden Library, and Curiosa.

Jamie tells the story of meeting Scheiner. "I remember taking the subway to Brooklyn and being the only white male there and the other passengers giving me curious looks. I had missed the Flatbush

station and had gone on. Anyway, after a nervous-making tour of Le Brooklyn Profond, where burly policemen not only seemed to walk around in pairs but actually held hands, I arrived at his curiously large apartment, and when the door had been unlocked—a process which took some minutes—he ushered me through various rooms which were full of freestanding bookcases like the stacks in a library to a tiny kitchen—the only book-free part of this cavernous flat. 'Do you mind if I smoke?' I asked. 'You can if you want but be warned, I'll stub it out on your forehead,' he charmingly replied. It sort of sums up the man."

Jamie was trying to buy Scheiner's mailing list, but he was doing it through a third party. "I just find dealing direct with Cliff too toxic an experience."

As the above suggests, Jamie Maclean is a man of some twinkly wit and charm, though I wouldn't want to be on the receiving end if he chose to be any other way. He had a lot to say about sex collecting. Because acquiring and owning sexual materials had been sub-rosa for so many centuries, the activity had created bonds between collectors, both within their own societies and across time. He reckoned the connections went back to at least the eighteenth century. As a boy, he'd played with friends at Inverary Castle in Scotland, home of the Campbell clan, and they'd found some very juicy and historic smut in the library there.

You might think there was less need to be furtive these days, he said, but it wasn't absolutely plain sailing. In order to reach customers for the books he published at the Erotic Print Society, he advertised in the Saturday London *Times,* but the paper wasn't entirely happy to be promoting smut. They would take his ads, but not for the main part of the paper, so they had to go in the "low traffic" sections, along with business and sport.

Jamie said the best collections had to contain rare items, cover all known areas, and they had to have the capacity to arouse what he called the "Peter-meter factor." He wasn't much concerned with dis-

tinguishing between art and pornography. "Is it good art or bad art? Is it good porn or bad porn?" And he especially disliked the word *erotica*. "It's such a mimsy word, that's come to mean middle-class pornography."

I was somewhat disappointed to find that Maclean himself wasn't a collector. If his collection had matched his personality it would have been quite intriguing. Some dealers are collectors, he said, some aren't. He said that for him, being a dealer was like sitting beside a conveyor belt, watching wonderful items go by and fully appreciating them as they passed, but he'd never wanted to own any of them. There's another sort of dealer, he said, who may buy and sell in order to make a living, but what he's really doing is distilling and improving his own collection, looking out for the very best that comes his way and keeping it for himself. Such a dealer is Joe Zinnato of Eros Archives, the one I finally got to talk to.

It was a chilly December evening when I first went to Eros Archives, an unmarked one-story building on Cahuenga Boulevard in North Hollywood, a place that is nowhere near either the real or the imagined Hollywood proper. Eros Archives deals mostly in erotic books and magazines with a strong fetishist emphasis. If you're looking to expand your collection of materials relating to bondage, female domination, spanking, flagellation, water sports, and so on, you'd probably find it indispensable as a mail-order or Internet resource. Getting into the premises is a different matter.

Eros Archives is not a shop. You can't just walk in. In fact, even calling up and saying you'd like to make an appointment to view isn't enough to guarantee access. You have to know what you want, which is also to say that you have to know what you're talking about. You have to display a level of expertise and connoisseurship before you get invited in. I felt both flattered and a little intimidated to be there.

Eros Archives is run by Joe Zinnato and his longtime girlfriend,

Laura Brody. Joe is in his midforties, lean, cool-looking, stubbly, with two earrings in each ear, and a false front tooth which he removes from time to time. He is a smoker of small, dark clove cigarettes which he holds in hands that are of a quite extraordinary delicacy. His default mode, until you get to know him, is gruff dismissiveness.

Laura joined the business when she joined Joe, about fourteen years ago. She's an Alaskan, fresh-faced, younger than Joe, and in many ways very conventional-looking, no makeup at all as far as I could see, and there's nothing flashy about the way she dresses. But then you notice that she has a ring through her nose. Well, actually, you notice it right away, because it's not one of those discreet little piercings that penetrate the flared part of the nostril, but rather one that goes right through the septum, like the ring through a bull's nose. She told me they were common in San Francisco when she had hers

Joe Zinnato examining some recently acquired European treasures.

done, but it still looked pretty outré to me. And of course, you can't help thinking that she probably has other piercings hidden under the unflashy clothes, and Joe confirmed that this was the case. She has them in "all the usual places," he said. He used to have them, too, until he had a stroke a few years back, right before he turned forty. The hospital removed them all when they hauled him in and saved his life, and apart from the ones in the ears, he never put them back.

In the front part of the Eros Archives building was an office of sorts. There were shelves of books, some racks holding magazines, photographs, and artwork, a display cabinet with erotic figurines, but there didn't seem to be much in the way of really serious merchandise. That was all in the back, a cold, harshly lit space, a warehouse of sorts, the kind of place you would become quite familiar with if you wrote a book on sex collecting. It was a place for storage as much as display, so a lot of what you saw was metal shelves and closed file boxes, not unlike Eric Godtland's arrangement in San Francisco.

Nevertheless there were some intriguing items lying around exposed: nudie playing cards, Swedish Erotica videos, old 8-millimeter movies, magazines with titles like *Bizarre, Boots and Bitches, Bondage Life, Burning Buns, Bound Women,* and many others of a similar kind whose titles didn't necessarily begin with *B*. There were pulp paperbacks from the Pompeii Press, gems such as *The Captive Debutante, Mercy! Mercy! Mercy!, Snowbound in Torment*. There were publications by foot-fetish photographer Elmer Batters, titles such as *Tip Top, Sheer Delight, Succulent Toes,* and *Leg-o-rama*. There were long runs of titles from the Greenleaf Press, a good few of them written by Ed Wood. There was also, fairly inexplicably, a roll of wallpaper with a Grove Press trademark on it, showing scenes from the *Kamasutra*.

I found most of the serious stuff a bit alien, and if I'm honest, not all that enticing. I wasn't speechless but I felt I didn't have a lot to say. Then my eyes fell on a set of books by William S. Burroughs. Having a background in modern literary fiction and rare books, I turned to these with some relief. One or two of them I even owned. Joe

explained that he'd once had quite a collection of Burroughsiana, some of which had been displayed at an exhibition Burroughs had attended.

It turned out that Joe had originally been a dealer in Beat literature, doing the rounds of antiquarian book fairs. Business had been okay, but it could have been better. In need of a second string, he'd started taking a few examples of erotica along to the fairs and discovered that they moved rather more swiftly than the Ferlinghettis and the Corsos. And so a dealer in erotica was born.

Joe was also a J. G. Ballard fan and collector. In the front office was a recent acquisition—the original cover artwork for a recent edition of *Concrete Island,* with a pair of sexy high heels and red-vinyl-encased legs. It won me one or two points with Joe that I'd met Ballard a couple of times, and he revealed that he also owned one of the rare-as-hen's-teeth early editions of Ballard's *Why I Want to Fuck Ronald Reagan.* It seemed to me an item without which any sex collection would be incomplete.

I noticed a towel hanging on the back of a door in Eros Archives. Woven into the fabric was a photographic image of a woman in dominatrix gear. The towel was a gift from a satisfied customer. In fact the woman in the original photograph had been the guy's wife. The original photograph was right there, too. We spent some time wondering whether putting your wife's image on a towel might be a hostile and misogynistic act. Wanting to have strangers rub their naked bodies all over your wife was surely, at best, an ambiguous gesture. Ah, but we decided at least these bodies would be clean and fresh from the shower. Having your wife's image on, say, a roll of toilet paper—that would be something different.

The towel guy sounded like of one the happier, less problematic customers. There had been, for instance, one who arrived knowing exactly what he wanted, photographs published by a company called RDF, specializing in "mean-spirited bondage," as Laura put it. The customer found one item he was particularly entranced by, and he

wanted to share his appreciation with Laura. He showed her a photo set of a bound girl in a dungeon. "Look," he said, "you can see it's for real. The girl gets thinner and thinner as the photo set goes on."

This, in Laura's experienced opinion, was clearly not the case. It was just a commercial photo shoot, evidently taken one afternoon in someone's basement. But the customer couldn't, didn't want to, see it that way. His perception of this "reality" excited him greatly, a little too much, in Laura's opinion. "No," she said, "she's only getting thinner *in your mind*." Then he was told to leave. To be abused and kicked out by a dealer who specializes in the very thing you love best must be a special kind of humiliation for a collector, but perhaps not such a rare one. Perhaps it would even be possible to encompass it in your notion of connoisseurship. There was another kind of customer, Laura said, who wants to buy S&M stuff they describe as "where you can see the fear in the models' eyes." They're not especially welcome either.

Inevitably the Eros Archives operation involves buying as well as selling. A typical, and unwelcome, phone call might come from someone who's decided to get rid of his long run of *Playboy*, which he's lovingly preserved all these years, and thinks it must have some value. He's pretty much wrong about this. To the serious collector there are very few issues of *Playboy* worth having: the very first with Marilyn, the one with Bettie Page, and hardly any others. When Joe fails to salivate at the chance to buy the collection, the seller asks what he should do with it. Joe suggests the Dumpster. "I've thrown away pallets full of *Playboy*," he said.

There are also guys who call up wanting to sell nude pictures of their ex-girlfriends. Have the girlfriends agreed to this? Well, no. So there wouldn't be anything like a model release to go with these pictures, would there? No, but hey, the bitch dumped me, right? She owes me. As a pragmatist, Joe offers a dollar per picture, on the basis that he knows he can sell them for three. The dumped boyfriend generally doesn't go for this, but evidently one or two do.

Perhaps inevitably, Joe has been busted by the LAPD. This was some time ago when he ran the business from his apartment. As he tells it, it was the predictable stuff of nightmares, a knock on the door in the middle of the night, cops barging in, some in uniform, some not, careening through his home, grabbing anything they did or didn't like the look of, not just his stock but also things from his personal collection. And yet, as so often seems to be the case in these matters, the cops seemed to have a slightly vague idea of what they were looking for. For instance, they took a particular interest in some books by Robert Mapplethorpe. "Yeah," Laura said, sneering, "it was the slices through peppers they were after." Then they packed up some stuff, carried it away, leaving Joe with the problem of hiring a lawyer to try to get it back.

It turned out the cops were looking for kiddie porn, which they didn't find, because there was none. They'd arrested a pedophile in a sting operation, and Joe's name was in his address book. That could hardly have meant much. Joe's address is in any number of trade directories. Joe says he did know the arrested guy as a customer, but he'd only ever sold him perfectly legal Tijuana Bibles.

To be fair, Joe's client wasn't just a collector. It appeared he really was having sex with his ten-year-old daughter, and the cops proved it in court. The guy got what was coming to him, and when he got to jail, no doubt a great more besides.

All Joe got was his stock back, and even then not all of it. After a suitably long process he and his lawyer went along to a police storage unit to pick up his property, but even then he feared entrapment. There was one box the cops were so keen to have him take away with him, he began to think they might have planted something in it. On his lawyer's advice he decided to leave that box right where it was.

I don't know if Joe's a typical dealer, or if there's any such thing, but he did say something that seemed quite extraordinary, confirming to me that he was a dealer second and a collector first. He said he already had plans for what would happen to his own personal collec-

tion after his death: a third would go to the British Library, a third to the Kinsey, a third to L'Enfer in Paris. I said I'd really like to see this collection before then. He said maybe.

If getting invited into Eros Archives was tricky, then being invited to Joe's home to see his personal collection felt like an honor indeed. Joe and Laura lived in a suburb twenty miles or so outside of L.A. The main drag was packed with archetypal roadside culture: a Kmart, gas stations, a biker bar, motels that do most of their business in the daytime. But you turned off this strip and right away you were in the suburban street of California bungalows, one of which belonged to Joe and Laura. Some multicolored bowling balls set in the flower beds by the front door were the only things to suggest that just plain folks didn't live here, but step inside the house and it was a different story.

Very few of the neighbors had ever crossed that threshold, Joe said, and he liked it that way. When one old-lady neighbor did get in and began asking what church they went to, Joe tried to fend her off with the remark "We don't believe in that shit." But he wasn't a complete monster; as he escorted her out he tried to shield her so she didn't have to see the row of devil figurines he kept as decoration, but I suspect she saw plenty.

The fact is, the moment you stepped inside you were right in the living room, in the middle of Joe's collection. It was a hipster space decked out with cool, modern furniture that included a pink-and-black vinyl couch, and there were bookcases full of titles that even the inexperienced eye would clock as exotic and sexual, books by Hans Bellmer, Mapplethorpe, Allen Jones, Pierre Molinier, Gilles Berquet. My eye fell on a copy of Gershon Legman's *The Rationale of the Dirty Joke* and I opened it to find two letters from Legman inside, though not addressed to Joe.

But it was the walls that gave the game away completely. They were covered with art and photographs showing what we might as well call "fetish scenes," women in high heels and corsets and thigh boots, in corsets and stockings, sometimes tied up, sometimes doing the tying, giving and receiving spankings and beatings. These were original paintings by big-name fetish artists: John Willie, Gene Bilbrew, Eric Stanton, Robert Blue.

Soie items were a good deal more full-on than others. There were posters and film stills in the kitchen that were more kitsch than kinky, from movies like *Nudes on the Moon* and *International Smorgasbroad* (sic). But head toward the deeper recesses of the house and there were vintage John Willie photographs showing his own wife surrounded by shoes or tied up and blindfolded. And there were original Bellmers, both drawings and photographs.

You had to beware of forgeries when it came to Bellmer, however, Joe said. Bellmer was valuable enough to be worth forging. Joe had come across a dealer who had a big supply of Bellmer prints. They looked authentic enough, but Joe couldn't help noticing that some of them were signed Beller rather than Bellmer. He figured that if nothing else, Bellmer would have spelled his own name right, although you'd have to think the same applied to any but the most pathetic forger.

When I arrived at the house that first time, Joe and Laura were writing captions to go with items they were putting up for auction on eBay. It wasn't fantastically rare stuff: female glamour and male physique magazines, along with a lot of glossy black-and-white pinup photographs. The trick, they said, was to include enticing buzzwords in the description, words that would leap out at potential customers: terms like *sultry temptress, pouty, big-breasted brunette,* and *barefoot blonde* were reckoned to be good ones. But it was harder than you might imagine. Some descriptions were immediately rejected by the automatic internal censor mechanisms of the eBay system. The word *tits*

was a nonstarter. An attempt to describe a woman's shoes as "strappy" also got bounced off, presumably because of its bondage context. And don't even think about describing a black woman with an Afro as a "soul sister." In cyberspace nobody can use the word *sister* without becoming mired in the most horrid thoughts of illegal sibling love.

Joe and Laura were doing this work in the room that housed more of Joe's own collection, mostly the stuff between hard covers. The collection was arranged in glass-fronted bookcases, organized by country. The German stuff was heavyweight, serious, elegantly bound, with typefaces that somehow managed to evoke both the Bauhaus and the Third Reich. The French stuff was more elegant. The American stuff was more all-American.

There was also one small, low bookcase that contained a collection of books published by Magnus Hirschfeld's Institut für Sexualwissenschaft. These were amazing things that I'd never seen before and they seemed highly desirable; there was a beautiful three-volume set of books called *Die Erotik in der Photographie,* and a volume called *Gifilde der Lust* which came with a pair of 3-D specs tucked into the back. I asked Joe whether these Hirschfeld items were highly sought after by collectors. Well, not by collectors of "erotica," he said, but he thought that historians of sexology might collect them. He wasn't sure how many of those there were.

Next Joe showed me a very, very limited edition (just seven copies) of a book called *Parfums mécaniques* by the photographer Gilles Berquet. Berquet strikes me as the very best kind of fetish photographer, the same old themes of bondage, high heels, and a fair bit of urination, but the images don't look like everybody else's. There's a passion and an obliqueness to them. Each book in this limited edition came in a box with a unique photographic print. Also in the box was a signed, numbered black dildo.

"Has it been used?" I asked.

"Well, not by me," Joe replied.

Then Joe had a new customer-related story. He'd got a call from a

man wanting to sell his lifetime collection of female domination materials. Joe had said okay, bring it to the office. The guy arrived, and Joe went out to meet him at his car, taking a trolley with him to carry the imagined collection. But it turned out the guy's collection could be contained in a single carrier bag, and consisted of items cut out of magazines and stuck in scrapbooks, with all the penises highlighted in yellow, thus having no resale value whatsoever. I found this somehow touching, but Joe was made of sterner stuff.

"We mercy-fucked him and gave him fifteen dollars," said Joe.

Eventually Eric Godtland came to town with his end-of-tax-year money, with the intention of buying magazines from Eros Archives and adding them to his own archive. He and Joe had previously struck a deal whereby, since Eric bought magazines in such bulk (he was planning to buy a thousand on this occasion, but in the end it was nearer fifteen hundred), the price would come down to just fifteen dollars each. But, of course, when I spoke to Joe, he wasn't wholly happy with the idea. Some of the magazines he had in stock were priced at far more than fifteen dollars, some as much as seventy-five dollars. These obviously couldn't be sold at the same bargain rate. Eric could see that Joe had a point, but even so, he thought Joe should give him a break on those magazines.

"They're not worth that much po me," Eric said. And Joe, bristling, had replied, "They may not be worth it to *you,* but they're worth that much to *me.*" By which he meant that there were other collectors out there who'd be prepared to pay that price of seventy-five dollars for them.

The relationship between dealers and collectors is always likely to be an uneasy one. You and I might think they'd enjoy a profitable form of symbiosis, but they don't see it that way. Each considers the other a necessary evil. Partly no doubt it's because the thing that makes one of them rich makes the other one poor, but it's more than

that. Dealers regularly feel that collectors don't fully understand and appreciate what they're buying. They're dilettantes, or worse still, merely *accumulators*. That's about as bad an insult as gets thrown around in this world. The collector on the other hand constantly fears he's being used. The dealer knows what the collector wants and ruthlessly exploits the rules of supply and demand.

Jamie Maclean tells a story, from the days when he was a dealer, of inviting a rich collector to his home for dinner hoping to sell him a very expensive piece of erotic art. Halfway through dinner the collector became outraged. "I know what you're doing! You only invited me here because you want to sell me something!" To which the droll, urbane Jamie could only reply, "Bloody right."

10

WHAT I DID AT THE KINSEY

A belief in data, increasing your happiness, the Documentary Collection, the missing "Spicies."

We're all Kinseyans now, whether we know it or not, and I suspect all too few of us do. A strictly nonscientific sampling of people I've talked to lately suggests that if you're under forty you probably have only the vaguest idea of who the great Dr. Alfred C. Kinsey was. The two Kinsey "reports" on male and female sexuality get all too easily confused with the work of Masters and Johnson, or Wilhelm Reich, or even (God help us) the Hite Report.

Kinsey's once-revolutionary, and sometimes reviled, ideas have become pretty much the received wisdom. The notions he espoused—that we are "human animals," that masturbation is more or less universal and a more or less universal good, that homosexuality and heterosexuality coexist on a sliding scale, that more harm is done by criminalizing nonstandard sexual desire than by trying to understand it—don't sound so very revolutionary today. And even among those who question Kinsey's methods, and condemn his easy acceptance of just about all sexual behaviors, few will doubt his central conclusion, that men and women get up to some pretty far-out sexual stuff. But this was news indeed in 1948 when he published *Sexual Behavior in the*

Alfred Kinsey and some University of California students
after a lecture he gave on women's sex lives.

Human Male and hardly less so in 1953 when he published *Sexual Behavior in the Human Female*. The extent to which his ideas have been accepted is perhaps the extent to which he's become invisible, but for me, and a great many people of my generation, he was, and remains, a colossal and heroic figure. He was also, by any standard, one of the world's, and history's, very greatest sex collectors.

That is why I'm standing in the basement of the Kinsey Institute for Research in Sex, Gender and Reproduction at the University of Indiana, in Bloomington, examining one of the many, many items that form the Kinsey archive. It looks like a fairly standard photograph album in some ways, with glassine sheets and those sticky pages that are supposed to hold the photographs in place but never quite do.

Consequently the ones in this album keep sliding around and threatening to drop out onto the floor, and I'm trying very hard to prevent this happening. The Kinsey is a serious place. I have the sense that I've been let into an inner sanctum and shown its most arcane treasures, and I'm trying to treat them with all the care and respect you'd give to any museum-quality artifact. In the current case, this is not without its absurdity.

Yes, this album is de facto a museum piece, but there are really rather few museums in the world that would contain it, and the Kinsey is by some way the most preeminent of these. The album contains scores of photographs of a man's penis, in color, in close-up, in detail, at rest and in motion, and often in the middle of ejaculating.

I'm no expert at dating photographs but these have a distinctly 1970s look to them. It's got something to do with the paper they're printed on, the brittleness of the gloss finish, the lurid yet faded colors. And you'd have to guess they were home processed, since it's hard to imagine any lab you could have taken them to back then, although I suppose it's possible the man had his contacts. Certainly the quality of the photographs is quite high: sharp focus, lots of detail, precise composition. And I get the feeling this was a do-it-yourself kind of guy. When I say he's in the middle of ejaculating I mean really in the middle: the ejaculate is in midflight, emerging from his penis, hanging in the air. It would be a couple of decades and a technical revolution later before Andres Serrano could take pictures like these and call them art. To have attempted it in the seventies would have been tricky and ambitious and I'm imagining our man must have had some fairly high-tech equipment for the era, something involving self-timers, remote controls, electronic flash, superfast shutter speeds. These images have the feel of a science project as well as of sexual obsession.

But I could be completely wrong about most of this. Maybe our man didn't do it all himself. Maybe he just had good friends with good equipment and an even better sense of timing. And maybe

they're not even from the seventies at all. The Kinsey isn't much help in these matters. For all the scholarly apparatus of the institute, donations of materials like this are generally anonymous, for entirely obvious reasons.

People donate to the Kinsey having reached the stage of their lives when they want to get rid of their collections. Again, the reasons are likely to be obvious enough: a marriage, turning over a new leaf, the arrival of offspring, the fear of impending death. Sometimes, of course, that fear may be well founded, and death may arrive before the individual has had time to make arrangements with the Kinsey. In that case a spouse or other relative has to enter the picture. It requires an extremely unusual person to find dad's or granddad's or hubby's secret stash and think, "Oh boy, I bet the Kinsey would love this." A few undoubtedly do, but rather more, you have to imagine, simply destroy their findings and breathe a sigh of relief. The Kinsey collection is a hedge against oblivion.

To this extent, the Kinsey is actually a collection of collections, an accumulation of accumulations. Kinsey himself actively sought and acquired certain materials, but then there were all the things he passively received and welcomed. Some items are also donated by police departments, following the arrest of sex offenders and the confiscation of their more dubious possessions. All this means that there isn't much quality control at the Kinsey, but that's precisely the way the great man would have wanted it. He wasn't in the business of turning things and people away, and neither is the current regime, which continues to collect in the Kinsey tradition, some fifty years after his death.

Above all else, Kinsey believed in data. He began his professional life as a zoological taxonomist, famously investigating the gall wasp. To understand a species, he reckoned, you collected all the information you possibly could about it, observed all the variants, all possible deviations from the norm. His method, in this case, involved collecting literally hundreds of thousands of gall wasps, maybe even a million,

measuring them, identifying them, mounting them on pins in boxes. This method did, of course, involve killing the thing he was investigating, a procedure he avoided when it came to the human animal.

His primary means of investigating human sexual behavior was the face-to-face, one-on-one interview. You sat down with Kinsey or one of his fellow researchers and answered a series of questions about what you had and hadn't done sexually. By all accounts Kinsey was a great interviewer, sympathetic, direct, nonjudgmental. People warmed to him. They told him everything, and he collected as many histories as he could. Anybody he ever met was invited to give his or her history and he was persistent and persuasive. He was aiming for 100,000 histories but had done fewer than 20,000 when he died in 1956. *Sexual Behavior in the Human Male* is based on interviews with just 5,300 men.

In global terms this is, of course, a minute sample, and Kinsey knew that it wasn't precisely representative. "Negroes" were so underrepresented that he hesitated to draw many conclusions on their sexual behavior. And although he makes some reference to differences between Jews and Gentiles, he ignores the ethnic makeup of his sample in ways that no scientist would today. Nevertheless he assembled a large, unprecedented amount of information about sex, about what people actually did.

However, the interviews on their own weren't enough for Kinsey. He wanted more data. He wanted to observe in detail. He hid himself in a prostitute's closet and watched her perform with clients. He filmed people having sex, including a thousand or so men masturbating, in order to see once and for all whether the majority of men squirted or dribbled on ejaculation. The latter apparently, despite what pornographers would have you believe, and it must be said that the man who made the album I described at the beginning of this chapter was certainly no dribbler.

Kinsey also realized there was more to sex than he could ever personally witness, so he wanted to obtain data from and about other

cultures and other periods of history. His problem here, anybody's problem, is that sex is so pervasive, its manifestations so oblique and diverse, that it's hard to see what bits of human behavior and endeavor *couldn't* be construed as sexual data. That wasn't a problem that seemed to worry Kinsey. It was all relevant as far as he was concerned, and so he tried to collect it all.

At the more conventional end of things, he wanted a good research library, and initially he funded one out of his own pocket. This meant buying books, journals, and magazines of all kinds, the scientific and the literary, the popular and the esoteric, the high and the low. A browse through the catalog of the Kinsey library will show how diverse, not to say random, his acquisition policy was.

Let's imagine you did a keyword search for *love,* and only looked at those books acquired in 1949. You would find, for example, *Love and Death: A Study in Censorship* by Gershon Legman, *The Love Letters of Henry VIII, A Study of the Love Emotions of American College Girls* by Albert Ellis, *How Not to Be Love-Starved* by David Oliver Cauldwell, *Meaning and Content of Sexual Perversions: A Daseinsanalytic Approach to the Psychopathology of the Phenomenon of Love* by Medard Boss, *Four Seek Love* by Clement Wood (a title incidentally that could also be summoned up by searching the catalog for the "Kinsey subjects" of *coitus* and *incest*). A copy of *The Canterbury Tales* also pops up under that word *love* and although nobody would doubt that Chaucer has a great deal to say on the subject, the question is, if you're going to start with fourteenth-century English literary texts, where exactly are you going to stop? It seems that Kinsey saw no reason to stop anywhere whatsoever.

I chose 1949 for the search because that was the year after publication of Kinsey's book on male behavior, the year the institute started receiving royalties. The book was a massive, scarcely imaginable success, an incredible best-seller. Kinsey and his institute now had money of their own, and there's nothing like a sudden influx of cash for making a collector reveal his true colors.

Kinsey already had a network of booksellers and dealers who were keeping their eye out for materials that might be of interest to him. Since he was interested in just about anything, and far too busy to do much quibbling or even order-checking, some of his contacts now took this opportunity to unload some dead stock on him. Robert S. Morrison, of the Rockefeller Foundation, wrote in his diary after visiting the institute, "It seems quite clear that Kinsey and the others have a very vigorous drive to collect things without always knowing why."

Since there was really nothing of a sexual nature that Kinsey didn't collect, his acquisitions, combined with all the other things gathered and donated since his death, really do amount to a universal collection. They've got pretty much everything sexual you can think of at the institute. There are erotic artworks and artifacts, about seven thousand items, everything from Picassos to pornographic ashtrays. There are about seventy-five thousand photographs, professional and amateur, arty to obscene. In addition to the films shot by the institute under Kinsey's direction, there is footage of animals mating, anthropological movies, porn films, erotic "art" movies: eight thousand films, four thousand videos. There are diaries, journals, erotic fiction, scrapbooks, private photo albums. Recently people have started downloading images from the Web, putting them on CD or DVD, and sending those in, documenting the current state of erotic technology while also displaying their own preferences and fascinations.

In its current form the collection also includes archival material from other sex researchers—Magnus Hirschfeld, John Money, Havelock Ellis, and Alex Comfort, among others—and there's material relating to the Sexual Freedom League and *Eros* magazine. Some of these things are much racier than others. The Ellis collection, for instance, contains correspondence relating to the National Committee on Maternal Health (1930–33), which really isn't much of a match for the "magazines, catalogs, advertisements, sketches and commercial photographs of bondage/pseudo-aggression (1971–1978)" to be found in the Alex Comfort collection. But it is all great, fascinating,

intriguing, important stuff. And for two days I got to hang out there at the institute and look at pretty much anything I wanted to. For a man interested in sex collecting, who'd long been fascinated by Kinsey, it was a sort of dream come true.

It will give you some indication of the kind of adolescence I had if I tell that for the last couple of years of my schooling I spent most Wednesday afternoons bunking off games and then, instead of hanging about in coffee bars and smoking cheap cigarettes as seemed to be the style at the time, I went to the main public library and tried to fill in the gaps that my English grammar school education was so obviously leaving. That's how I discovered Kinsey and his reports.

A boy could read Kinsey in a public library in those days without drawing much attention to himself. In their somber burgundy-and-blue bindings, published by the W. B. Saunders Company of Philadelphia and London, they looked sober and scholarly, which of course they were, but they were also extravagantly titillating if you happened to be a sixteen-year-old.

My interest might not have been strictly scholarly (though at that point it was certainly largely academic), but I did have a serious curiosity, about sexuality in general and my own sexuality in particular, and knowing where the two coincided, or failed to, was endlessly engaging. And that is surely something that I, and just about everybody else, share with Kinsey. When it comes down to it, we're all sex researchers, aren't we? And if, as I read his books, I was more interested in the sensational and the extreme manifestations of sexuality, well, again Kinsey seemed to be on my side.

Yes, he may have believed that all data was important, but the data you got from more or less virginal college girls clearly didn't fascinate him in quite the way that data from sexual athletes and exotics did. For my part, I wasn't at that time terribly riveted to read about the

variations in sexual behavior as they related to education or father's profession. I was far more intrigued by, say, a "set of observations" in the male volume concerning a "Negro male" who'd averaged three orgasms a day from the age of thirteen to thirty-nine, and "at the latter age was still capable of 6 to 8 ejaculations when the occasion demanded it." I don't suppose anybody's ever read Kinsey for the prose style, but that sentence strikes me as demonstrating a wonderfully deft turn of phrase.

I was probably even more intrigued to read in the female volume that "there are some females who regularly reach orgasm within a matter of fifteen to thirty seconds in the petting or coital activities." This sounded like very good news to me back then, and it must still be very good news today for "some females" and their partners.

I've looked at both Kinsey volumes again recently and, not surprisingly, they're a good deal less titillating to me now than they were back then. This is probably no bad thing. To be stimulated in the same way by the same things thirty years on would show a certain lack of development. It's good to have grown up. And our society has grown up, too, in certain ways, and Kinsey has played quite a part in that growth.

Even back then, however, there were indications that Kinsey belonged to an earlier age. According to his data only 5 percent of females had had more than eleven premarital sexual partners. At the time I was reading his books I already knew several girls who would have skewed his statistics. In the twenty years between Kinsey's time and my own adolescence, the Pill had been invented and embraced. In one way that seemed to have changed everything. In another way, however, reading Kinsey, and many years later looking at his collection, seems to prove that there's something at the very heart of sexuality that hardly changes at all over the millennia and throughout different civilizations. Kinsey would be pleased to have me say so. To that extent I am a Kinseyan. But, as I say, we all are.

You could argue that I entered the inner sanctum at the Kinsey Institute under very slightly false pretenses. I say this in case anyone there reads this and makes the same accusation. I went there as "assistant" to someone—actually my girlfriend—who now works for a book publisher (not mine), and she went there to discuss publishing one or more books based around the archive. The Kinsey is keen to do this sort of project, since like any educational institution they need all the income they can get. The project faltered, unfortunately, but the intentions were sincere enough at the time, and I certainly assisted, mostly by helping with some photography, asking, "Hey, what's in this box?" and then, using an expert's jargon, saying, "Wow, this stuff is really amazing." That I had my eye on another kind of project, too, is undeniable.

The Kinsey looks and feels like a perfectly ordinary academic institution in many ways. It's housed in a Victorian Gothic building on the Indiana University campus in Bloomington. There aren't any signs around saying "Vast Sex Collection This Way" but the place is welcoming enough. Inside it presents the standard set of corridors, offices, meeting rooms, notice boards, cheap durable furniture, and so on. But there's one thing that completely gives the game away, and that's their choice of pictures decorating the walls. The people at the institute are evidently immune to being surprised or shocked by anything sexual, but some of these images were pretty eye-popping. A series of large, close-up photographs of women's faces while they were having orgasms wouldn't be regarded as standard decor in many institutions I can think of. As a result of writing this book, however, I do understand how people can come to accept the most explicit representations of sexuality and take them in their stride.

My guide through the collection was Catherine Johnson, the institute's curator, a calm, middle-aged, amused woman with a background in art history. She was someone who had seen it all, many

times, and some of it obviously struck her as a bit tired. The image of the lighted cigarette inserted in the pussy, for example, is evidently one that generations of photographers, male undoubtedly, have found pretty darned hilarious. I saw dozens of examples in the archive. For Catherine Johnson the joke has worn a little thin, but she seemed philosophical, and resigned to the repetitive nature of human sexuality rather than overtly critical of it.

There's a small permanent museum at the Kinsey that shows some fairly standard sex-museum artifacts: Oriental erotica, a fetish corset and high heels, some artfully displayed condoms stretched around what look like test tubes. It was all interesting enough, but given what we knew lay ahead, these exhibits seemed a bit tame. I wanted to go behind locked doors and in due course I did.

I don't for a moment think that I saw "all" the Kinsey archive, and I don't just mean that I didn't see every single item they owned—that would have been impossible anyway, even if you had all the time in the world at your disposal—rather I mean that I got the feeling there were inner sanctums within inner sanctums, locked boxes within locked boxes, subcollections that showed the true heart of sexual darkness. I have only the slightest evidence of this.

Most of my two days at the Kinsey were spent in a large, thoroughly institutional, climate-controlled basement room. No daylight would ever penetrate these regions, and shadowless fluorescent light poured down from overhead. Of all the sex collections I've ever seen this was by far the most orderly. In fact I think it was probably the most orderly room I'd ever entered in my life. This is not precisely the way the collection was arranged or housed when Kinsey was alive, but the taxonomist in him would surely have approved mightily. Here was organization, here was classification, here was data ready to be accessed, marshaled, interpreted.

All around the room were metal cupboards and metal shelving. The cupboards had their doors firmly shut. On the shelving were row after row, column after column, of blank, bland library storage

boxes, each with a small, inscrutable label. There was nothing to see. Everything was concealed and stored away. And yet I suspected that if you opened any cupboard door, took the lid off any box, you'd be presented with evidence of the wildest, most chaotic sexuality. My suspicions proved to be absolutely correct.

Catherine Johnson donned a pair of white gloves to protect the things she touched. This is common practice for any curator, but the effect here was to make her seem like both a surgeon and a conjuror. She began by opening the metal cupboards. It wasn't precisely like opening a Pandora's box, but it was certainly like gaining access to a variety of cabinets of the highest sexual curiosity. These cupboards contained *things,* not images of things, not written words about things, but objects and artifacts, ancient and modern, some useful and some decorative, some really quite tasteful and some utterly kitsch and vulgar. Some of them could no doubt have been construed as folk art, though some of them looked more like knickknacks and holiday souvenirs, and by no means all of them had gained much charm or status simply by virtue of being old or in a collection.

There were cups and mugs with naked women as handles, a set of thirty-six different king-size coasters all on the theme "Sexual Misbehavior in the Human Female." There were hundreds of what I suppose you'd have to call figurines, models of naked people, sometimes just posing, sometimes actually having sex: some sedate Art Deco bronzes, lots of Central American fertility figures in clay and terra-cotta, a Santa Claus exposing a festive pink erection, Egyptian carvings of naked slaves, a wooden, articulated, copulating couple made by an inmate of San Quentin prison. Quite a few of them were lying around unboxed on the cupboard shelves looking like some highly detailed, yet not quite to scale, model of a mass orgy.

Sometimes all you saw was a box within the cupboard, and although these were usually labeled, the labels often left you none the wiser. What exactly was contained in boxes marked "Twentieth Cen-

tury Flower Cards" or "Scarf Trick When Folded" or "Microscopic Photos on Plastic Rods," or my favorite, "Phallus with Agricultural Tools"?

There were, need I tell you, a great many phalli—from all over the world, from many historical periods, made from wood or horn or ivory or plastic. Some were designed to be strapped on and so came with ties and ribbons. One was a pink, ribbed thing called a "Wife Tamer—100% guaranteed." And there were some Japanese molds for making yet more phalli. Cynthia Plaster Caster would surely have been envious.

There was a substantial box labeled "Male Feminization: Clothing and Miscellaneous." It contained shoes, stockings, wigs, restraints for arm, leg, and thigh, dildos "large and medium" according to the label, and something cataloged as a "Small blue plunger?" That question mark is theirs, not mine.

Catherine Johnson's white-gloved hands, holding a water pistol.

There were Japanese scroll paintings, erotic scrimshaw, painted erotic miniatures, playing cards, T-shirts, badges—one that plaintively announced, in red letters on a yellow background, "Pornography Is Fun." And frankly there was some very odd stuff that you thought probably didn't really belong there at all—the penis bone from a raccoon, a chunk of Mr. Zog's Sex Wax: "Hey, dude, that's something you use on your *surfboard!*"

The Kinsey owns some very serious art by some very serious artists—Matisse, Hogarth, Leonore Fini, Otto Dix, Paul Cadmus—and at least some of it was in this basement room. The chance to look at these examples of high art was irresistible, and I didn't entirely resist, but in a way they weren't so very compelling because they were extant. We're already familiar with these people's work. Far more attractive were the boxes labeled "Artist Unknown," though even here some seemed far more unknown than others. Some people, it turned out, had actually signed their work, it was just that they were too obscure to be thought of as "known."

Some of this "anonymous" art was very skilled, by accomplished artists satisfying their own or someone else's erotic imagination. Some was just as obviously wholly amateur, some was cartoonish, some as crude as could be. There was a fair bit of work by prisoners. All the usual and unusual sexual practices were represented, performed by singles, couples, groups. Among the more remarkable items: a rosy-cheeked couple urinating to each other's evident delight, a milkman filling bottles with his semen prior to delivery, a rather well-drawn pair of legs in high heels and fishnet stockings but where the woman's body should have been there was a huge egg instead. There was a fair amount of cheerful zoophilia, some of it more or less conceivable, involving ducks, dogs, and so forth, some involving more fantastical, not to say mythological, scenes. There was a drawing of a man having his penis "ironed" by a surprisingly

benign-looking woman, and a painting of a group of 1920s flappers holding a man at gunpoint and forcing him to perform oral sex on them. That old chestnut.

The artifacts, the paintings and drawings, were all great, but I suspected I was going to enjoy seeing the photographs even more, and I was absolutely right. The Kinsey owns a big collection of work by two pioneering gay photographers: Wilhelm von Gloeden (who generally tried to make naked Italian lads look like Greeks) and George Platt Lynes (who succeeded in making naked ballet dancers always look pretty much like naked ballet dancers). I had seen original work by both of them in Vince Aletti's apartment. The Kinsey also has lots of work by photographers such as Arnold Newman, Irving Penn, Andre de Dienes, and Joel-Peter Witkin, but as with the high art, these weren't really what intrigued me.

You see, one whole section of the room's shelving, probably a majority of the boxes around us, contained what is known as the Documentary Collection: fifty thousand or so more or less anonymous erotic photographs. Am I being hopelessly naive and literalist if I say that photographs of sex seem to me far more intense and real than drawings or even personal written accounts? And even if the answer is yes, the fact remains that I do feel that way. As far as I was concerned, the Documentary Collection was the star attraction. This was what I really, really wanted to see.

If the rest of the archive was highly organized, the Documentary Collection was organized to within an inch of its life. Kinsey had a system, oh boy did he have a system, whereby any sex photograph you can imagine, and many you possibly couldn't, would be given a code, consisting of letters, abbreviations, and male and female symbols indicating what kind of activity was going on in it. The boxes on the shelves were duly labeled with these codes, so that each box contained a group of photographs showing the same activity. The compare-and-contrast element is always important in any collection, and here you had the opportunity to see multiple examples of three-

somes or oral sex or dildo insertions or whatever, and check them for similarities and differences.

The Kinsey "code" is a long way from being uncrackable. GO, for instance, stands for genital oral, FTSH stands for fetish, SDM for sadomasochism, WRSTL for wrestling. (There were far more photographs in the wrestling category than I'd have imagined.) The titles on some of the boxes hardly seemed coded at all. In a box categorized as HUMOR 1915–20 a blustery, big-thighed, grinning woman with splayed legs and bared vagina posed above a handmade sign that read "Stick It in Quick." In the box SCAT 1940–63 was a photograph of a masked couple, she smoking a cigarette, he smoking a pipe, she holding an empty glass over his penis, he holding a beer bottle at the opening to her vagina. Undoubtedly there was some scatological intention here, but I'd have thought there was some humor there as well.

There were, however, places where the code became overwhelmingly arcane. I suppose this is to be expected. Something very specific and rare is quite easy to code. But where you have thousands of photographs that simply show a naked figure, or a couple having more or less conventional sex, it's hard to know how to make meaningful distinctions between them. To deal with so much overt similarity, the code was developed to describe the placement of bodies, hands and arms, whether the genitals were covered or not, the relative positions of participants.

In fact this system was devised by Paul Gebhard, at Kinsey's request, and the evidence is unclear as to whether Gebhard had a very wry sense of humor, or no sense of humor whatsoever. He went to enormous lengths to provide precise written definitions of what was meant by the terms *standing, sitting, stooping;* definitions that came with diagrams of the angles at which sitting became lying and so forth. This leads to labels that read "C (♀) Stoop DV 1935–1964" or "C (♀) Supine VV (♂) Arm prop 1910–1946." I can only make guesses at what these mean.

I've spent a lot of time being intrigued and amused by this coding system. There are times when it strikes me as plain madness. What possible use is there to be made of this kind of categorization? Okay, so the guy in the photograph was supine, so his hand was raised; I mean, what are you actually ever going to be able to *do* with that information? Especially when certain other forms of categorization, race or age for instance, don't appear in the code at all. Other times I think, "Well yes, fair enough, you couldn't just have fifty thousand photographs in one big pile, could you? You'd have to classify them one way or another, especially if you were a taxonomist like Kinsey." The very act of collecting at all demands some kind of categorization and ordering, doesn't it? What other system could you devise that wouldn't ultimately be just as quixotic?

Personally, I suspect I might have had just as much fun delving into some great unsorted, unfiled mass of photographs as I did looking through this highly organized collection, but if nothing else it enabled me to keep a scholarly dignity. Since there was no possibility of seeing everything, a day was spent choosing boxes of photographs more or less at random, the process sometimes made more random still, and certainly more tantalizing, by the abstruseness of some of the labeling. It was by a very long way the most fun I've ever had in a university archive.

And again, inevitably, I was attracted to the more outlandish, the more extreme end of things. Conventional pinup or art photographs just don't hold the attention the way photographs of, say, 1950s suburban housewives elaborately roped to their dinette counters, or performing enthusiastic analinctus, do. They just can't.

Looking at any "found" photograph is always a complicated experience. There's usually some comedy from the quaintness of the pose and the silliness of the fashions, but there's usually a certain amount of self-recognition, too, since we know that we look equally quaint and out of fashion in our own old photographs. And inevitably there's

some melancholy. These people in the found photographs are now absent, certainly transformed, very possibly dead.

When it comes to looking at found *erotic* photographs everything is notched up a little. The poses seem sillier. Why did he feel the need to keep his hat on? Couldn't she at least have washed her feet? And the melancholy of absence seems far more poignant. To be having sex, even if only for the benefit of the camera, implies a certain vitality, a profound separation from mortality and death. And yet these old photographs, of people probably now dead, remind us that the separation isn't so profound after all.

I can't imagine there's anyone who wouldn't find some of these images in the Documentary Collection to be appealing or entertaining, touching or arousing, even if many, possibly a majority, left you cold. You'd have to be inhuman not to find some of this stuff a turn-on. But equally I can't imagine anyone who wouldn't find some of these images shocking or offensive, to say nothing of obscene and potentially illegal. The collection acts as a sort of Rorschach test. What you see reveals who you are.

I'm not sure that Kinsey had much insight into himself as a collector, or felt that he needed any. I don't think he considered collecting to be anything remotely in need of explanation. But he did once write about the subject, thus:

> Most of us like to collect things, and some of us have quite a dose of that instinct. Some folks collect stamps, others collect cigar bands, or autographs, a pocket full of junk, or dollars and dollars. Whatever their value or lack of money value, all collections are very real possessions to their owners. If your collection is larger, even a shade larger, than any other like it in the world, that greatly increases your happiness. It shows how complete a work you can accomplish, in what good order you

can arrange the specimens, with what surpassing wisdom you can exhibit them, with what authority you can speak on your subject.

This seems so naked, so guileless, so freighted with sexual undercurrent and unintentional revelation, that you've got to feel a little embarrassed for the man. You feel he really shouldn't be giving this much of himself away, especially not when writing a biology textbook for high-school students, as he was here.

The book is *An Introduction to Biology,* published in 1926. My own copy once belonged to a schoolboy called Richard Mickelson. He was issued with the book by the board of education of the city of Chicago in 1929, and if the label inside is anything to go by, he never returned it. This label also suggests that he was nicknamed Pickle. Perhaps schoolboys were a little more innocent back then, but even so I can't imagine the lad who wouldn't be sent into exquisite paroxysms by one of Kinsey's photographs captioned *Dung beetles rolling their balls.*

The quotation about collecting appears in a chapter entitled "Taxonomists as Explorers." Kinsey suggests that the reader "may want to know why some men spend their lives giving names to plants and animals, and arranging them in classifications." And his answer is "For the fun of it!" He then promises to show us precisely what fun taxonomists have. Kinsey's idea of fun, by his own account, involved collecting specimens, making discoveries, traveling, exploring, hiking, camping, and living out of doors, preferably while wearing a wool shirt and khaki trousers.

I have put up with lumberjacks and miners, slept with hermit prospectors whose blankets were undescribable and unforgettable, met cattlemen and sheep herders . . . have been held for a day by moonshiners, have passed bulls in narrow canyons . . . Of these and of more I might tell you, rambling along, if our fire burned not too low.

In all of those days I collected insects. I also collected memories of trails, of hundreds of camps, of such folks as are to be met, and stretches of glorious countries. I am not certain which of my collections is the more precious.

But now do you see why some men are taxonomists?

Well, Alfred, only up to a point. This is also, I know, a passage that suggests I may have been wrong about the sprightliness of Kinsey's prose.

In the beginning at least, Kinsey's own collecting was multifaceted. He didn't collect only sexual material, just as previously he hadn't collected only gall wasps. He had a big record collection, for instance, at a time when such a thing was comparatively rare, and he held soirees at his house where he'd play the records, and lecture his guests on what they were hearing. Later, in a similar way, he'd lecture his staff while they were watching live sex acts. He gardened but not just for recreation, and he put together a vast collection of irises, even running a mail-order business in iris bulbs. He wasn't much of a boozer, but he learned to drink in order to get on better with his interviewees. He transformed this into a form of collecting by amassing a large number of cocktail recipes, mostly rum-based apparently—Planter's Punch and the Zombie being particular favorites. Eventually his interest in sexuality became so all-consuming that he didn't have much time for his other collections, or even other topics of conversation, but by then his sex collecting was so diverse and all-encompassing that it's hard to think of it as narrow exactly.

If there's one meeting in the history of sex collecting that I'd like to have witnessed, it was the one that took place in 1944 between Kinsey and the legendary, egregious Mr. X, a man referred to as "Kenneth S. Braun" by Kinsey's biographer Jonathan Gathorne-Hardy, but in reality called Rex King, an otherwise unremarkable government

employee. The guys at the Kinsey thought they'd seen everything, but they knew they'd never seen anything like Mr. X. Kinsey had been aware of him for a while, he'd been recommended as a particularly prime specimen of a certain sort of polymorphous, all-accepting, all-consuming sexual player. He was off the charts in terms of what he'd done, how many times, with how many partners. But he needed to be handled gently, flattered and seduced into giving up his data. As part of the seduction process, Kinsey wrote to him, "I congratulate you on the research spirit which has led you to collect data over these many years." Research? Data? Well, that's one way of looking at it. Kinsey had to "collect" him. He and Ward Pomeroy traveled eighteen hundred miles to interview Mr. X: it took seventeen hours to record his sexual history.

Mr. X was like Kinsey in some respects, scientific in his way, a collector of data, a recorder of information, something of a taxonomist. Like Kinsey he loved to observe. When he traveled he drilled holes in hotel-room walls so he could watch what was happening in the adjacent room, then he'd write down what he'd observed. Not that you'd think he needed that sort of distraction or stimulation since he seems to have constantly been having sex with everyone and everything he ever encountered.

Mr. X was, by any reckoning, an abused child. He was introduced to heterosexual sex by his grandmother, to homosexual sex by his father, eventually having sex with seventeen members of his own family. As an adult, he had sex with thousands of men and women, and "animals of several species" according to Pomeroy, though he doesn't tell us which ones. Mr. X had a complex and ritualistic masturbation regime that sometimes involved mechanical devices. He was also a pedophile. He had sex of one sort or another with six hundred preadolescent boys and two hundred girls (these figures are again Pomeroy's), from babies upward, often apparently with the mothers' assent and cooperation. Having had sex with the mother, he'd have sex with her kids, too. And all the time he was recording

and measuring: penis and clitoris size, amount of semen ejaculated, length of time to orgasm. At the age of sixty-three he could have his own orgasm in ten seconds, a feat that he demonstrated during the interview. He kept a diary because, according to Gathorne-Hardy, "erotic description was a way of experiencing it a second time." He also took a lot of photographs.

A lot of the information provided by Mr. X on preadolescent sexuality appears in Kinsey's books in a more or less undigested form, with phrases like *we have data* hiding the source. Of all the sticks that have been used to beat Kinsey, this is the one that refuses to break. At the very least you have to feel Kinsey shouldn't have chosen a pedophile to be his authority on childhood sexuality. Another option would obviously have been to report him to the cops.

You can see why Kinsey didn't do that. If he'd started blowing the whistle on people who performed illegal sexual acts—and in America in the 1940s some of what we now think of as entirely harmless practices were very much illegal—his sources of data would surely have dried up entirely. This, arguably, would have been the greater harm. The interview was also, *pace* Foucault, a form of confessional. Like a priest, Kinsey would ensure the sanctity of the confession, although he was not a man to instruct you to perform penance. So yes, Kinsey's acceptance of Mr. X and his data is understandable—data was data, Kinsey would have argued—but it still leaves you feeling very uncomfortable, because some of Mr. X's research wasn't "just" data, it was evidence for the prosecution.

I saw no explicitly pedophilic photographs in the Kinsey's Documentary Collection, and I certainly didn't want to, but you know they have to be there somewhere. The more ordinary photographs that Mr. X took are no doubt to be found in the body of the Documentary Collection, but apart from the date and the code, they're now pretty well anonymous. Mr. X's collection has been spread around, been subjected to a more rigorous classification system.

Although Catherine Johnson was entirely welcoming, good company, and very generous with her time and expertise, she was noticeably watchful. She didn't want to leave some stranger there in the archive unattended. I don't blame her. I had no intention of stealing anything, but she didn't know that, and I can't absolutely guarantee that given the opportunity to own a piece of genuine Kinsey archive, I mightn't have slipped something small and quirky into my pocket. I was glad not to be tempted.

However, there was some evidence that others might have given in to temptation. We took a look in a locked room where runs of erotic magazines were kept. What I'd come to think of as the Kinsey paradox was much in evidence here, too: some very racy sexual material, sanitized by the severest, most boring-looking bindings.

I asked to see some "Spicies," a series of magazines from the 1930s, pulps more or less, with titles like *Spicy Adventure, Spicy Mystery, Spicy Detective,* even *Spicy Western*. They seem tame enough now, and they have rather charming painted covers, but in their day they were the most sexually explicit magazines you could buy. Today they're massively popular and desirable, with collectors paying $500 on eBay for a particularly choice issue.

The Spicies weren't to be found in the magazine room at all, despite being listed in the catalog. The library assistant was certain they had to be there somewhere, probably misfiled, but he didn't sound very convincing or convinced, and the room really wasn't that big and not at all disordered, and after a brief search he certainly failed to find them.

Perhaps the guy was right. Perhaps we were seeing a simple act of incompetent librarianship, but other possibilities inevitably presented themselves, chiefly that someone had simply stolen the magazines, either because they'd been driven by their own urgent sexual or

acquisitive needs, or because they wanted to make money selling them. Either way the Kinsey collection was being redistributed, only very slowly and very slightly perhaps, but for all the massive ingathering and accumulation, there was also leakage. The inevitable regrouping, reordering, and changes of ownership that accompany all collecting was going on here, too. I know I should have considered that to be a terrible, terrible thing, that the integrity of the Kinsey Institute and its collection was being hurt, but given the compelling nature of sexuality and collecting, it seemed not only inevitable but thoroughly human and natural. I think Kinsey would have understood.

11

THE FATHERLAND, THE MOTHER LODE

Porn art, an old Etonian, a book club,
some barbed wire, a failed collector.

> I defy any lover of modern art to adore a
> painting as a fetishist adores a shoe.
>
> —Georges Bataille in *"L'Esprit moderne*
> *et le jeu des transpositions"*

In a project like this, there are always the ones who got away, collectors you want to talk to, whom you feel you *ought* to talk to, the ones whom people say you really *need* to talk to. You accept all this, but sometimes it just can't be done. You can't make contact, or you make contact and they don't want to talk, or neither party is in the right place at the right time.

One of my first significant misses was Hans-Jurgen Döpp, a Dutch collector based in Frankfurt, an art historian and psychologist who has written a number of books about collecting and helped put together the Beate Uhse collection in Berlin. I made contact with him quite early on and he seemed willing to talk, and I was more than willing to go to Frankfurt to see his collection. But after a promising

243

exchange of e-mails the trail went cold and I couldn't warm it up again.

Then there was, and no doubt still is, an English female shoe collector called Angie Kurdash whom I read about in *Shoo* magazine. When she was fifteen she saved up all her allowance and spent £500 on a pair of Vivienne Westwood cream-and-chocolate-brown buckled bondage boots. At the time of the article she owned about a thousand pairs of shoes, vintage Manolo Blahnik, Westwood and Galliano, classic and modern Dior and Sonia Rykiel. She particularly loved her Dior hand-painted, spike-heeled Saigon mules. However, 70 percent of the collection bore the Gina label, not surprising when you realize she's married to Aydin Kurdash, one of the three Kurdash brothers who run the company. Pride of the collection is a pair he made for her in pale green alligator, with enough diamonds in the buckle at the front to bring the value up to about £18,000. In truth I wasn't too unhappy to let her get away. It would probably have been possible to talk to her about her collection, but since I'm the author of a novel called *Footsucker* I thought it might come over as just too weird.

And above all others, the one who really got away was Paul Reubens, better known as his character Pee-wee Herman. In November 2002 the Los Angeles City Attorney's Office charged Reubens with one misdemeanor count of possessing material that depicted "children" engaged in sexual conduct. (The quotation marks are mine, not the attorney's.) Police duly seized some thirty thousand items from Reubens's home.

This constituted a large chunk of Reubens's collection of what he called "vintage erotica," though probably no more than 30 percent. The number of seized items was so high because police also took away a lot of distinctly nonerotic photographs and family albums, as though it might be suspicious to own pictures of yourself as a child.

If you believe Reubens, and I think I do, his problems stemmed from a mania, not for sex, but for collecting. His home, by all accounts, is a crammed treasure-house of kitsch collectibles, and

when he began acquiring retro porn—mostly 1950s and 1960s magazines, photographs, and films, although there's some original art there, too—he did so on the grand scale. He bought up other people's entire collections, and in such quantities that when they arrived he never even had time to open many of the boxes, let alone check every single item for decency and legality.

Detectives from the LAPD evidently had more time on their hands. Having been through the thirty thousand items, they said they'd found images of underage boys. Reubens's position, in the literal sense, was indefensible since he admitted he had no precise idea what was in his collection. However, given what we know about retro porn, it seems perfectly likely that somewhere in one of the magazines or films there was some seventeen-year-old strutting his stuff. Reubens was certainly in no position to say there wasn't. So the case might well have come down to the question of whether acquiring such materials *unknowingly* is any sort of mitigation, a nice legal point I'd have thought, but as it turned out Reubens never had his day in court.

When I first became interested in Reubens he was thinking about publishing a book of his collection, at least the part that hadn't been seized. His idea was that once the public saw how playful, harmless, and *ironic* his sex collection was, they'd understand and forgive all. This struck me as a very, very risky strategy, but all the more fascinating for that reason.

At that time it seemed he might be willing to talk to me. I hoped he might think an interview would form part of his public mission to explain. I tried direct approaches and sideways approaches, and it looked promising for a while, but then he ran me past his public-relations people and they decided I'd be bad for his career. In any case, he copped a plea. In exchange for pleading guilty to a misdemeanor obscenity charge, Reubens was fined a hundred dollars and given three years' probation, during which time he wasn't allowed to have unsupervised contact with minors. He also agreed to register as a sex

offender. And then he gave an interview to *Entertainment Weekly*. "It's been made to sound exclusively gay, but it's not" was one of his comments.

The LAPD destroyed 170 items, and in that same article Reubens reacted by saying, "It's like book burning." I'd have thought some of it actually *was* book burning but perhaps I'm being too literal. I understand that as time's gone by the police have gradually returned parts of his collection, and the last I heard he was again thinking of publishing a book to show how innocent his collection really is.

For a variety of reasons, not least moral repugnance and the desire not to be arrested, I've resisted the urge to "investigate" the collectors of what we might call child pornography, although in some cases I think we might call it something else. In the art of Franz von Bayros and Graham Ovenden, in photographs by Lewis Carroll and Irina Ionesco, in writings by Nabokov and the anonymous author of *My Secret Life,* in the British Library and in the archives of the Kinsey Institute, you'll find plenty of depictions of the sexuality of the very young. Underage sex, however defined, provides a frisson of the extreme and the forbidden, and it seems that historically it always has. We are currently required to be appalled by its very mention. However, things that appall also tend to have the unfortunate power to excite. A simple picture of a naked child now seems as transgressive and as unacceptable as the most extreme pornographic image. I'm hardly the first to point out that the professed desire to protect the innocence of children is in itself a part of their sexualization.

And it's not only the perverts who are running scared. When I saw my girlfriend tearing pages from some 1970s men's magazines she'd acquired, I had no doubt what she was doing: destroying those parts of the magazine that contained mail-order ads for "Lolita" material—in this case pornographic playing cards published by *Lolitots* magazine, a companion to *Nudist Moppets*. My girlfriend didn't want them in the house, which is to say she feared the knock on the door from the cops, a thoroughly reasonable fear.

Jeremy Beale, the managing director of Quartet Books in London, reports a visit he received from the Metropolitan Police, who had suddenly become interested in a book his company had published, written by Peter Webb, entitled *Hans Bellmer.* The book contained a postage-stamp-size reproduction of a Victorian photograph, which (undeniably) showed a man having sex with two children. Webb included the image to indicate (again undeniably) that Bellmer had used it as source material for his art.

The book had been published quite a few years before the police arrived at the Quartet offices, and the inclusion of the image had caused no trouble until then. In fact, at the time of the visit, the book was already out of print. But Webb had now been charged with, and was subsequently jailed for, having sex with a minor. The police had gone through his personal collection and found his book containing this image, and by Jeremy Beale's account, they were now very keen to cause the publisher some anxiety, to assert how seriously they took the matter, and to suggest they were contemplating a prosecution.

Nevertheless, the visit wasn't without its comic aspects. The cops were entirely baffled by the idea of book publishing. Their questioning was along the lines of "Where are these books? Who have they been sold to?" Jeremy had to explain that the books were largely in the hands of private citizens who'd bought them quite legally in bookshops. He was also able to tell them that there were copies in the libraries of various colleges and art schools around the world. Jeremy recalls the encounter as being absurd, but no less scary for that.

Finally he had to write a letter promising that Quartet wouldn't reprint the book, a deal that he's stuck to. However, there's an American-published academic tome on Bellmer currently in print that reproduces this same pedophilic image. Given the incredibly low quality of the reproduction in the book, I'd guess it was scanned from the Quartet edition, but the blotchy graininess does disguise some of its explicitness.

If I was sad to miss out on Hans-Jurgen Döpp, Angie Kurdash, and Paul Reubens, and if I was more than happy to miss out on the collectors of child pornography, there was one collector I absolutely wasn't prepared to let get away, whom I came increasingly to think of as indispensable, and that was the legendary Karl-Ludwig Leonhardt.

From the moment I started researching, people kept telling me that if I was serious about meeting sex collectors, Herr Leonhardt was the man I had to see. They described him as a wealthy, shadowy, distant figure, based in Hamburg, in Germany, who might very well not be willing to talk to me. It sounded like a challenge.

Once I was aware of him, his name came up repeatedly in all sorts of contexts: as expert, connoisseur, publisher, translator, editor, and bibliographer, as well as very serious collector. For instance, he was responsible for a three-volume work called *Ars Erotica,* showing French erotic book illustration from the eighteenth century. It includes all the title pages and all the plates from all the books described, books that he owns. As Patrick J. Kearney gently puts it, "It is unlikely that anything of importance has been omitted." I'd seen Patrick's own copy. I also knew that when he was researching his history of erotic literature he'd visited Leonhardt because he owned books that simply weren't in any libraries.

Under the pseudonym Ludwig von Brunn, Leonhardt had edited a book of Franz von Bayros illustrations, and I was particularly impressed by another of his works, a bibliography cowritten with Franz Bayer called *Seltun und Gesucht* (literally, "Rare and Searched For"), which is essentially a bibliography of erotic bibliographies. One section within it is called *"Bibliographien der Bibliographien,"* so in the context of the whole book this part actually becomes a bibliography of bibliographies of bibliographies. I liked that a lot, though it

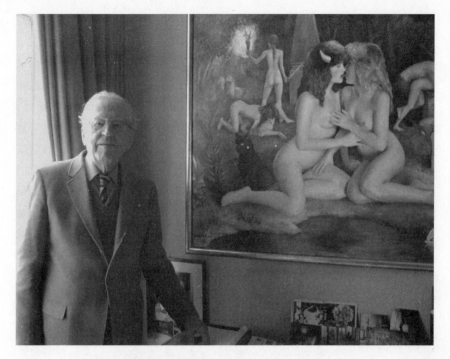

Karl-Ludwig Leonhardt in his Hamburg apartment.
The painting is by David Russell.

was a little disappointing, if hardly surprising, that there were only three books in that particular category.

Joe Zinnato had also visited Leonhardt in Germany. He and a dealer/editor called Jeff Rund had been involved in an abortive project to set up a Web site of fetish art and had been to Leonhardt's home to scan some of his collection. Joe spoke of Leonhardt with awe, and gave the impression that he owned anything and everything you could possibly think of in the way of erotic art and literature, all of it of the very highest quality.

Herr Leonhardt gradually came to seem vital to my collection of collectors, and I decided I'd better have my ducks in a row before I tried to make contact with him. So, on a freezing January weekend I made a journey to Hamburg, to the Museum of Erotic Art, which is

housed in a vast, empty, occasionally unsettling industrial space, a for-mer warehouse now packed with art, real art by real artists, not just "erotic art." For long stretches I was the only person in the museum, and there were moments when I was able to entertain the mad fantasy that this collection was all mine, and that I was moving from room to room, savoring the highlights of my own collection.

In fact, I was well aware that the vast majority of the work on dis-play there, about 80 percent, belonged to Herr Leonhardt and had been loaned by him to the museum. Even if he owned the "worst" 80 percent, that was still a pretty remarkable collection. Here were large numbers of eighteenth- and nineteenth-century erotic prints and etchings, grouped together thematically: solo sex, group sex, sex and food, sex with animals. There were many Japanese woodcuts and scroll paintings. There were works by Bellmer, Grosz, Hockney, Picasso, significant quantities of Felicien Rops and Franz von Bayros, pop art by Mel Ramos and Allen Jones, thirty or so ink drawings by Cocteau, a whole room full of sixty or more works by Tomi Ungerer. There were some terrific anonymous 1950s pinup drawings, some fetish work by Eric Stanton and John Willie. There was an antique glass display case with dildos, erotic tiles, pillboxes, eggs painted with corsets, a phallic glass bottle complete with balls.

However, the most devastatingly erotic works on display were in the basement, dozens of photographs taken by a French photogra-pher called Dahmane. They all featured the artist's partner, and cer-tainly collaborator, and very possibly muse, Chloë des Lysses. She looked like a slightly old-school fashion model, very serene, very self-possessed, very sophisticated, very French. She certainly didn't look like the sort of woman who'd be performing the various sexual acts that she actually is performing in the photographs—chiefly putting things in her vagina and/or anus, things like dildos, vibrators, carrots, a pencil, a Coke bottle (blunt end first, in the rear). In certain photo-graphs she's being given a hand by a couple of rather elegant, anony-mous, sinister haut-bohemian older men.

In fact I'd seen some of these pictures before in a couple of books, *Porn Art* and *Porn Art 2,* and I knew that Dahmane and Chloë were, or at least had been, a couple. Subsequent research revealed that although Chloë des Lysses may not "look the type" in the Dahmane photographs, there are other places where she looks like it a good deal more. It turns out she was once a bona fide porn actress with movies such as *Adolescenza perversa, Orgasmo Haus,* and *Perverted Virgins* to her credit. In any case, I couldn't help wondering about the relationship between artist and model here—a woman who'll apparently do anything you ask, including have sex with other men, and happily be photographed by you while doing it. This seemed like a relationship, and perhaps love, of a very special kind.

In the museum there were also at least twenty large, startling oil paintings by an English artist, unknown to me at the time, called David Russell. They showed precise, colorful erotic scenes, often with abstract, geometrical backgrounds, where young people, contemporary-looking and in some ways very ordinary, were having sex with mythological creatures and gods—satyrs, devils, Ganesh—as well as one another. Brian Catling of Ruskin College, Oxford, says of David Russell's work, "[His] humans are not stained by brutality and greed, they possess a classical detachment from base matter, a gift to our tired isolation, a Euclidian geometry of desire that smiles quietly allowing us to recognize the reflection beneath our memory." And yes, they did indeed seem like paintings you might say that about.

After visiting the museum, I wandered the snowy streets of Hamburg, knowing that somewhere in the town was Karl-Ludwig Leonhardt and the rest of his collection. I had absolutely no idea of how to find him.

About eight months later I was in Paris, in David Russell's apartment and studio. I had been put in touch with him by Jamie Maclean of the

Erotic Print Society, who had published some of his work. Partly I went to meet him because of my ongoing interest in what it was like for an artist to be "collected." Not so good in this case apparently. Those paintings I'd seen in the Hamburg museum didn't belong to Herr Leonhardt, it turned out (though he did have a couple of other David Russells in his private collection), but had been loaned to the museum by Russell himself on condition that they buy one per year and send him an annual check. Well, some time had gone by and no checks had arrived, and being an English gentleman, in fact an old Etonian, David was reluctant to say too much, but I got the impression that not very far beneath his charming, urbane surface he was seething with rage and resentment at the situation.

At some point we talked about Dahmane's photographs, and I discovered that David was a friend of his, and also of Chloë des Lysses, although he confirmed that the two of them had recently split up. We both reckoned that Dahmane's latest work lacked the edge it had had when Chloë was his subject. Chloë meanwhile had become an artist in her own right. And then David told me that he actually appeared in some of the photographs I'd seen. He was one of the rather elegant, anonymous haut-bohemian older men assisting Chloë with some cheek spreading and dildo insertion. I was gobsmacked, but it was undoubtedly true, his face looked suddenly very familiar, although he looked a good deal less sinister in life than in the photographs.

Talking to David Russell was a great pleasure. He was amusing, informed, gossipy, and I liked his work a lot. However, there's no point denying it, I had chiefly gone to see him because I hoped he might be a conduit to the mysterious Karl-Ludwig Leonhardt, although I had no real reason to believe he would be. I hated the feeling that I was trying to get something out of him. Eventually, however, and without much prompting from me, David said that I really should talk to a good friend of his: Karl-Ludwig Leonhardt. In itself it was familiar advice, but he made it sound a good deal more possi-

ble than most other people had, and without hesitation he gave me an address, and two telephone numbers, for Herr Leonhardt, one in Hamburg where he and his wife had an apartment, and one in Schleswig-Holstein, where they had their country house. I should contact him, David said, and I agreed that I would. I felt pleased. I felt I had made a connection. I felt my quest was succeeding. If I'm honest I also felt that in a way it had been a little bit too easy. Weren't there supposed to be more rigorous tests and ordeals I should have gone through?

I wrote to Herr Leonhardt, sent him a copy of *Footsucker*, and in due course I phoned him up. He'd been expecting it. David Russell had told him I might call. He didn't exactly sound thrilled to hear my voice, but he wasn't hostile. I asked him some easy questions, in English, the first one being whether or not he was happy to talk to me about his collection. "It is plus or minus zero," he said in his cautious, heavily accented English. How long had he been collecting? "Since fifty years." Had he given any thought to why he was a collector? Well, he'd read one or two books on the theory of collecting, found them interesting enough but not as interesting as all that, and in any case, when it came to his own collection, "The real reason is I don't know."

The conversation wasn't exactly flowing, and I felt that the awkwardness wasn't only because of language difficulties. We agreed that it would be much easier to talk face-to-face. Would I be in Hamburg anytime in the near future? Herr Leonhardt wondered. Did that mean he would show me his collection? He said certainly. I said I'd be in Hamburg in the very near future.

So, not long after that telephone conversation, and about a year after I'd first visited Hamburg to see the Museum of Erotic Art, I was there again, this time to see Karl-Ludwig Leonhardt. I really did have the sense of having achieved some vital, infinitely desirable objective, that I was visiting the final authority, the gray eminence, the man himself. I thought I was about to encounter the mother lode.

On a bleak Saturday morning in November I made my way from my Hamburg hotel to the pleasant, well-heeled suburb where the Leonhardt apartment was. I rang the doorbell and muttered *"Guten Tag"* into the intercom. "Ah, Mr. Nicholson," a man's voice said at the other end, "I see you have learned some German"—this was as near as we got to a joke—and then Karl-Ludwig Leonhardt came down to let me in.

He was a small, dapper man, formal, very polite, a little bit severe. I knew he was in his early eighties, but he looked younger than that: healthy, mobile, nothing conspicuously frail about him. He was a good deal less imposing and saturnine and mysterious than I'd been expecting. In fact he looked like most people's idea of a nice old man.

We went up in the tiny elevator to his very substantial apartment. It was stunning. I don't know much about German Baroque interior decor, and I'm not entirely sure that I like it, but I do believe that the Leonhardt apartment was the last word in that style: heavy wooden furniture, eighteenth-century prints and tapestries, a wooden chandelier made up of rows of tiny painted faces, whole walls of leather-bound books. This in itself seemed to require some explanation.

Again my host didn't really have one. He said that before the Second World War he and his family had lived in Dresden, and as a boy, he'd played in the Zwinger Palace, which was considered to be the finest flowering of German Baroque architecture, and he thought he might very well have developed the taste there, but really he wasn't sure. Of course, he reminded me, the Allies had firebombed Dresden at the end of the war, and worse than that in his opinion, recently in London, the perfidious English had erected a statue of Bomber Harris, the engineer of all that destruction and of much more besides. I thought it best to let that one whiz over my head, though I did assure him there'd been some protests in London about the statue.

There was nothing in the opulent Leonhardt apartment that shrieked "major sex collector," but I wondered if perhaps all those leather-bound volumes contained erotica. But no, they were just

eighteenth- and nineteenth-century nonerotic works in French. I say "just" but I'm sure they represented a fabulous and important nonsexual collection in themselves.

In fact the living room contained just one concentration of sexual material, a discreet, tall, thin, glass-fronted bookcase, tucked around a corner. The books in there looked much like the others, sober, elegant, leather-bound, but on close inspection you'd have seen titles in English and French like *The Pearl* and *Les Nonnes lubriques* and Aleister Crowley's *White Stains*. I knew enough to know this was serious stuff. And on top of the bookcase there was a bust of Franz von Bayros by an Austrian sculptor called Gustinus Ambrosi. I'd seen photographs of von Bayros but I would never have recognized him from the bust. This was only a clue for the very well informed. I knew, of course, that Herr Leonhardt had edited a book on von Bayros, and he said he owned pretty much the complete works, but alas, these works were at the house in Schleswig-Holstein. I said this was a great pity. Actually I've since discovered that Herr Leonhardt was being droll, or very modest, or simply misleading in saying he owned the "complete works." What he might have said was that he owned the complete von Bayros archives, bought directly from the artist's family, who were embarrassed by their pervy old ancestor and glad to be rid of the evidence. Apparently Herr Leonhardt got a bargain.

It's always hard to judge how much money other people have. At various points in our interview Herr Leonhardt complained that he'd never been rich enough to collect on the scale he wanted to. He said, for example, he wished he could have afforded an original Boucher or Fragonard but they were beyond his means. Nevertheless, by any ordinary standards, and judging by what he owned and how he lived, you couldn't imagine he was anything other than a wealthy man.

I knew he'd had a career working for Bertelsmann, the giant German publisher, and I'd heard he'd been CEO. That wasn't quite accurate, he said. For thirty years or so he'd run the Bertelsmann book club, more or less from its origins in about 1950 until the early eight-

ies, when he was forced to take what was evidently an unwanted and unwilling retirement.

Book clubs are a very big deal indeed in Germany, and the Bertelsmann operation was massively successful and profitable. Their book club operated then in countries all over Europe, now all over the world, and by Herr Leonhardt's account, it created the foundation from which Bertelsmann could become the media behemoth it is today, with colossal holdings in record companies and TV stations as well as book publishing. I assume they paid Herr Leonhardt accordingly.

"I had to make many journeys in my time for Bertelsmann," he said, "and searched for books in Vienna, in Paris, in London, Amsterdam, Brussels, Copenhagen, and so on, and I have bought much at antiquarian bookshops and also at auction." And then he paused before he said, "No more. No more."

I found it hard to imagine the man I met being entirely at home in the world of corporate cut and thrust. His old-world manners and bookishness seemed wholly ingrained, but I don't suppose anybody could have had a successful thirty-year business career without being able to demonstrate some steeliness from time to time, and no doubt anyone would soften after twenty years of retirement. Now he seemed to relish a sort of unworldliness. He told me with some pride that he had no computer, no Internet access, not even a fax machine. I asked whether the Internet mightn't be a help in his collecting. "I'm not sure I could find much," he said, which I guess was fair enough. You really don't see too many original Fragonards for sale on eBay.

Before we went any further, however, I wanted to clarify which of the artworks in the Hamburg Museum of Erotic Art were his. Well, not the Mel Ramos or the Allen Jones for instance (though he'd owned some Allen Joneses in the past, he said), nor the Picassos for that matter, nor the photographs by Dahmane, but most of the rest.

I said that I found it hard to understand how someone could give up such a collection, even if only to a museum, even if you retained

ownership. Once you'd assembled it, and once you'd lived with so much great art, how could you possibly live without it? He gave me an explanation, which I accepted without quite understanding, possibly without quite believing. He seemed to say it was a matter of decor. He and his wife had once lived in a much larger apartment, one with sufficient wall space to display a great deal of art. In fact I've since heard that it had the floor area of a whole city block. But then they'd moved and downsized. The current place simply didn't have enough room. Besides, that sort of art wouldn't have fitted in with the Baroque style of the new apartment.

This seemed true enough as far as it went, but it seemed like only a partial explanation. He didn't *have* to surround himself with Baroque finery, did he? And for that matter he surely didn't really have to live in that particular apartment. One option might have been to sell off some of his less treasured items, to have downsized a little less and bought an apartment smaller than the previous place but still big enough to display the remaining, pruned collection. But perhaps I was putting too much emphasis on the collection rather than the man. Perhaps there was actually something very sane about the arrangement. His collection had to fit in with his life, not the other way round. And in any case this was none of my business, and I kept all these speculations to myself.

Herr Leonhardt now offered to show me the part of the collection he kept in his Hamburg home. He said he split his domestic collection more or less equally between this apartment and the house in Schleswig-Holstein. I knew therefore I was going to be seeing only a part of a part, but that was fine. I'd learned that on visits like this, that was all I ever saw.

We walked down the central corridor of the apartment, past a large vitrine full of wineglasses, past a row of fur and leather coats belonging to his wife. Was his wife a collector? No, he said, slightly ruefully I thought. He'd tried to encourage her to be one, but it obviously hadn't come off. Did she share his tastes in erotica? I asked. "No," he

said, with clipped finality. Did she disapprove? "No," he said again in exactly the same tone. "She knows me only with my collection."

The room we went to, in which the collection was kept, was surprisingly small, surprisingly narrow, made more cramped by a desk and a chair, made more cramped still by the presence of Herr Leonhardt and me. There were a couple of paintings on the wall, one showing nuns getting up to the kind of things nuns get up to in pornographic paintings, but essentially I was looking at another book collection.

By then I'd pretty well decided that as far as my own tastes go, books are by some way the most satisfactory and satisfying things you might collect, but I was also aware that they're perhaps the least satisfactory things to show off to other people. The appreciation of a book is an essentially private, singular matter. It requires you and the book to spend some time alone in each other's company. When somebody shows you a few thousand books all at once, you may be impressed by the number of them, by the look, the bindings, the covers, possibly the illustrations, you may be aware of the value or rarity, but you can't have anything like the authentic experience of sitting down with a book. That pleasure is reserved for the collector himself.

I was certainly impressed by the concentration, the density, of the collection, but here was a clear example of not being able to see the wood for the trees. Endless rows of tightly packed books, floor to ceiling, many without titles on their spines, made for a rather forbidding experience. This was in no sense a display or exhibition. I didn't really know what I was looking at. But certain titles did immediately pop out at me. Many of them were French, but it was the kind of French even I could understand: *Vicieuse Maman, Dressage de salopes, Juveniles amours, Flagellation pour couples pervertis*. The titles of the English works were even more straightforward: *Forbidden Friends; Tender Bottoms; Pleasures of Being Beaten; Happy Tears: A Family Idyll*.

I suppose I tended to notice the bigger, gaudier, less exquisite items. There was a huge modern edition of *Mémoires d'une chanteuse*

allemande illustrated by Georges Pichard. It had some pretty rough sadism in its pages. One image stays with me of a plump peasant woman being roasted on a spit. Even Herr Leonhardt seemed to find this a bit much. "Pichard is an acknowledged artist in France," he said, "but his sadism is . . ." He didn't come up with a word but his face showed disapproval. These modern things did seem a bit out of place, as did *The Best of Screw,* for example, or a book of glossy photographs of girls and cars called *Driving Fantasies,* or a photo book called *Golden Pissy Girls,* or a book of photographs of Charlotte Rampling. "She is erotic," my host said, "but it is not an erotic book." In any case, I knew his real interests lay elsewhere.

He showed me a book by Louis Perceau called *Bibliographie du roman érotique du XIXe siècle,* a volume over a thousand pages long, listing and annotating 870 prose works published in French between 1800 and the "present day" when Perceau was writing, i.e., 1930. It was evidently a considerable feat of scholarship. However, for Leonhardt it had more than academic interest. He owns all the books that appear in that bibliography, every one, and they were all there in the room with us, arranged in precisely the same order as in the book, 870 volumes, from *L'enfant du bordel* to *L'Histoire de l'oeil,* by way of *Orgies coloniales, Cousin et cousine* and *Pédérastie active* by one P.-D. Rast, along with works by Pierre Louÿs, Prosper Mérimée, Alfred Jarry, and of course the divine Marquis. This was the kind of thing that reminded me, if I needed any reminding, of the colossal difference between a great collector and the rest: the obsessiveness, the thoroughness, the urge for completion. I tried to imagine the amount of time and energy, the sheer willpower and relentlessness, to say nothing of the amount of money that it must have taken to create that part of the collection; and this was only a fraction of Leonhardt's holdings.

He showed me a modern facsimile of *Gamiani, ou Une Nuit d'excès.* The original was published in the early nineteenth century and is attributed to Alfred de Musset. The lesbian heroine is supposedly based on George Sand, and according to Patrick Kearney, the book is

probably the most reprinted erotic work in history. Herr Leonhardt said there was a time in the 1960s when he could have bought an original. He'd let the chance go by because it was too expensive for him, but of course compared with what you'd have to pay these days, it was an absolute bargain. "The really precious things are always rising in price," he said.

I asked him if he was still buying antiquarian erotica. "Good erotic works are very, very expensive today," he said, "and I'm not sure I would pay so much as they want to have. There are certain books you almost cannot search for, searching makes no sense, one must find it. Modern books you can search for, but the eighteenth century, one can almost not search for such books. There is not much more."

I'd heard that he owned a great deal by the Marquis de Sade. "Yes," he said, "the complete works in many editions, but always with illustrations." And I'd also heard that he owned a manuscript of one of de Sade's works. "No, not one of his works," he corrected. "I have sixteen pages, a list of his books, in his own hand and he wrote it in the Bastille for his wife to send him all these books." For a bibliophile and bibliographer such as himself, I suggested, a document such as that must feel like a sacred relic. He smiled and didn't deny it. "You know, de Sade was a highly cultivated man," he said.

But I didn't get to see the de Sades, neither the books nor the manuscript. They were in the country house in Schleswig-Holstein. There, too, was his collection of works by Restif de la Bretonne, which he thought, rightly, that the author of *Footsucker* would be interested in. He said I was welcome to see them if I ever came to Schleswig-Holstein.

Perhaps it was a little tactless to ask an eighty-two-year-old man if he had any thoughts about the future of his collection, but it was clearly something that had been on his mind. "A difficult question," he said. His wife really didn't have much interest in his collection. He had a grown-up son who had even less. "No, absolutely not."

I told him about Joe Zinnato's intention of splitting his collection

between the British Library, the Kinsey Institute, and L'Enfer. He didn't think much of that idea. "For me the buying was never an investment. I have always collected, and it was only the things that were interesting for me. I never thought of the price I would have when I sold it. But as a gift to a museum? No, I would like something back.

"I could give it to an auction or something," he continued, "but one can see that the best things would be sold and the other not and one day the auctioneer calls me and say I must take them back. The ideal would be a collector like Nordmann in Geneva who could buy the whole."

Ah yes, Gerard Nordmann. Another legendary and mysterious sex collector whom I'd heard a great deal about, and according to Herr Leonhardt a man with pockets much deeper than his own, a man who'd made his fortune in supermarkets, and married a woman who had her own fortune from department stores. "He bought *everything*," Leonhardt said ruefully. And yes, I knew his collection contained many wonders, and that he especially liked to collect unique items; the only known surviving sixteenth-century edition of Aretino's *Postures,* the manuscript of *The Story of O,* and indeed a de Sade manuscript, of *The 120 Days of Sodom.*

The only problem: Nordmann wasn't in much of a position to do any buying. He was dead, and had been for a decade or so. At the time I interviewed Herr Leonhardt, Nordmann's widow was organizing an exhibition of highlights from the collection and was about to publish an accompanying book called *Éros invaincu.* There weren't any other "Nordmanns" in the offing as far as we knew.

"It's very difficult," Herr Leonhardt said. "Very difficult."

My visit with Herr Leonhardt was not so long or intense as it might have been. I felt I was given the very basic tour of the collection, not the VIP's or connoisseur's tour, but that was certainly his prerogative.

Even so I feared I'd exhausted the old chap. His English became less and less fluent as our meeting went on. The tape of our conversation shows me burbling more and more, and his answers becoming ever shorter and less articulate. I've also learned subsequently that his wife was ill. She was in the apartment, though she kept well out of the way, and when Herr Leonhardt excused himself from time to time during our conversation, I now realize he was probably tending to her. He had, I'm quite sure, and quite reasonably, other things on his mind.

Still, I have to admit that I came away from the Leonhardt apartment feeling disappointed. I would certainly have liked to see the de Sades and the Restif de la Bretonnes and the von Bayros archive, all of which were in Schleswig-Holstein, and I had a feeling I wouldn't be going there anytime soon. And once I was out on the street I realized I hadn't asked Herr Leonhardt about his first edition of *My Secret Life*. It certainly hadn't been visible in his book room. And I suppose if I'm honest I had been expecting this Hamburg part of the collection to be bigger and less confined, to fill more than one room, however tightly packed. Perhaps I'd been wanting something more like Naomi Wilzig's two housefuls of crazy, teeming, unorganized materials, though I'd never for a moment thought that would be the Leonhardt way.

Still, I knew I had no right to be disappointed at all, and perhaps my disappointment had more to do with unrealistic expectations, and with my own needs, my self-invented quest, a desire to have my preconceptions fulfilled, than with any failing on the part of Herr Leonhardt and his collection. And perhaps a part of me had always been prepared to be disappointed, had always known that there was no ultimate collector or ultimate collection, that the world's greatest collector would always turn out to be a Wizard of Oz figure, that in the end there was no mother lode. Whatever you saw, you could always imagine a bigger and better collection, a collector more acquisitive and obsessive, someone who could better satisfy your own prejudices

of what a collector could and should be. This, I realized, had very little to do with any actual collector, and nothing at all to do with Karl-Ludwig Leonhardt.

Although I had gone to Hamburg specifically to see Herr Leonhardt, and would not have been there otherwise, I had another, slightly odd, essentially unserious, though not completely irrelevant reason to be in Hamburg. On my first visit there I'd been along the Reeperbahn, and gone into one of the many sex shops, and I'd been impressed by some of the erotic paraphernalia on sale, though I hadn't bought anything. One item that I particularly remembered was a hollow glass dildo, filled with some kind of red liquid, with a length of barbed wire floating in it. It didn't seem like a device you'd actually use during sex—the glass looked too brittle, for one thing, to say nothing of the dodgy symbolism—but as an object, as a collector's item, it seemed highly desirable. I decided to go back and buy it.

The fact was, in the course of writing my book, I'd acquired a fair few sexual collectibles: a lot of books for a start, books that had been useful to me in my research. Some of them had been comparatively expensive, though I don't think any of them was exactly precious. Highlights included a three-volume set of Henry Spencer Ashbee's bibliographies, a Grove Press single-volume edition of *My Secret Life,* Patrick J. Kearney's *A History of Erotic Literature,* a signed copy of the French edition of Catherine Millet's *The Sex Life of Catherine M,* and an illustrated volume by David Russell called *Sophie's Dream Book.* The majority I'd bought myself(but a few were gifts from the artist or writer concerned, and they pleased me most. Eric Godtland had also given me a few of his duplicate pulp novels, including *Sex Playground, Lust Be My Destiny,* and *The Velvet Rut.*

There were the bookplates given to me by Gordon P. Smith, a set of Aubrey Beardsley prints—the illustrations for *Lysistrata*—given to

me by Jamie Maclean of the Erotic Print Society, and a set of Jane Marshall's von Bayros prints.

There were DVDs and tapes of Cynthia Plaster Caster and Richard Kern, of course. I also happened to have accumulated a few personalized signed photographs of, I suppose you could say, sex stars: Linda Lovelace, Tura Satana, Vanessa del Rio, Dixie Evans. Dixie was the only one who'd spelled my name right, though I had stood over her and spelled it out for her.

Then there was all the ephemera I'd picked up on my travels, lots of flyers and leaflets, and all the postcards I'd bought, not least some from the Kinsey Institute showing their great former leader. Also in this group were a few kitsch souvenirs, some nudie playing cards, a little plaster model of an apple with a snake emerging from a vagina-shaped opening that came from the Beate Uhse Erotic Museum in Berlin, and the souvenir mug showing Dixie Evans as a stripper. There was also a copy of *Teri Martine's Bondage Photo Book,* bought from Eros Archives: Teri Martine had appeared in that very first copy of *Carnival* I'd bought all those years ago, though bondage had been a long way from my mind at the time, and possibly from hers, too.

Finally there were all the materials I'd created myself, the photographs, the tape recordings, the notebooks, the correspondence. Put this all together and it was possible to believe that it formed a collection. What's more, it had started to make me think of myself as a bit of a collector. The barbed-wire dildo would fit in very nicely, I thought.

After some searching I found the shop again and was pleased to see that the dildo, or one very similar to it, was still in stock. In fact the product range had expanded since I was last there. The dildo was now available with several different colors of liquid inside, though the barbed wire still loomed as threatening as ever. And now that I looked more closely, the glass appeared even more fragile than I remembered it, and it had a handcrafted look. You could see where the glassblower had snipped off the glass, leaving a horrible, potentially dangerous glass point.

Since I was planning to buy the thing only for decorative purposes, these dangers didn't really matter, but a new doubt now occurred to me. The liquid didn't quite fill the dildo, and there was a fairly large air bubble inside, which meant that the water would splash around and the barbed wire rattle, and I did wonder whether after a while the whole thing mightn't take on that stale look of an old snow globe. This didn't seem all that appealing. What's more, the price was far, far higher than I remembered: 120 euros, about £80 or $150 at that time. It seemed far too much. I hesitated, began to wonder if I really wanted this thing. More than that, something that Karl-Ludwig Leonhardt had said to me earlier in the day had stuck with me naggingly.

He was one of the few collectors who had shown any interest in who I was and why I was writing this book. I did my faltering best to explain. Suddenly he said to me, "And you collect nothing." I think it was intended as a question, but the way he said it sounded like an accusation, or a piece of stringent character analysis. I sensed that he had looked into me and seen that, whatever I thought about myself, whatever I professed, I really wasn't any sort of collector whatsoever by his vertiginously high standards. I suppose few are. And then he said, with some contempt and disgust, "These days, every man who buys something at a flea market considers himself a collector."

At that moment I was very glad indeed that I had made no claims for my own pathetic collecting instincts. And that was certainly a moment when I knew I wasn't a "true" collector, not really a collector of any sort. I should have known it all along. Any of the serious sex collectors I'd met on my travels would have looked at the few humble specimens I'd accumulated and immediately dismissed me as a complete trifler. If I'd tried to claim kinship with them they'd simply have laughed at me, and I would have deserved it. To a layman I might just possibly have looked like a collector, but to a collector of any seriousness, I looked like the most complete and dismal layman. And although I was never naive enough to take all collectors' utterances at their face value, on this occasion I would have been forced to

accept their judgment. It takes one to know one, and any true collector would have seen that although I may have been a supporter, a sympathizer, possibly even a fellow traveler, when you came down to it I simply wasn't one of the tribe. So I didn't buy the barbed-sire dildo, for all sorts of reasons, but chiefly because I wasn't a sex collector.

I keep thinking of a passage in Andy Warhol's book *Popism:* "I loved porno and I bought lots of it all the time," he writes, "the really dirty, exciting stuff. All you had to do was figure out what turned you on, and then just buy the dirty magazines and movie prints that are right for you, the way you'd go for the right pills or the right cans of food. (I was so avid for porno that on my first time out of the house after the shooting I went straight to 42nd Street and checked out the peep shows with Vera Cruise and restocked on dirty magazines.)" This seems rather wonderful. A man has survived an attempt on his life and can think of no better way of feeling alive than by going out and buying some pornography. How many of us would have the nerve either to do it or to admit to it? And, of course, I can't help thinking about another thing Warhol said, "Sex is the biggest nothing of all time," which may or may not be true, but if it is, then that's surely better than being a *small* nothing.

John Richardson, in his article "Warhol at Home," writes, a bit dogmatically it seems to me, "For Andy things became a substitute for lovers. Things don't leave you or die." This is true as far as it goes, but if things don't leave you, then sooner or later you have to leave them, and for the collector, the pain of this separation may be terrible indeed.

Karl-Ludwig Leonhardt was, by a decade or more, the oldest collector I spoke to, and his concerns about the future of his collection were inevitably tied up with concerns about his own mortality. But the fact is, issues of change, decline, and ultimately of extinction are

inherent in any collection, regardless of the age of the owner. Collections may indeed be a hedge against mortality, but they're also reminders of it. However much work, love, and money go into making a collection, except in the very, very rarest of circumstances, it will ultimately be unmade by the simple passage of time, by the inevitable demise of the collector. By this process, the most exquisite items in any collection become memento mori. Perhaps this isn't so bad. If we're going to be reminded of own our mortality, then personally I'd much rather be reminded of it by a von Bayros nude or a Helmut Newton photograph of a big-breasted Amazon in high heels than by skulls, skeletons, or an allegorical figure of death.

I still have the small erotic accumulation that I acquired while writing this book, an accumulation that I no longer feel able to describe as a collection. It is what it is, and I certainly haven't felt any desire to be rid of it, or for that matter to "improve" it. In general I'm happy enough to live with the idea that I'm not a sex collector, certainly not in the way that Naomi Wilzig or Eric Godtland or Joe Zinnato or Karl-Ludwig Leonhardt are sex collectors. However, I do console myself with one final collecting claim.

In writing this book, it seems to me that I have been collecting sex collectors. The process has involved assembling and ordering; seeking out interesting examples, prime specimens, rarities; comparing and contrasting them; exercising choice, judgment, and connoisseurship. It's involved scholarship, detective work, a certain amount of negotiation, and some lucky finds. I think it's a good collection, I'm happy with it, it gives me pleasure, but I know it's partial, prejudiced, incomplete, culturally slanted, colored and limited by my own personality, interests, and means. Exactly like any other collection. It's easy to imagine bigger, better, more inclusive, more gaudy collections; the only problem: they wouldn't be mine.

Bibliography

Compiling a bibliography, as we've seen, may well be a form of collecting. Therefore there's often the urge to make a bibliography as vast, inclusive, and showy as possible. I've resisted this, and tried to make a small, relevant collection. Most of the books listed below are mentioned in the text, and even if they aren't, I've found all of them useful in writing the book. The editions are generally the ones I've used, except where I've consulted particularly obscure editions, in which case I've also cited more easily available ones.

Aljasmets, Erna, "Introductory Essay." In *Garden of Eden on Wheels: Selected Collections from Los Angeles Area Mobile Home and Trailer Parks*. Exhibition catalog. Los Angeles: Museum of Jurassic Technology, 1996.

Anon. *My Secret Life*. 11 vols. Amsterdam(?): privately printed, c. 1888–94. The book exists in many popular editions, most of them incomplete or abridged. The various editions published by the Grove Press, New York, in 1966 remain the most authoritative and most easily obtainable.

Ashbee, Henry Spencer. *Index librorum prohibitorum* by Pisanus Fraxi. London(?): privately printed, 1877.

———. *Centuria librorum absconditum*. London(?): privately printed, 1879.

———. *Catena librorum tacendorum*. London(?): privately printed, 1885. These are most easily available as a three-volume set called *The Encyclopedia of Erotic Literature* (New York: Documentary Books, 1962).

Bibliography

Barker, Stephen, ed. *Excavations and Their Objects: Freud's Collection of Antiquities*. Albany: State University of New York Press, 1996.

Baudrillard, Jean. *System of Objects*. Translated by J. Benedict. London: Verso, 1996.

Bayros, Franz von. *The Amorous Drawings of the Marquis von Bayros.* Edited by Ludwig von Brunn [Karl-Ludwig Leonhardt]. Preface by Wilhelm M. Busch. North Hollywood: Brandon House, 1968.

Belk, Russell W. *Collecting in a Consumer Society.* London and New York: Routledge, 1995.

Benjamin, Walter. *Illuminations*. Translated by Harry Zohn. New York: Schocken Books, 1969.

———. *The Arcades Project.* Translated by Howard Eiland and Kevin McLaughlin. Cambridge, Mass., and London: Belknap Press of Harvard University Press, 1999.

Berquet, Gilles. *Parfums mécaniques.* Paris: J. P. Faur, 1996.

———. *The Banquet.* San Francisco: Last Gasp, 2000.

Blom, Philipp. *To Have and to Hold: A Study of the Collecting Mind.* London: Allen Lane, Penguin Press, 2002.

Cross, Paul James. "The Private Case: A History," in *The Library of the British Museum: Retrospective Essays on the Department of Printed Books,* edited by P. R. Harris. London: The British Library, 1991.

Dahmane, and Chloë des Lysses. *Porn Art*. Paris: Éditions Alixe, 2000.

———. *Porn Art 2.* Paris: Éditions Alixe, 2000.

Danville, Eric. *The Complete Linda Lovelace.* New York: Power Process Publishing, 2001.

Döpp, Hans-Jurgen. *The Erotic Museum in Berlin*. London: Parkstone Press, 2000.

Eccles, Lord. *On Collecting*. London: Longmans, 1968.

Foucault, Michel. *The History of Sexuality*. Vol. 1, *An Introduction*. Translated by Robert Hurley. New York: Pantheon, 1978.

————. *The Order of Things: An Archaeology of the Human Sciences*. Translated by Michel Foucault. New York: Pantheon, 1970.

Freud, Sigmund. *The Psychopathology of Everyday Life*. Translated by A. A. Brill. New York: Macmillan, 1914.

Gathorne-Hardy, Jonathan. *Alfred C. Kinsey: Sex the Measure of All Things*. London: Chatto and Windus, 1998.

Gibson, Ian. *The Erotomaniac*. London: Faber and Faber, 2001.

Henric, Jacques. *Légendes de Catherine M*. Paris: Éditions Denoël, 2001.

Hyde, H. Montgomery. *A History of Pornography*. New York: Farrar, Straus and Giroux, 1964.

Jackson, Beverley. *Splendid Slippers: A Thousand Years of an Erotic Tradition*. Berkeley: Ten Speed Press, 1997.

Jackson, Roger, and William E. Ashley. *Henry Miller: A Personal Archive*. Sale catalog. Pismo Beach, Calif., and Ann Arbor, Mich.: privately printed, 1994.

Jones, James H. *Alfred C. Kinsey: A Public/Private Life*. New York: W. W. Norton, 1997.

Kearney, Patrick J. *A History of Erotic Literature*. London: Macmillan, 1982.

————. *The Private Case: An Annotated Bibliography of the Private Case Erotica Collection in the British* [Museum] *Library*. London: Jay Landesman, 1981.

Bibliography

Kendrick, Walter. *The Secret Museum: Pornography in Modern Culture.* New York: Viking, 1987.

Kern, Richard. *New York Girls.* New York: Taschen, 1997.

Kinsey, Alfred C. *An Introduction to Biology.* Philadelphia and London: J. B. Lippincott, 1926.

Kinsey, Alfred C., Wardell B. Pomeroy, and Clyde E. Martin. *Sexual Behavior in the Human Male.* Philadelphia and London: W. B. Saunders, 1948.

————. *Sexual Behavior in the Human Female.* Philadelphia and London: W. B. Saunders, 1953.

Kronhausen, Phyllis, and Eberhard Kronhausen. *Erotic Bookplates.* New York: Bell Publishing Company, 1970.

Lacan, Jacques. *Écrits: A Selection.* Translated by B. Fink. New York: W. W. Norton, 1977.

Legman, Gershon. *The Horn Book: Studies in Erotic Folklore and Bibliography.* New York: University Books, 1964.

Leonhardt, Karl-Ludwig [Ludwig von Brunn]. *Ars Erotica, Die erotische Buchillustration im Frankreich des 18. Jahrhunderts.* 3 vols. Hamburg: Harenberg, 1989.

Leonhardt, Karl-Ludwig, and Franz Bayer. *Selten und gesucht: Bibliographien und ausgewählte Nachschlagewerke zur erotischen Literatur: Bearbeitung der Bibliographien und Auswahl der Illustrationen.* Stuttgart: Anton Hiersemann, 1993.

Lovelace, Linda. *Ordeal.* With Mike McGrady. Secaucus, N.J.: Citadel Press, 1980.

Marcus, Steven. *The Other Victorians: A Study of Sexuality and Pornography in Mid-Nineteenth-Century England.* New York: Basic Books, 1974.

Bibliography

Muensterberger, Werner. *Collecting: An Unruly Passion*. Princeton: Princeton University Press, 1994.

Miller, Henry. *Quiet Days in Clichy*. Paris: Olympia Press, 1956.

Millet, Catherine. *The Sexual Life of Catherine M*. Translated by Adriana Hunter. London: Serpent's Tail, 2002.

———. "The Arch Innocent: Warhol, Gnosticism and Sex." *Art Press* 296 (December 2003).

Nead, Lynda. *The Female Nude: Art, Obscenity and Sexuality*. London: Routledge, 1992.

Nin, Anaïs. *The Diary of Anaïs Nin*. Vol. 2: 1934–39. New York: Harcourt, Brace and World, 1967. This is the volume in which she writes "Dear Collector, we hate you."

Partridge, Burgo. *A History of Orgies*. New York: Bonanza Books, 1960.

Pomeroy, Wardell B. *Dr. Kinsey and the Institute for Sex Research*. New York: Harper and Row, 1972.

Scheiner, C. J. *The Encyclopedia of Erotic Literature*. 2 vols. New York: Barricade Books, 1996.

Simenon, Georges. *Intimate Memoirs*. Translated by Harold J. Salemson. New York: Harcourt Brace Jovanovich, 1984.

Squiers, Carol, and Jennifer Yamashiro. *Peek: Photographs from the Kinsey Institute*. Santa Fe: Arena Editions, 2000.

Steele, Valerie. *Fetish*. New York and Oxford: Oxford University Press, 1996.

Warhol, Andy, and Pat Hackett. *Popism*. New York: Harcourt Brace Jovanovich, 1980.

Bibliography

Webb, Peter. *The Erotic Arts*. London: Secker and Warburg, 1975.

Weschler, Lawrence. *Mr. Wilson's Cabinet of Wonder*. New York: Pantheon Books, 1995. A book about the Museum of Jurassic Technology, in Los Angeles, and the smartest rumination I know about the nature of collecting and the museum.

Wilson, Charis, and Wendy Madar. *Through Another Lens: My Years with Edward Weston*. New York: North Point Press, 1998.

Winnicott, D. W. *The Child and the Family*. London: Tavistock, 1957.

About the Author

Geoff Nicholson is the author of fourteen novels, including *The Hollywood Dodo, Hunters and Gatherers, The Food Chain,* and *Bleeding London,* which was short-listed for the Whitbread Prize. He divides his time between Los Angeles and London.